THE DRAMATIC IMAGINATION

Reflections and Speculations
on the Art of Theatre

Robert Edmond Jones

戲劇性的想像力　大師寫給創作靈魂的藝術通則

羅勃・愛德蒙・瓊斯——著　王世信——譯　聶光炎——審定

羅勃・愛德蒙・瓊斯
美國二十世紀最具影響力的劇場設計師

　　1887年12月12日，羅勃・愛德蒙・瓊斯（Robert Edmond
Jones, 1887–1954）出生於美國東北部新罕布什州的米爾頓小
鎮。進入哈佛大學就讀時，修讀了許多文學與戲劇的課程。
1910年，自哈佛大學畢業便留校擔任助教。兩年後，他前往
紐約開始他的舞台設計生涯。在紐約歷經了工作洗禮，讓瓊
斯渴求更多的知識，因此毅然決然離開美國、前往歐洲取經
──然而他並未得到佛羅倫斯Gordon Craig藝術學院的青睞
與入學機會。不過，同時期他為Shelley設計的作品 *The Cenci*
卻贏得紐約評論家一致好評，這似乎預言了日後羅勃・愛德
蒙・瓊斯以概念性的舞台設計美學理念，對美國劇場造成的
巨大浪潮。此後，他改而轉往柏林Max Reinhardt's Deutsches
Theatre，展開為期一年的見習，卻遇上第一次世界大戰爆
發，旋即終止了歐洲的學習旅程而返美。

　　回到紐約之後，瓊斯立即推出舞台設計作品《威尼斯商

人》（*The Merchant of Venice*）。在這部作品當中，他的才能吸引了亞瑟・霍普金斯（Arthur Hopkins）的目光，也因此在1915年，獲霍普金斯邀請、替英國導演 Harley Granville-Barker《家有笨妻》（*The Man Who Married A Dumb Wife*）一劇擔任舞台及服裝設計。在劇中，瓊斯大膽使用簡約的概念來表現，舞台與服裝設計以黑、白、灰為主色調，與當時百老匯的戲劇製作大相逕庭。而比起當時流行的傳統寫實風格，顯然他的設計更能扣合導演及劇本的需求，贏得了空前的成功。瓊斯反對百老匯劇場風行一時的「寫實主義風格」，尤其不喜色彩過度繁雜；相對地，他那簡潔的風格，反而更能迎合導演的想法、並將其他設計元素融合渾一，達到了新穎而不落俗套、引人入勝卻不突兀的視覺效果。《家有笨妻》一劇，建立起羅勃・愛德蒙・瓊斯的設計創作風格，也為當時美國的舞台設計帶來新的革命。

之後，瓊斯接受亞瑟・霍普金斯的邀約再度合作《惡魔花園》（*The Devil's Garden*）。此劇的成功，也開啟了二人日後緊密的合作關係。《惡魔花園》講述政府官僚體系的醜陋，瓊斯以「室內寫實景」（box setting）的簡單設計，表現出幽暗、陰險的場景氛圍，評論家甚至說「彷彿撒旦隱匿其中，不時搧動著劇中主角出賣靈魂」。瓊斯再次印證這種新的設

計風格也同樣可以用於寫實的表現，這種簡約的寫實風格漸漸變成美國舞台設計的主流。至此，羅勃·愛德蒙·瓊斯已在美國劇場史上留下不可抹滅的一頁！

此後的十九年間，瓊斯陸續創作了諸多出人意表的獨特演出。在和霍普金斯合作的 39 齣劇作中，皆由他擔任舞台設計（多數也兼任服裝設計），多齣作品也都成為美國劇場設計的公認指標。如由約翰·巴瑞爾摩（John Barrymore）演出的《哈姆雷特》、《理查三世》、以及由里歐納·巴瑞爾摩（Lionel Barrymore）演出的《馬克白》等。1916 年，為了慶祝莎士比亞 300 周年誕辰紀念，瓊斯與 Joseph Urban 合作 *Caliban by the Yellow Sands*，這齣戲因為涵蓋了大量室外燈光的設計及運用、超過三千件的服裝設計，被公認為具有歷史紀念價值，更成為他職業生涯的高峰。

在《古利奈人西門》（*Simon the Cyrenian*）這部極富現代感的創作中，羅勃親自出任導演，在選角時便大膽地突破窠臼，決定全部啟用黑人演員——如此創新而跳脫的思維，更加說明他何以能超越時代的潮流獨領風騷。不久之後，他替麻州的 Provincetown 實驗劇場導戲、設計及製作演出。這間劇院原是由他及尤金·歐尼爾（Eugene O'Neill）及肯尼士·

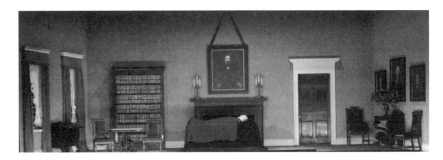

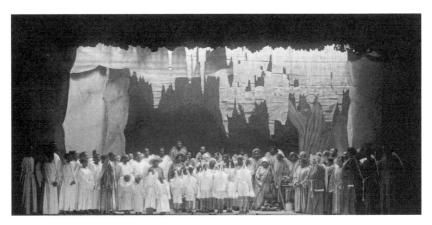

△ 《素娥怨》以室內寫實景方式呈現（1931）。
Courtesy of The Billy Rose Theatre Collection, The New York Public Library.

▽《青青草原》演出劇照（1930）。
Courtesy of The Billy Rose Theatre Collection, The New York Public Library.

麥克歐文（Kenneth Macgowan）共同創立。在忙碌的劇場工作之餘，他也不吝於把心力灌溉於立言著述。1922年，瓊斯再度回到歐洲，期間與肯尼士‧麥克歐文共同出版《歐陸舞台藝術》（*Continental Stagecraft*）一書。三年後，已卓然成家的瓊斯集結出版了個人設計作品集，名之《彩繪劇場》（*Drawings for the Theatre*）。其他著名的劇場作品如《青青草原》（*The Green Pastures*，1930）、《素娥怨》（*Mourning Becomes Electra*，1931）、《啊，荒野！》（*Ah, Wilderness!*，1933）、《費城故事》（*The Philadelphia Story*，1937）、《朱諾與孔雀》（*Juno and the Paycock*，1940）、《奧賽羅》（*Othello*，1943）、《賣冰人來了》（*The Iceman Cometh*，1946）及《魯特琴之歌》（*Lute Song*，1946）。其中，《青青草原》（*The Green Pastures*），堪稱瓊斯歷年來最成功的商業作品，並於1951年又再度加演，共計演出1642場──這一次的演出也是他最後一齣製作了。而《魯特琴之歌》更被視為他一生最後的代表作。

1934年起，瓊斯接受了好萊塢的邀約，同時為電影長、短片設計。其後重回劇場，瓊斯持續製作、導戲、設計及寫作。最知名的著作即是《戲劇性的想像力》（*The Dramatic Imagination*，1941）。本書自出版以來，在劇場界始終佔有

舉足輕重的地位，其中闡述的設計理念更是歷久彌新，直到今日都顯見其真知灼見已遠遠走在時代的前端。1940年代晚期，瓊斯的健康情況逐漸開始走下坡，雖然他仍堅持設計、寫作的工作直到1950年初，但已明顯的受到了衰病的限制。最終，他返回故鄉療養，於1954年的感恩節當天與世長辭。

羅勃‧愛德蒙‧瓊斯，他的精神與思維，始終為劇場散播性靈、真切的種子，那樣的真誠也仍在今日的劇場裡燦爛綻放。

譯者序

　　我想很多人都會在問：這本老書幹嘛還要翻譯（原書出版 1941年），包括補助申請的審查委員們也都抱持著相同的態度，因此三年前就這麼被甩出了申請審查，整個譯稿也就在我電腦硬碟內半夢半醒地躺了三年，因為想說沒人要的東西至不濟歹也可以拿來當上課講義。一直到去年底台灣技術劇場協會才又重提出版之事，並且相當積極地為這本書談版權、找贊助、找出版社，更努力找到合適的編輯為我的文字做譯註和校正，才讓它像睡美人般地如夢乍醒。

　　初讀 Robert Edmond Jones 的文字，是大三那年在聶光炎老師的舞台設計課堂上所印給我們的一篇講義 *To A Young Designer*。當年懵懂根本沒力氣（也沒那英文能力）把它讀完。一直到大五畢業前，再次從聶老師口中聽到 Robert Edmond Jones 的 *The Dramatic Imagination* 這本書，糊裡糊塗地讀完了，只覺得文字寫的好美，但是……還是看不懂。這本

粉紅色封皮的影印書（好在當年沒有著作權法），不知怎地就跟著我飄洋過海的去到了芝加哥和紐約。一直到我在紐約做完畢業製作後，突然閒到發慌不知所從時才又再一次從書堆中，把這本書翻出來認認真真的看了一遍。許是成熟了；許是英文進步了；一篇又一篇的文字看的我熱淚盈眶，尤其是當我一句一句用聲音讀出來時，更感覺到文字的熱情，一把把撫慰著我、召喚著我，一如慈父的諄諄教誨。如果說聶光炎老師是我設計的啟蒙師，那Robert Edmond Jones就是我心靈的啟蒙師。

剛回台灣的頭幾年被設計案追著跑，也被工作壓的喘不過氣來，經常有一種「我在幹什麼？」的念頭。是這本書一次又一次讓我回到清明的神思和朗朗的天地。每次閱讀都有不同的感動，每每在對劇場沮喪失望的時刻，讓我重新燃起對自己工作的熱情。的確，這是一本老書，也是一本小書，通篇文字沒有一張圖片，和現下坊間、網路上精美絕倫的彩色印刷或流動頁面的呈現比較起來實在是謙卑又低調。但正也是這純文字的力量，勾起了腦海中的無數美麗風景。文章中有許多的用語和例證在今天看來是有點脫節的，但是其中主要的精神卻足足影響了現代劇場設計觀念將近一個世紀。這些精神在今天看起來依然像清晨綻放的花朵般清新宜人。

Robert Edmond Jones 一而再、再而三的提示著我們，做為一個劇場工作者如何從內在——人的內在、角色的內在、文本的內在、時代的內在、來探討設計。一個由內而外的設計作品才能夠擺脫形式超越阻隔，呈現出它當有的風貌、應有的氣息而渾然天成。

由於希望想和所有設計朋友們分享這本令人心曠神怡的書（我實在覺得他所傳達的意念，早已超出劇場的範疇而是一種藝術的通則了），因此野人獻曝的試著揣摩作者如韻如詩的語氣，時而激昂時而低迴的聲調，把這本對我來說意義非凡的書譯成了中文。但也怕自己的譯文失去原文韻味，因此更大膽的把英文並列其旁，讓想一品原作芳香的朋友們能即時享用。又擔心年輕的朋友因年代的隔閡無法得窺堂奧，因此斗膽的在每篇之後，加上了我這個「現代人」的延伸思考，來拉近讀者與原著的距離。在譯文中，補述了一些關於劇作家、知名演員及作品及典故的註釋，希望讓讀者更加了解作者所描述的境地。我想這本書如果能有所成，應該是作者的心念透過我來感動這一個世代的人；如果有所敗，也應當是我這續貂的狗尾吧！

在翻譯及出版的漫長過程中，感謝聶光炎老師給予審閱及

建議，感謝協會辦公室及佳慧對於所有行政支援的努力；感謝原點出版社給予出版發行的協助；更感謝綉茵不厭其煩地幫我校正譯文中語法的錯誤、指導我文學的典故、釐清注釋中摸不著頭緒之處。也要在這裡謝謝所有扶持著我成長的師長們，和一起在劇場中甘苦奮鬥的工作朋友們。有劇場真好！有你們更好！

王世信

戲劇性的想像力
The Dramatic Imagination

CONTENTS

目錄

Introduction

John Mason Brown

The theatre Bobby Jones believed in and created was a theatre that did not take the dim view and had not lost its sense of wonder. It was an extension of life, not a duplication, a heightening rather than a reproduction. The vision of what the theatre might be, as opposed to what it is, was present in almost every word Bobby ever wrote or spoke. On the printed page, as in his settings, he was our stage's high priest of evocation. No one who heard him could doubt his dedication, no one who saw his work question his genius. He was an unashamed pleader for beauty and, far more important, an unsurpassed creator of it.

"The artist should omit the details, the prose of nature, and give us only the spirit and the splendor," Bobby contends in *The Dramatic Imagination*, and he practiced what he preached. "The spirit and the splendor", plus "an excitement, a high rare mood,

序言

<div style="text-align: right">約翰・梅森・布朗[1]</div>

　　包比・瓊斯（Bobby Jones）[2]所堅信和創造的劇場觀，從不以晦暗不明姿態出現，卻又從不曾失去其中的神妙。它像是生命的延伸而非仿製，更是生命的擴大而非重製。相對於劇場的現況，包比在所有的言論和文章中提出了他對於未來的願景，不論在他的論述中或者在他的設計作品裡，在在都顯示他是一位召喚性靈的高僧，沒有人能夠質疑他的貢獻，更沒有人會質疑他的才華，稱他為美的追尋者毫不為過，但更重要的是：他所創造的美是無人能夠超越的。

　　「作為一個藝術家應該提供的是精神和它所帶來的壯闊，而應當省略細節和它所帶來的乏味本質。」這是包比在這本書裡的主張，而他也身體力行。「精神和它所帶來的壯闊」

1　1900–1969，美國著名的戲劇評論家與作者。早年於 *New York Evening Post* 工作，知名的評論專欄〈Seeing Things〉在 *The Saturday Reviews* 刊載了25年之久。
2　熟識者都暱稱 Robert Edmond Jones 為 Bobby Jones。

and a conception of greatness," were with him life-long dreams which he turned into realities.

The theatre for him was always "an exceptional occasion." That is why Bobby hated it when its dialogue was dictaphonic, its concerns humdrum, or when it fed the eye on the drab, the non-selective, or the undistinguished. At one point in *The Dramatic Imagination* he says in a parenthesis, "It would be hard perhaps, to make the waterfront saloon setting of *Anna Christie* lustrous." Then he added, "But I am not so sure." In his case he had no reason to be unsure. Just as Midas had the touch of gold, Bobby had the quickening touch of radiance.

The ugliest scenes in real life throbbed with beauty when he had transformed them into scenery. Not as insipid or self-advertising prettiness. Not that at all. Instead they acquired a tension, a sense of mood, a luminosity, and a quality of drama which made spectators at once aware that reality had been lifted into theatre, and theatre into art. "Lustrous" was precisely what Bobby did make that waterfront saloon in 1921, even as "lustrous" to a greater extent is what he made the backroom and

以及「一種悸動、一種罕見的高貴氣質、一種雍容大度的理念」，是他畢生的夢想，也是他終生的實踐。

劇場對他而言永遠是一個「特殊的場域」，這也是他之所以討厭演出的台詞像筆錄般的無趣，或是主題單調乏味，更或者是視覺上未經仔細篩檢的貧乏和平庸。在本書當中他曾以插句的方式說：「也許要讓《安娜·克麗絲蒂》（*Anna Christie*）[3]一劇當中的河畔沙龍場景看起來閃耀動人，似乎有點不太可能。」隨後又說：「但也不盡然！」但是，對他來說沒有什麼好不確定的，就像米達斯（Midas）[4]能將所有碰觸過的東西變成黃金一般，凡是到了包比手上的東西都能立即煥發光彩。

現實中最醜陋的場景，到了他的手上都能幻化成令人讚嘆的美景。絕非單調或喧鬧的美，取而代之的是，他們掌握著一種張力、一種基調、散發出一種光輝、一種令觀者即刻體悟到戲劇被提升為劇場，而劇場被昇華為藝術。「隱隱生輝」正是包比在1921年時創作的河畔沙龍，甚至在25年以

[3] 詳見第六章〈光與影〉，註14，p. 220。
[4] 希臘神話中 Phrygia 國王，能點物成金。

bar of Harry Hope's saloon in *The Iceman Cometh* twenty-five years later. Throughout his career this very attribute of being "lustrous" was an outstanding characteristic of his work, and one that set it apart.

I have to write about Bobby and his career in personal terms. Not to do so would be as false as referring to him as "Mr. Jones" and pretending that I had not known him long and fairly well. Since we were friends in spite of occasional disagreements, he was "Bobby" to me and his career is one that I followed almost from its beginning. As a matter of fact, the first article about the theatre I ever wrote for a newspaper was about him. It appeared in the *Louisville Courier Journal* in the winter of 1919 under the title of "Craftsmanship of Robert Edmond Jones." I was then a freshman at Harvard who had been introduced the year before to a new world by "Mr. Jones's" unforgettable settings for *Redemption* and *The Jest.*

5 作者為尤金・歐尼爾（Eugene O'neill, 1888–1953），這是他被公認為最好的作品之一，是一個以死亡為主題的作品。

6 作者為列夫・托爾斯泰（Leo Tolstoy, 1828–1910），約1900年的戲劇作品，在他死後才得以出版。

後的《賣冰人來了》（*The Iceman Cometh*）[5] 當中，哈利·霍普（Harry Hope）的酒吧和背景上，他把這「隱隱生輝」的意義推向一個更高的境界。他一生所追求的「隱隱生輝」屬性，使得他的作品有了傑出的特質，也正是這樣的特質使他超越了所有人。

　　我必須從一個比較個人的觀點來談論包比和他的工作，不然的話我就必須稱他為「瓊斯先生」，然後假裝並非和他相知熟識多年。縱使在某些工作場合裡，我們的意見不盡相同，但是對我而言他就是「包比」，一個我追隨多年的人。事實上，我為報紙所寫的第一篇報導，就是有關於他。那是在1919年冬天的「路易斯維爾信使報」上，文章題目是〈羅勃·愛德蒙·瓊斯的工藝〉，當年我還只是一個哈佛的新鮮人，在前一年才經由「瓊斯先生」為《救贖》（*Redemption*）[6] 和《笑柄》（*The Jest*）[7] 所做的設計，引領進入了一個嶄新的世界。

7 出自義大利詩人及劇作家 Sem Benelli (1877–1949) 的成名作品 *La Cena Delle Beffe*，該劇在美國的演出即以《笑柄》為劇名。

The first time I ever saw Robert Edmond Jones was when he came to speak at Harvard during my sophomore year. To those of us already stage-struck his coming was the cause of considerable excitement. "Art" with a capital "A" was very much in the theatrical air and this Jones man was known to us as one of its chief votaries and practitioners. We undergraduates who cared about the stage had not read our Kenneth Macgowan for nothing. We were steeped in Gordon Craig's *On the Art of the Theatre* and *The Theatre Advancing*, in Hiram Motherwell's *The Theatre of Today*, in Sheldon Cheney's *The New Movement in the Theatre* and *The Art Theatre*, and in the pages of Mrs. Isaacs' *Theatre Arts* (still a quarterly).

Bobby stepped onto the pink and white platform of the Music Building, wearing evening clothes as if they pained his spirit. His face was paler than the moon. He looked young, incredibly young. His hair was full and black, and in addition to

8 1888–1963，美國劇場評論家，現代劇場作品有 *The Theatre of Tomorrow* (1921) 與 *Continental Stagecraft* (1922)。

9 詳見第二章〈劇場藝術〉，註4，p. 43。

10 1888–1945，美國記者及評論家。

　　第一次看到羅勃・愛德蒙・瓊斯是我在哈佛的第二年，對我們這群著迷於舞台的人來說，他的來到無疑地引起相當騷動。這個以A開頭的字「藝術」（Art），在當年的劇場空氣中瀰漫著，而這個叫瓊斯的人也是眾多的信仰者和實踐家當中的佼佼者。我們這群在乎戲劇的大學部學生並非徒然研讀肯尼士・麥克歐文（Kenneth Macgowan）[8]，我們浸淫在葛登・克雷格（Gordon Craig）[9]的《劇場中的藝術》（On the Art of the Theatre）和《進步中的劇場》（The Theatre Advancing）；海瑞姆・馬德威爾（Hiram Motherwell）[10]的《今日劇場》（The Theatre of Today）；還有雪爾登・錢尼（Sheldon Cheney）[11]的《劇場新趨勢》（The New Movement in the Theatre）和《藝術劇場》（The Art Theatre）；以及愛薩克（Isaacs）女士[12]主編的《劇場藝術雜誌》（Theatre Arts Magazine）。

　　包比踏上了音樂館裡粉紅與白色相間的台子，他的面容比月光還要蒼白，身上隆重的禮服似乎困擾著他的心神。他看起來很年輕，不可思議的年輕。一頭濃密的黑髮，除了跟了

11　1886–1980，美國作家，創辦《劇場藝術雜誌》。
12　1878–1956，美國作家及評論家，1918年起為《劇場藝術雜誌》編輯至1946年，達28年之久。

the mustache he wore throughout his life he then sported a beard which, more than being "Left Bank," was almost sacrilegious.

He seemed shy, frightened really, and there was something about him of the holy man which he did not try to hide. It seemed to come naturally to him and we sophomores accepted him on his own terms. His speech, though hesitant, was sonorous. Most of what he said I do not now remember. I can, however, hear the richness of his voice. I also recall surrendering to his gift for conjuring visions with words.

Towards the lecture's end he confessed that he looked forward to the time (he seemed to see it right in front of him, too) when in the theatre the imagination would be set free, and realism abandoned because no longer necessary.

It was during that same season that Bobby did his celebrated settings for the Arthur Hopkins production of *Macbeth* in which Lionel Barrymore and Julia Arthur appeared. The revival, though a brave attempt, was a resounding failure. One reason was that the all too solid flesh and realistic performances of Mr. Barrymore and Miss Arthur were constantly at war with the symbolical abstractions of Bobby's scenery. On the Sunday before this *Macbeth* opened, however, Mr. Hopkins contributed

他一輩子的小鬍子之外，當年他還蓄著落腮鬍，與其說看起來有點「左岸」，不如說有點猥褻。

他看起來有點害羞，更實際一點說看起來有點受驚嚇，但是這個聖人卻並沒有隱藏他的某些特質。這些質地對他來說是那麼的自然，而我們這群大二生也就這樣理所當然地接納了他。整個演講雖然有點遲疑感，但無疑地卻是相當的宏亮，當時說了些什麼我大多已不復記憶，但是我還能聽到他豐厚的聲音，還記得被他視覺文字化的魔力所深深懾服。

在演講將結束時，他向我們表明所企望（他眼中似乎正看到這想望一般），有那麼一天可以讓想像力在劇場中釋放且奔馳，揚棄不再所需的寫實主義。

就在這演講的同一季，包比為亞瑟‧霍普金斯（Arthur Hopkins）所製作，里歐奈‧巴瑞摩爾（Lionel Barrymore）、茱莉亞‧亞瑟（Julia Arthur）所主演的《馬克白》（*Macbeth*）設計了值得頌揚的舞台。這是一個極為大膽的嘗試，卻是一個徹底的失敗，其中一個原因是：兩位主角極度寫實的表演方式，似乎整晚上都在和包比象徵式的抽象舞台戰鬥。但是話說回來，就在《馬克白》首演的前一個星期天，霍普金斯

an article to the *Times* which, tattered and yellowed is still pasted in my Temple edition of the play. I continue to cherish it as a statement of courageous intentions and particularly value the opening line which reads, "In our interpretation of *Macbeth* we are seeking to release the radium of Shakespeare from the vessel of tradition." When I came to know Bobby after my graduation and during my years on Mrs. Isaacs' *Theatre Arts Monthly*, I realized more and more that he was always trying to release the radium not of Shakespeare alone but of whatever he touched "from the vessel of tradition."

There are the cathedral and the Broadway approaches to the theatre. These are the two extremes. Bobby's approach, though he worked brilliantly on Broadway, was unquestionably the former. But it would be both unfair and untrue to suggest that he was a kind of grave St. Cecilia of scenic art. He loved life and he loved laughter, and his own laughter was the merriest of music. He was as ready to welcome the theatre of Valeska Suratt, Eva Tanguay, Olga Petrova, the Fratellinis, Bill Robinson, Florence Mills, or the Marx Brothers, as he was the theatre of

13 1882–1962，美國知名舞台劇、默劇演員，首度於 The Kiss Waltz 登台即大放異彩。
14 1879–1947，加拿大歌手，演員。
15 884–1977，英國出生的她，是知名好萊塢及百老匯演員。
16 義大利小丑家族，在十九世紀初，第一次大戰後大受歡迎。
17 1878–1949，非裔美籍舞者及演員。
18 1895–1927，非裔美籍歌手，知名百老匯演員。
19 五名紐約出生的兄弟，皆為知名百老匯喜劇演員。

先生在紐約時報發表了一篇文章，雖然至今已泛黃殘破，但依然還貼在我經典演出的剪貼簿上，至今我依然珍惜文章中所提出的大膽企圖，尤其是在文章起始處：「在我們的《馬克白》演出中，是期望從傳統的窠臼中釋放莎士比亞的光芒。」當我畢業以後，在愛薩克女士的劇場藝術月刊工作時認識了包比以後，我深深的了解到他所要釋放的不只是莎士比亞光芒而已，而是所有他所碰觸過的「傳統窠臼」。

　　從事劇場有兩種極端的態度，一種是神聖的；一種是商業的，縱然包比在百老匯的商業場域中獲得極高的評價，但是他的態度無庸置疑地絕對屬於前者。可是如果要把他看成像是某種中世紀的殉道者一般悲情的話，那是絕對的錯誤與不公平。他熱愛生命與歡笑，他的笑聲是世上最令人愉悅的樂音。他已經準備好迎接薇拉斯卡・史拉特（Valeska Suratt）[13]，伊娃・譚桂（Eva Tanguay）[14]，奧佳・佩卓瓦（Olga Petrova）[15]，法塔里尼三兄弟小丑組（the Fratellinis）[16]，比爾・羅賓森（Bill Robinson）[17]，芙羅倫絲・米爾（Florence Mills）[18]，或者像是馬克斯兄弟（the Marx Brothers）[19]等劇場新秀的劇場藝術表演新型式，就如同當初接受薩拉・柏恩哈特（Sarah

Sarah Bernhardt, Duse, Chaliapin, Nijinsky, John Barrymore or the Lunts. His own desire was that what he saw on a stage, regardless of its level or kind, should be something different from life and more highly voltaged, something that had vitality and style, something that he could recognize and respond to at once as "theatre."

Jo Mielziner, who once was his assistant, says that Bobby was "the most practical of all dreamers." He assures me that, beautiful as his drawings were, Bobby never sketched for the sake of making beautiful drawings. The lines that he put down were always capable of realization on a stage. The Renaissance glories of his backgrounds for *The Jest*; the ominous outline of the Tower of London which dominated his *Richard III*; the great arch at the top of the long flight of steps in John Barrymore's *Hamlet*; the brooding austerity of his New England farmhouse in *Desire Under the Elms*; the background of mirrors, as bright as Congreve's wit, in *Love for Love*; the lovely Sunday-school

20 詳見第七章〈新的企望〉，註 10，p. 254。
21 詳見第三章〈劇場古今〉，註 2，p. 86。
22 詳見第二章〈劇場藝術〉，註 10，p. 50。
23 1890–1953，烏克蘭出生的芭蕾舞者。
24 1882–1942，美國劇場演員。

Bernhardt）[20]，杜絲（Duse）[21]，夏里亞賓（Chaliapin）[22]，尼金斯基（Nijinsky）[23]，約翰‧巴瑞摩爾（John Barrymore）[24]或者是朗特（the Lunts）[25] 這些人在劇場躍起時。姑不論舞台的型式或優劣，他所關心的是在他眼中所看到的，應該不等同於一般生活，相反的應該更充滿動能；在形式上更富含生命力，是那種一眼即可辨識的「劇場」感。

　　曾當過他助理的喬‧麥哲納（Jo Mielziner）說過，包比是一個「最務實的夢想家」，他告訴我不論包比的設計圖看起來有多漂亮，但是包比從來不是為了美麗而設計，他圖面上沒有一條線是不能在舞台上被實際執行的。在《笑柄》一劇當中充滿文藝復興光華的背景；在《理查三世》（Richard III）[26]當中，倫敦塔令人毛骨悚然的輪廓，主宰著整齣戲的進行；在約翰‧巴瑞摩爾的《哈姆雷特》中，長長階梯頂端的宏偉拱門；在《榆樹下的慾望》（Desire Under the Elm Tree）[27]中籠罩著禁慾氣息的新英格蘭農莊；在《為愛而愛》（Love for Love）裡鏡面的背景，一如返照著康格里夫（Congreve）[28]的

―――――

25　1892–1980，美國演員及導演，1922年與英國女演員 Lynn Fontanne 結婚，之後35年間以兩人為名的 Lunt – Fontanne Theatre 為美國劇場界重要團體之一。

26　詳見第七章〈新的企望〉，註14，p. 269。

27　作者為尤金‧歐尼爾。

28　詳見第三章〈劇場古今〉，註12，p. 103。

innocence of his cutouts for *The Green Pastures*; the way in which he connected the portico of the Mannons' Greek revival home in *Mourning Becomes Electra* with the house of Agamemnon; the subtle suggestions of decadence in his living room for *The Green Bay Tree*; the bold bursts of Chinese red in *Lute Song*; or the George Bellows-like depth and shadows of his bar-room for *The Iceman Cometh*—all these are stunning proofs of how completely Bobby was able to turn his dreams into realities and produce settings which lived as characters in the plays for which they were designed.

His driving hope was to give the theatre glory and dignity and excitement. This he did again and again in visual terms and as no one else has done for our stage. If only more people at present dared to talk and write as Bobby did because they shared his determination and ability to restore dreams to our almost dreamless theatre!

29　詳見第七章〈新的企望〉，註2，p. 240。
30　作者為尤金・歐尼爾。
31　作者為 Mordaunt Shairp (1887–1939)，為 30 年代少數以同志議題為主的重要劇作
　　之一。

機巧；在《青青草原》[29]（*The Green Pastures*）中，無知於背後密謀的美麗主日學堂；在《哀悼伊蕾克特拉》（*Mourning Becomes Electra*）[30]中，巧妙的將復古希臘式房舍與阿嘉曼儂的宅第結合；在《綠灣樹》（*The Green Bay Tree*）[31]中，將客廳賦予微妙的頹蔽暗示；在《魯特琴之歌》（*Lute Song*）[32]當中大膽迸發的中國紅；在《賣冰人來了》裡，有著喬治·拜羅斯（George Bellows）[33]式的深度與光影的酒吧——在在都證明了包比能夠完整地將他的夢想化為實踐，在此同時，這些設計作品成為劇中另一個未曾發言的角色。

　　他始終寄望著能為劇場帶來榮光、尊嚴與激盪，他以一種前所未有的視覺不斷呈現在作品中來實踐如此的願望。唯願當今能有更多人敢於和包比一般作出論述，那是因為他們和他享有共同的意志與才份，為這個幾乎已經無夢的劇場找回它原有的夢想。

32 百老匯音愛情音樂劇，劇作者為Sidney Howard及Will Irwin，故事內容即源自中國的《琵琶記》。
33 1882–1925，美國畫家及版畫家，作品大膽描繪紐約都市生活。

Preface

Robert Edmond Jones

The reflections and speculations which I have set down here are the fruit of twenty-five years of almost continuous work in the American theatre, during which I have had the good fortune to be associated with the foremost artists of my time. These thoughts have come to me in the midst of rehearsals and in dress-parades and on the long journeys to out-of-town tryouts and in the continual collaboration with playwrights and managers and actors and stagehands and costumers and electricians and wigmakers and shoemakers which has made up my life in the theatre. Out of the manifold contacts of my experience the image of a new theatre has gradually formed itself—a theatre not yet made with hands. I look forward to this ideal theatre and word toward it.

作者序

羅勃‧愛德蒙‧瓊斯

我在這裡寫下的一些反饋和思考，是25年來在美國劇場中幾乎不間斷的工作下的果實。在這一段時間裡，我有幸和當代一流的藝術工作者一起創作。這些想法的生成是來自我在排練中、彩排時，以及到遙遠城外試演的路途上，還有來自我生活中很重要的一群人，像是和我長期合作的編劇家、劇團經理、演員、後台工作人員，其中包括了服裝師、電工、假髮師、鞋匠等等。從這些多樣的接觸經驗中，我感覺到一個新的劇場形式逐漸成形──一個不是經由人工刻意製造出來的劇場。我企盼著這樣一個理想劇場的來到，也努力的朝它邁進。

A New Kind of Drama

新的戲劇

In art...

there is a spark which defies fore knowledge...

and all the masterpieces in the world

cannot make a precedent.

— Lytton Strachey

I
新的戲劇
A New Kind of Drama

在藝術的領域裡……

有一種火花是去挑戰先前的智識……

所有的經典作品

都是無先例可循的。

——斯特雷奇[1]

In the last quarter of a century we have begun to be interested in the exploration of man's inner life, in the unexpressed and hitherto inexpressible depths of the self. Modern psychology has made us all familiar with the idea of the Unconscious. We have learned that beneath the surface of an ordinary everyday normal casual conscious existence there lies a vast dynamic world of impulse and dream, a hinterland of energy which has an independent existence of its own and laws of its own: laws which motivate all our thoughts and our actions. This energy expresses itself to us in our conscious life in a never-ending stream of images, running incessantly through our minds from the cradle to the grave, and perhaps beyond. The concept of the Unconscious has profoundly influenced the intellectual life of our day. It has already become a commonplace of our thinking, and it is beginning to find an expression in our art.

Writers like James Joyce, Gertrude Stein, Dos Passos, Sherwood Anderson—to name only a few—have ventured boldly into the realm of the subjective and have recorded the results of their exploration in all sorts of new and arresting forms. The stream-of-consciousness method of writing is an

1 1880–1932，英國傳記作家及文藝評論家，以描繪維多利亞時期見著，著有*Eminent Victorians* (1918)、*Queen Victoria* (1921)。

2 1882–1941，愛爾蘭小說家、詩人，使用「意識流」創作手法，作品有*Dubliners* (1914)、*A Portrait of the Artist As a Young Man* (1916)、*Ulysses* (1922)、*Finnegans Wake* (1939)。

在上個世紀（指十九世紀）的後四分之一，人們才開關注所謂的內在生命，一個未經表達而且迄今仍無法表達的深層自我。現代心理學已經讓我們認識了潛意識的世界，我們理解到在每天一般正常的意識存在之下，潛藏著的世界是充滿了爆炸性的衝動和夢想，它是一種獨立而自主的內部能量，是這股能量主宰了我們的思想和行為。這能量透過一連串無止境的影像流動表現在我們有意識的生活中，它一直在我們的腦海中流動，從出生襁褓到走入墳墓，甚或更遠。潛意識這個觀念已經深遠的影響了我們這個時代的知識份子，在我們的思維當中它已經變成相當普遍的觀念，而它也在我們的藝術當中尋求適當的表現。

例如詹姆士·喬伊斯（James Joyce）[2]、葛楚德·施泰因（Gertrude Stein）[3]、多斯·帕索斯（Dos Passos）[4]、雪伍德·安德森（Sherwood Andreson）[5]等這些作家，曾大膽的探索主觀世界的領域，並且用新穎奇特的方式紀錄了他們的結果。意識流的寫作方式已經是既成的文學型態，它很快的被人們

3 1874–1946，長期旅居巴黎的美國女作家及藝術贊助家，其創作喜好使用重複疊辭，作品有 *Three Lives* (1908)、*The Autobiography of Alice B. Toklas* (1933)。
4 1896–1970，美國作家及藝術家，主要作品有 *Three Soldiers* (1921)、*Manhattan Transfer* (1925)、*U.S.A.* (1930–36) 等。
5 1876–1941，美國作家，著有 *Winesburg, Ohio* (1919)、《小城畸人》（2006遠流出版）、*Poor White* (1920)。

established convention of literature. It is readily accepted by the public and is intelligible to everyone. We find it easier today to read *Ulysses* than to read *Lord Ormont and His Aminta*, and we are no longer bewildered by *A Rose Is a Rose Is a Rose Is a Rose*.

Our playwrights, too, have begun to explore this land of dreams. They are casting about for ways in which to express the activity of the sub-conscious mind, to express thought before it becomes articulate. They are seeking to penetrate beneath the surface of our everyday life into the stream of images which has its source in the deep unknown springs of our being. They are attempting to express directly to the audience the unspoken thoughts of their characters, to show us not only the patterns of their conscious behavior but the pattern of their subconscious lives. These adventures into a new awareness of life indicate a trend in dramatic writing which is bound to become more clearly understood. But in their search for ways in which to embody this new awareness they have neglected to observe that there has recently come into existence the perfect medium for expressing the Unconscious in terms of the theatre. This medium is the talking picture.

6 英國小說家及詩人 George Meredith 於 1894 年所著小說，故事內容是歐爾蒙老爺娶了和他年紀相殊二十幾歲的年輕貧女子阿敏坦，其後歐爾蒙的助理愛戀阿敏坦，兩人私奔，歐爾蒙老爺最後在臨終前寬恕了他們。此書因文體清晰獲得高度評價。Meredith 其他作品向來多隱喻且富內在獨白。

接受、理解，今天重讀《尤里西斯》會發現比讀《歐爾蒙老爺和他的阿敏坦》（*Lord Ormont and His Aminta*，該書目前沒有中譯本，依其書名直譯）[6]容易多了，同時我們也不會被「玫瑰是玫瑰，就是玫瑰，真的就是玫瑰」[7]這類文句搞昏頭了。

　　編劇家也開始探索這美妙的領域，他們極力找尋方法要表達出潛意識下的行為，也同時表達還沒被說出來的內在想法，尋找穿透我們日常生活的表象下所流動的影像，而這些影像正來自於我們存在的本源。這些劇作家企圖在觀眾面前直接表現角色無法言喻的思想，不只是告訴觀眾角色表面上有意識的行為，同時表現出他們在潛意識裡的生命。這樣的戲劇創作企圖已經愈來愈能夠讓人理解，但在他們尋找並擁抱這種新的體認同時，他們卻忽略了一種新的劇場媒介可以完美的表現這樣的企圖，這一媒介就是「影話」（talking picture）[8]。

7　美國女作家葛楚德‧施泰因寫於 1913 年的詩作 *Sacred Emily* 當中一句，意指事物本身即其本質，亦被引述討論語言會隨時間及歷史改變其隱含用意。
8　這裡指的是1940年代之後大量出現的有聲電影。

In the simultaneous use of the living actor and the talking picture in the theatre there lies a wholly new theatrical art, whose possibilities are as infinite as those of speech itself.

There exists today a curious misconception as to the essential nature of motion pictures. We accept them unthinkingly as objective transcripts of life, whereas in reality they are subjective images of life. This fact becomes evident at once if we think of some well-known motion-picture star appearing in person on a stage and then of the same star appearing on the screen, a bodiless echo, a memory, a dream. Each self has its own reality, but the one is objective and the other is subjective. Motion pictures are our thoughts made visible and audible. They flow in a swift succession of images, precisely as our thoughts do, and their speed, with their flashbacks—like sudden up-rushes of memory—and their abrupt transition from one subject to another, approximates very closely the speed of our thinking. They have the rhythm of the thought-stream and same uncanny ability to move forward or backward in space or time, unhampered by the rationalizations of the conscious mind. They project pure thought, pure dream, pure inner life.

Here lies the potential importance of this new invention. A new medium of dramatic expression has become available at the very moment when it is most needed in the theatre. Our

在舞台上同時使用演員和影話是一種嶄新的劇場藝術
形式，它將和語言一樣充滿無限的可能性。

今天對於動態影像存在著奇異的誤解，我們不加思索的接
受它是生活的客觀紀錄，然而它同時卻可以是人生的主觀映
像。如果我們把一個知名的影星放在舞台上，同時在螢幕裡
播放他的影像，這個事實立刻就變的很明顯，這樣的畫面像
一個無形的回音、一個記憶、一個夢。演員和影像之間都是
真實存在的，但一個是主觀的，另一個卻是客觀的。動態影
像把我們的思想變成聽得到看得見，快速流動的影像正如我
們的思想一樣，它的倒敘功能正有如我們突然湧現的記憶，
它不連貫的主題跳躍非常接近我們思考的速度，同樣具有一
種思考流動的韻律，能奇妙的在時空中忽焉在前、倏而在後
地穿梭自不受意識阻礙。他們反映出純粹的思考，純粹的夢
想，純粹的內在生命。

這是一個有潛力的重要發明，這個媒材在表達新型態戲劇
最適當的時候出現。戲劇創作者可以將視野放大到幾乎無限

dramatists now have it in their power to enlarge the scope of their dramas to an almost infinite extent by the use of these moving and speaking images. Some new playwright will presently set a motion-picture screen on the stage above and behind his actors and will reveal simultaneously the two worlds of the Conscious and the Unconscious which together make up the world we live in—the outer would and the inner world, the objective world of actuality and the subjective world of motive. On the stage we shall see the actual characters of the drama; on the screen we shall see their hidden secret selves. The drama will express the behavior of the characters set against a moving background, the expression of their subconscious mind—a continuous action and interaction.

All art moves inevitably toward this new synthesis of actuality and dream. Our present forms of drama and theatre are not adequate to express our newly enlarged consciousness of life. But within the next decade a new dimension may be added to them, and the eternal subject of drama—the conflict of Man and his Destiny—will take on a new significance.

延伸這種動態發聲的影像，現在有些劇作家在舞台上方和後方安排動態影像，來同時呈現意識與潛意識兩個世界，一如我們所身處真實世界一般——內在的主觀動機世界和外在的客觀現實世界。在舞台上我們看到戲劇裡的角色，在螢幕裡我們看到角色隱藏的自我，劇情在表現潛意識的動態背景前表演出角色的行為——是意識的體現與互動。

各種藝術型態都無法逃避這一現實與夢幻綜合體的趨勢，現有的戲劇和劇場形式並不能適切的表現我們對生命意識的新體悟，但是在未來十年裡[9]將會有新的特質加入劇場藝術中，而人與命運的衝突這一個戲劇永恆的主題將會產生新的意義。

9 本書首次出版時間為1941年。

現代人的延伸思考

初版的1941年，作者已經預言了影像與劇場的結合，在這過去的60年以來世界各地的戲劇也好、舞蹈也好、甚或是音樂界都一樣，沒有人停止嘗試做這樣的努力，但事實上成功的演出並不多見。因為我們必須清楚的體認一個事實，就是說影像一旦使用到舞台上通常都是被放大的（除非某些特殊離魂效果才會使用真人尺寸影像），因此在視覺上已經成為一種強勢；靜態影像如此，更何況動態影像，舞台上的人伸懶腰的大動作，根本敵不過影像中人的一眨眼，因此導致兩種結果：

第一，很多時候影像搶過舞台上的表演者，使得整晚的演出不知台上演些什麼，或是跳些什麼，倒是過度的影像充斥，完全本末倒置，表演者反而成了配角。

第二，又或者因為導演顧慮周全怕影像太搶戲，所以刻意壓低影像的功能，讓它變成一個串場配角，或是另一種畫外音（O.S.），無法讓影像發揮它充分的效能。

但這通常不是導演（有時候還包括舞台設計）或影像工作者單方面的問題，而是這兩者之間的思考平台出了狀況。影像工作者的大多不熟悉（粗魯一點說是不懂）劇場語言，劇場工作者又很少（或者說從來沒有）用鏡頭在思考。因此當雙方都很客氣地尊重對方專業的時候，就會讓兩樣東西都發揮不了功能

反而充滿尷尬。而當其中一方比較強勢的時候，另一方就很容易淪為配角。這兩方人馬必須有很長時間的工作、溝通、嘗試，雙方（甚至是連舞台設計也算進去的話是三方）開始用對方的語言思考之後，才可能有相輔相成、並蒂蓮開的效果。就台灣的環境來說，先撇開製作經費的困境不談，這些年來並沒有看到本土製作有稱得上成功的例子，反倒是在 2002 年由表演工作坊所引進，由香港導演林奕華導演、胡恩威舞台及影像設計的《張愛玲，請留言》一劇，以極簡單的舞台設計，不高的製作成本，完成了一齣演員、舞台和影像三位一體的演出。而我所謂的三位一體的演出，是指當這三樣元素缺了其中任何一樣，這個演出就會變得乏味無趣。

想想看，我們這些年所看到使用影像的演出，有多少是各說各話？自言自語？不知所謂？不知所云？不要怪時間不夠，不是今天才懂得可以在劇場裡使用影像，知道要用影像就要早早開始計畫籌備。不要怪經費不足，從來沒有一個製作認為自己的經費充裕，精采的創意通常在最窮困的時節誕生。如果影像這個媒材，不能幫劇場人把話說的更清楚、更動人，為什麼不好好專心的把本業經營好？劇場中每一個專業的本質，都還有太多值得我們去摸索探尋的，何苦虛耗時間、精力在一樣我們不專長的事情上，然後畫出一條什麼都不像的四腳蛇來呢？

II
Art in the Theatre

劇場藝術

Art...teaches to convey a larger sense

by simpler symbols.

— Emerson

II
劇場藝術
Art in the Theatre

藝術……教我們用簡單的符號

表達廣闊的意念。

——愛默生[1]

There seems to be a wide divergence of opinion today as to what the theatre really is. Some people say it is a temple, some say it is a brothel, some say it is a laboratory, or a workshop, or it may be an art, or a plaything, or a corporation. But whatever it is, one thing is true about it. There is not enough fine workmanship in it. There is too much incompetence in it. The theatre demands of its craftsmen that they know their jobs. The theatre is a school. We shall never have done with studying and learning. In the theatre, as in life, we try first of all to free ourselves, as far as we can, from our own limitations. Then we can begin to practice "this noble and magical art." Then we may begin to dream.

When the curtain rises, it is the scenery that sets the key of the play. A stage setting is not a background; it is an environment. Players act in a setting, not against it. We say, in the audience, when we look at what the designer has made, before anyone on the stage has time to move or speak, " Aha, I see! It's going to be like *that*! Aha!" This is true no matter whether we are looking at a realistic representation of Eliza crossing the ice or at the setting for one of Yeats' *Plays for Dancers*, carried to the limit

1 1803–1882，被稱為「和諧聖人」（Sage of Concord）的美國評論家、詩人、超經驗主義者。作品有*Nature* (1837)、*Representative Men* (1850)。

當今之世似乎對劇場的本質充滿了歧義，有人說它像殿堂、有人說它是妓院、也有人說它是實驗室或工作坊，更或者有人質疑它是一種藝術型態、還是玩物或者是企業。不論劇場的真意是什麼，其中只有一件事實，那就是到處充斥著不適當的東西，而精緻的技藝太少，劇場需要它的從業人員清楚的了解自己的職分。不論在劇場裡或生命中我們都不能停止學習和鑽研，而劇場就如同一座學校，先得極盡所能從各自的侷限中自我釋放，接著才能開始學習這一門高貴又奇幻的藝術，然後我們才能開始有夢。

　　大幕升起的那一刻，佈景是通往戲劇的關鍵之鑰。舞台佈景並不是單純的背景，而是一種情境，表演者是在佈景中演出，而不是在佈景面前表演（in a setting, not against it）。當舞台上的表演者還沒開始動作或說話之前，觀眾一看到設計師的作品呈現時，我們會希望觀眾想著：「啊！原來會是這樣！我知道了！」不管我們是看伊麗莎（Eliza）穿越冰雪寫實演出的場景[2]，或是葉慈（Yeats）極具象徵性的劇作《為舞者寫的劇本》（*Plays for Dancers*）其中一景也好[3]，這個期望

2　出自Harriet Beecher Stowe 1952年出版的反奴隸小說 *Uncle Tom's Cabin*《湯姆叔叔的小屋》或譯《黑奴籲天錄》，經常被改編為舞台劇，其中對於女奴伊麗莎越過俄亥俄冰河逃離一幕刻畫生動。

3　原書作者筆誤，原著為 *Four Plays For Dancers*，1921年初版，應用日本能劇的戲劇形式，極富深奧象徵性，作者葉慈（1865–1939）。

of abstract symbolism. When I go to the theatre, I want to get an eyeful. Why not? I do not want to have to look at one of the so-called "suggestive" setting, in which a single Gothic column is made to do duty for a cathedral; it makes me feel as if I had been invited to some important ceremony and had been given a poor seat behind a post. I do not want to see any more "skeleton stages" in which a few architectural elements are combined and re-combined for the various scenes of a play, for after the first half hour I invariably discover that I have lost the thread of the drama. In spite of myself, I have become fascinated, wondering whether the castle door I have seen in the first act is going to turn into a refectory table in the second act or a hope-chest in the last act. No, I don't like these clever, falsely economical contraptions. And I do not want to look at a setting that is merely smart or novel or *chic*, a setting that tells me that it is the latest fashion, as though its designer had taken a flying trip like a spring buyer and brought back a trunk full of the latest styles in scenery.

I want my imagination to be stimulated by what I see on the stage. But the moment I get a sense of ingenuity, a sense of effort, my imagination is not stimulated; it is starved. That play is finished as far as I am concerned. For I have come to the theatre to see a play, not to see the work done on a play.

都將是不變的事實。當我走進劇場，我希望能大飽眼福，這又有何不可？我不想看所謂的「暗示性」舞台設計，企圖用一根哥德式柱子來表現一座大教堂應有的恢宏，這讓我覺得像是受邀去參加一場重要的典禮，偏偏座位被安排在柱子後面一樣。我再也不想看到所謂「概說式」的舞台，就是那種拿一些建築元素來結合和重組，企圖用來製造劇中所有不同的場景，因為我發現在半個小時後我已經完全找不到戲劇的思路了，而開始入迷的猜想第一幕裡的城堡大門，會不會在第二幕變成修道院的餐桌？還是最後一幕會變成少女的嫁妝箱？我不喜歡看到這樣為了省錢而不適當的奇計淫巧。我也不想看到佈景設計只是賣弄時髦或新潮的流行，這樣只讓設計者像個時裝採購員，空運了一大堆當季的流行佈景回來。

　　我希望我的想像被舞台上的景象激發，可是當我一旦感覺到匠心、感覺到造作，我的想像不但沒有被激發反而死去了，我認為這樣一齣戲已經完了，因為我走進劇場是為了看一齣戲，而不是來看這齣戲被作成怎樣。

A good scene should be, not a picture, but an image. Scene-designing is not what most people imagine it is—a branch of interior decorating. There is no more reason for a room on a stage to be a reproduction of an actual room than for an actor who plays the part of Napoleon to be Napoleon or for an actor who plays Death in the old morality play to be dead. Everything that is actual must undergo a strange metamorphosis, a kind of sea-change, before it can become truth in the theatre. There is a curious mystery in this. You will remember the quotation from *Hamlet*:

> *My father!—methinks I see my father.*
> *O where, my lord?*
> *In my mind's eye, Horatio.*

Stage-designing should be addressed to this eye of the mind. There is an outer eye that observes, and there is an inner eye that sees. A setting should not be a thing to look at in itself. It can, of course, be made so powerful, so expressive, so dramatic, that the actors have nothing to do after the curtain rises but to embroider variations on the theme the scene has already given away. The designer must always be on his guard against being too explicit. A good scene, I repeat, is not a picture. It is something seen, but it is something conveyed as well: a felling, an evocation. Plato says somewhere, "It is beauty I seek, not beautiful things." This is what I mean. A setting is not just a beautiful thing, a collection

　　好的舞台設計不應該像一幅畫而是一種意象，它更不該像
一般人認為是室內設計的一種分支。舞台上的一個房間絕
不該是另一個房間的重製，有如扮演拿破崙的演員絕不會是
拿破崙，或者在古老的道德劇中扮演死神的絕不會是死人一
樣。一切的真實必經歷過一種奇妙的羽化過程，像是一種劇
變。在舞台設計中有一種奇妙的涵義，我想你應該記得《哈
姆雷特》（Hamlet）中的對白：

　　哈姆雷特：我的父親！我彷彿看到我的父親！
　　霍拉旭：在哪？殿下！
　　哈姆雷特：在我心靈的眼中！霍拉旭。

　　舞台設計應該和心靈的眼睛對話。我們用外在的眼睛觀
察，同時用內在的眼睛閱讀。一個舞台不應該只有看到的表
象，它應該是而且必須是，如此的強而有力、如此的有表現
性、如此的具戲劇性，以致於幕起之後，演員只能在它已經
傳達的主題當中去潤飾、變化而已。一個設計者永遠要小心
不要表現的太過明顯。我再重複一次，一個好的舞台絕不會
是一幅畫，它不只是被看到；同時也能主動傳達情感、喚醒
記憶。柏拉圖曾經說過：我追求的是美，而不是美好的事
物！我說的正是這個意思，舞台不僅是美的東西或是美好物
件的蒐藏，它是一種儀態、一種情緒、一股煽動戲劇燃燒的

of beautiful things. It is a presence, a mood, a warm wind fanning the drama to flame. It echoes, it enhances, it animates. It is an expectancy, a foreboding, a tension. It says nothing, but it gives everything.

Do not think for a moment that I am advising the designer to do away with actual objects on the stage. There is no such thing as a symbolic chair. A chair is a chair. It is in the arrangement of the chairs that the magic lies. Moliére, Gordon Craig said, knew how to place the chairs on his stage so they almost seemed to speak. In the balcony scene from *Romeo and Juliet* there must be a balcony, and there must be moonlight. But it is not so important that the moon be the kind of moon that shines down on Verona as that Juliet may say of it:

> *O, swear not by the moon, the inconstant moon*
> *…Lest that thy love prove likewise variable.*

The point is this: it is not the knowledge of the atmospheric conditions prevailing in northern Italy which counts, but the response to the lyric, soaring quality of Shakespeare's verse.

暖風，它引起共鳴、強化力量、賦予生命，它更是一種期待、一種預兆、一種張力。它一句話都沒說，但它呈現了所有的一切（It says nothing, but it gives everything）！

千萬不要以為我建議設計師們不要在舞台上放實際的物件，椅子就是椅子，從來沒有所謂象徵性的椅子，而是椅子安排的方式創造出劇場中的魔術。葛登‧克雷格（Gordon Craig）[4] 曾指出：莫理哀（Molière）知道如何安排他舞台上的椅子，以致於他的椅子似乎會說話。《羅密歐與朱麗葉》（*Romeo and Juliet*）中的樓台會一景中，一定要有個露台，也一定要有月光，但並不一定要像照耀在維洛那的月光，如同朱麗葉所形容的這樣：

噢！不要對著月亮起誓，那多變的月亮……
那只會讓你的誓言像她一樣多變。

重點並不是義大利北方的月光所透露出的氛圍，而是對莎士比亞崇高的詞句所具有特色的回應。

4 1872–1966，具有世界影響的英國演員、舞台設計師和戲劇理論家，女演員 Ellen Terry 之子。

The designer creates an environment in which all noble emotions are possible. Then he retires. The actor enters. If the design's work has been good, it disappears from our consciousness at that moment. We do not notice it any more. It has apparently ceased to exist. The actor has taken the stage; and the designer's only reward lies in the praise bestowed on the actor.

Well, now the curtain is up and the play has begun.

When I go to theatre to see a play performed, I have got to be interested in the people who are performing it. They must, as the saying goes, "hold" me. It is my right as a member of the audience to find men and women on the stage who are alive. I want to respect these players, to look up to them, to care for them, to love them. I want them to speak well, to move well, to give out energy and vitality and eagerness. I do not wish to look at the physically unfit, the mentally defective, or the spiritually violate. They bring to my mind Barnum's cruel remark that normal people are not worth exhibiting. I wish to see actors in whom I can believe—thoroughbreds, people who are "all there." Every play is a living dream: your dream, my dream—and that dream must not be blurred or darkened. The actors must be

　　舞台設計創造了一個引發崇高情緒的情境之後，他就隱
退，演員隨之登場。如果它的設計夠好，在此同時作品本身
將從我們的意識裡消失，我們再也不會去注意它，它已然停
止存在，因為演員已經佔領了舞台，而設計者所得到的獎賞
是觀眾給予演員們的讚美。

　　好啦！現在幕已升起，戲已開演。

　　當我走進劇場觀賞一個演出，我期待舞台上的表演者能引
起我的興趣。作為一個觀眾我有權利要求台上的表演者是有
生命的，我想要尊敬這些演員們，仰望他們，憐惜並且愛他
們。我希望他們能好好的說話、好好的行動，從而散發出他
們的能量、活力以及渴望。我不願意看到那種在生理上不自
在、心理上不健全、精神上受侵害的演員在台上遊走，這些
人讓我想到巴納姆（Barnum）[5]對「一般人不適合被展示」
的殘酷評論。我期待看到能讓我相信的演員——一種「全然
存在」的高尚人種。每一齣戲都是一個夢，是你的也是我的
夢——但這個夢絕不能夠模糊或者晦暗，在其中的每一個演

5　1810–1891，美國職業演出家、馬戲大王，與 James Anthony Bailey (1847–1906) 共同創
　辦 Barnum and Bailey's Circus。

transparent to it. They may not exhibit. Their task is to reveal.

To reveal. To move in the pattern of a great drama, to let its reality shine through. There is no greater art than this. How few actors live up to its possibilities! Some actors have even made me feel at times that they were at heart a little bit ashamed of being actors. I call this attitude offensive. The right attitude is that of the distinguished old English character actor who, when engaged to play a part, was accustomed to say, "Sir, my fee is so-and-so mush," as if he were a specialist from Harley Street. It is easy of course, to understand why there are not more good actors on the stage today. The métier is too hard. This art of acting demands a peculiar humility, a concentration and dedication of all one's energies. But when an actor moves before us at last with the strange freedom and clam of one possessed by the real, we are stirred as only the theatre can stir us.

I am thinking of the company of Irish Player from the Abbey Theatre in Dublin who first gave us the dramas of Synge and Yeats in 1910. As one watched these players, one saw what they

6 1871–1909，愛爾蘭劇作家、詩人，作品有 *Riders to the Sea* (1904)、*The Playboy of the Western World* (1907)。

7 1865–1939，愛爾蘭劇作家、詩人，作品有 *The Land of Heart's Desire* (1894)、*The Wind among the Reeds* (1899)、*Last Poems and Plays* (1940)，獲1923年諾貝爾文學獎。

員必須清晰透亮。他們不是用來被展示的，他們的工作是來展現。

　　展現。一齣戲劇崇高的精髓，經由演員的運轉展現出來，而戲劇因此散發光芒。沒有一種藝術型式比表演更高貴了，但是又有多少演員實踐了這樣的可能性！有時候有些演員讓我覺得他們在內心深處就不以自己的工作為傲，這樣的態度令人反感，正確的態度應該像一些卓越的古代英國演員一樣，當被邀請去扮演一個角色的時候，習慣告訴人家：「先生！我的酬金是……！」因為他們把自己看成和倫敦一流醫生住宅區哈雷街（Harley Street）上的專科醫生一樣崇高。這也就很容易理解到，為什麼現在已經沒有幾個好演員存在在舞台上了。這個行業太嚴苛了，它需要極度的謙遜，需要全心全意奉獻自己一切的能量和精力。最後，當我們看到一個演員被不可思議的自在和冷靜所完全佔據時，我們才能被撼動，唯有如此，這樣的劇場才能撼動我們。

　　這讓我想到在1910年首度把辛吉（Synge）[6]和葉慈[7]的戲劇介紹給我們的那一群，來自都柏林愛比劇院（Abbey

knew. I kept saying to myself on that first evening: Who are these rare beings? Where did they come from? How have they spent their lives? Who are their friends? What music they must have heard, what books they must have read, what emotions they must have felt! They literally enchanted me. They put me under a spell. And when the curtain came down at the end of the play, they had become necessary to me. I have often asked myself since that time how it was that actors could make me feel such strange emotions of trouble and wonder; and I find the answer now, curiously enough, in an address spoken by a modern Irish poet to the youth of Ireland—*keep in your souls some images of magnificence.* These Irish players had kept in their souls some images of magnificence.

Exceptional people, distinguished people, superior people, people who can say, as the old Negro said, "I god a-plenty music in me." These are the actors the theatre needs.

I think it needs also actors who have in them a kind of wildness, an exuberance, a take-it-or-leave-it quality, a dangerous quality. We must get clean away from the winning, ingratiating, I-hope-

Theatre）[8]的愛爾蘭演員們，當你看到他們的表演後，你能夠看到他們所有的經歷。看完表演之後的第一個晚上；我不斷的問自己，這些傑出奇才是誰？他們從哪來？他們怎樣過日子？他們的朋友是些什麼樣的人？他們聽些什麼音樂？看些什麼書？而從當中他們又得到怎樣的感動？他們像下了魔咒一樣的讓我深深著迷。當演出結束大幕落下的同時，他們已經變成我不可或缺的一部分了，從此以後我常常自問：一個演員要怎樣才能讓我在情緒上，感受到如此特殊的困擾與迷惑？很有趣的是，我發現答案竟然在一位愛爾蘭詩人對他們年輕人的演說中——讓你的靈魂中保有一些壯麗的映像。這一群愛爾蘭演員辦到了！

正好像老黑奴驕傲的說「音樂就在我身體裡」一樣，這麼特殊的一群人，這麼傑出的一群人，這麼超凡的一群人，我可以說這樣的人才是劇場需要的演員。

我想作為一個演員必須有著旺盛的精力、狂野的心、提的起放的下的特質，那是一種危險的特質。我們必須要揚棄那

8　都柏林的劇場，1904年建立，1951焚毀。1966重建，孕育了葉慈、辛吉、O'Casey等劇作家的愛爾蘭國民戲劇中心。

you're-all-going-to-like-me-because-I-need-the-money quality
of a great deal of the acting we find today. I remember Calvé's
entrance in the first act of *Carmen*. Her audiences were actually
afraid of her. Who has seen Chaliapin in the mad scene of *Boris*?
Some of the best actors in the world are to be found on the
operatic stage. What a Hedda Gabler Mary Garden would have
made! It seems as if these actor-images were set free by the very
limitations of opera—the fixed melodies, the measured steps
and pauses. They cannot be casual for one instant. They must be
aware. They must know how to do what they have to do. They
must have style. And they must have voices.

It is surprisingly difficult to find actors who seem to mean
what they say. How often one is tempted to call out to them
from the audience, "It's a lie! I don't believe a word of it!" A
deep sincerity, a voice that comes form the center of the self, is
one of the rarest things to be found on stage today. It seems odd
that this quality of conviction should be so hard to find in the
theatre.

9 1858–1942，法國歌劇女高音，以演出卡門尤為聞名。
10 1873–1938，俄國男低音歌唱家，著名的演出角色即為包瑞斯‧郭德諾夫。
11 俄羅斯國民樂派作曲家穆索斯基1874年完成之作，俄國最重要的歌劇作品之一，包
 瑞斯為劇中主角俄國沙皇。

種像乞丐一樣，討好取悅觀眾的惡劣習性，可是偏偏在當今的舞台上，經常看到這樣的演員。世界上一些最優秀的演員反而是出現在歌劇舞台上。我記得卡爾威（Calvé）[9]所扮演的《卡門》（*Carmen*），在第一幕裡的確令觀眾驚歎又畏懼。有誰看過夏里亞賓（Chaliapin）[10]在《包瑞斯·郭德諾夫》（*Boris Godunov*）[11]當中的瘋狂場景？如果讓瑪利·加登（Mary Garden）[12]來扮演《海達·蓋伯勒》（*Hedda Gabler*）[13]，那將會是怎樣的畫面啊！似乎這些優秀演員的形象，反而是建立在一個具高度限制性的歌劇裡才能被發揮出來——固定的旋律、精準的步伐和喘息，一秒鐘都不能放鬆，他們要建立語調、建立聲部，必須隨時提高警覺，明白的知道下一步該怎麼做。

令人驚訝的是，演員似乎很難精確的傳達他們台詞中的意義，有多少次你坐在觀眾席裏，想對著演員大喊：「你在說什麼？見鬼了！我一個字也不信！」今天在舞台上，很難找到從內心裏所發出來真誠的聲音，在劇場裡找不到這樣有說服力的特質，似乎是一件奇怪的事。

12 1874–1967，出生於蘇格蘭，活躍於美國歌劇界女高音。
13 挪威劇作家及詩人易卜生（Henrik Ibsen, 1828–1906）1890年完成的劇作，女主角海達為極富戲劇性的角色，有「女哈姆雷特」之稱。易卜生以社會問題劇著稱，名作有《玩偶之家》（*A Doll's house*）、《群鬼》（*Ghos*）、《野鴨》（*Then wild duck*）等等。

But I have been speaking of actors, not of acting.

Great roles require great natures to interpret them. Half our pleasure in seeing a play lies in our knowledge that we are in the presence of artists. But this pleasure of watching the artists themselves is soon forgotten, if the play is well performed, in the contagious excitement of watching a miracle: the miracle of incarnation. For acting is a process of incarnation. Just that. And it is a miracle. I have no words to express what I feel about this subtle, ancient, sacred art—the marvel of it, the wonder, the meaning. The designer creates with inanimate materials: canvas, wood, cloth, light. The actor creates in his living self. And just as the good designer retires in favor of the actor, so does the good actor withdraw his personal self in favor of the character he is playing. He steps aside. The character lives in him. You are to play Hamlet, let us sat—not narrate Hamlet, but *play* Hamlet. Then you become his host. You invite him into yourself. You lend him your body, your voice, your nerves; but it is Hamlet's voice that speaks, Hamlet's impulses that move you. We may be grateful to Pirandello for showing us, in his *Six Characters in Search of an Author*, the strange reality of the

14 1998年台灣商務出版社出版中文譯本。

　　我現在說的是演員，而不是表演。

　　精采的角色需要精采的本質去詮釋。欣賞戲劇的愉悅，有一半來自我們體認到與藝術家們共同存在的事實，如果藝術家表演得精采，這種看明星的愉悅很快就被忘記了，忘情於熱切地企盼參與一種幻化的奇蹟之中，因為表演本身沒有別的，就是一種幻化的過程，同時也是一種奇蹟。我不知道能用怎樣的言語表達，這一種精緻、古老又神聖的藝術中，它的精采、神妙與真意。就如同設計師們用無生命的素材，像是木頭、布料、燈具來創造藝術，演員們卻是用他們活生生的生命來創造藝術。也正如出色的設計師在幕啟後將劇場退讓給演員一樣，優秀的演員也必須把自己退讓給所扮演的角色。演員真實生活中的自我在這個時候暫時離開，而角色在此時鮮活了起來。假如你今天扮演——而不是「敘述」哈姆雷特，你就變成了哈姆雷特的「宿主」，把你的身體、你的聲音、你的神經借給他，但是說話的是哈姆雷特的聲音，是哈姆雷特他的衝動帶領著你移動。我們很感謝皮藍德婁（Pirandello）在《六個尋找作者的劇中人》（*Six Characters in Search of an Author*）[14] 當中，讓我們看到了劇作家在創作角色

creations of the playwright's mind. Hamlet is as real as you or I. To watch a character develop from the first flashes of contact in the actor's mind to the final moment when the character steps on the stage in full possession of the actor, whose personal self looks on from somewhere in the background, is to be present at a great mystery. No wonder the ancient dramas were initiation-ceremonies; all acting is an initiation, if one can see it so, an initiation into what Emerson calls "the empire of the real." To spend a lifetime in practicing and perfecting this art of speaking with tongues other than one's own is to live as greatly as one can live.

But the curtain is up, and the play has begun. We look into a scene that is filled with excitement. See. That man is playing the part of a beggar. We know he is not a real beggar. Why not? How do we know? We cannot say. But we know he is not a beggar. When we look at him we recall, not any particular beggar we may happen to have seen that day, but all beggars we have ever seen or read about. And all our ideas of misery and helplessness and loneliness rush up in our imaginations to touch us and hurt us. The man is acting.

How is he dressed? (And now I am speaking as a costume-designer.) The man is in rags. *Just rags*. But why do we look at

時腦袋裡的奇形怪狀。但是哈姆雷特卻和你我一樣真實。看著一個演員和角色靈光乍現的第一次接觸開始，到演員完全被角色佔有後走上舞台，而演員自己卻成了後台旁觀者的那一刻為止，那真如一場神奇又偉大的儀式啊！也無怪乎古老的戲劇源自於啟蒙的儀式，如果我們把所有的表演當成一種啟蒙，一種愛默生所謂 "the empire of the Real" 的啟蒙，那麼就值得我們花上一輩子的時間，去鍛鍊、精粹這表演他人的藝術，而不只是扮演生活中的自己，這就是人生最精湛完美的演出。

幕已升起，戲正上演。我們眼前的景象充滿驚奇。看！有一個人在扮演乞丐！我們為什麼會知道他不是真的乞丐？有哪些事證明了他不是乞丐？很難說，但是我們明確的知道他不是乞丐。因為當他出現在我們眼前時，他絕不是我們今天走進劇場前，所碰到的某一個特定乞丐，而是所有關於遭遇不幸、無助、孤獨的感受湧現我們腦海，觸動我們內心，所以我們知道他不是真的乞丐，而是演出。

他是怎麼打扮的？（現在我以服裝設計的身分來說話。）他的穿著破爛，只是破布而已！如果他只是穿著普通的破

him with such interest? If he wore ordinary rags we wouldn't look at him twice. He is dressed, not like a real beggar, but like a painting of a beggar. No, that's not quite it. But as he stands there or moves about we are continually reminded of great paintings—paintings like those of Manet, for instance. There is a curious importance about this figure. We shall remember it. Why? We cannot tell. We are looking at something *theatrical*. These rags have been arranged—"composed" the painters call it—by the hand of an artist. We feel, rather than see, an indescribable difference. These rags have somehow ceased to be rags. They have been transformed into moving sculpture.

I am indebted to the great Madame Freisinger for teaching me the value of simplicity in the theatre. I learned from her not to torture materials into meaningless folds, but to preserve the long flowing line, the noble sweep. " Let us keep this production noble," she would say to me. The costume-designer should steer clear of fashionableness. That was the only fault of the admirable production of *Hamlet* in modern dress. It was so *chic* that it simpered. I remember that in the closet scene, as the Queen cried out:

布，我想我們不會多看他一眼，但我們又為什麼會充滿興趣地看著他？因為他被裝扮過，而不是真的乞丐，反倒像是畫作中的乞丐。不！也不全然是這樣。很難說為什麼當他起身開始移動的時候，他會像一幅又一幅偉大的畫作——一如馬奈（Manet）的作品，深深地刻印在我們腦海。因為我們看到了被「劇場化」的東西，這些破布是被藝術家們所親手「安排」過的——畫家們會喜歡用「構圖」（compose）這個字眼。我們不只是看到，同時也察覺到這些破布已經不再是破布了，它們已經轉化成移動的雕塑品。

在服裝的領域裏非常感謝佛萊辛夫人（Freisinger）[15]，讓我認識了在劇場中不造作的重要性，我從她身上學到了保留長而流暢的線條，體現了高雅的延伸，而不再浪費時間處理一大堆不必要的細節。她常常跟我說：「我們讓這個製作品看起來高雅一點吧！」服裝設計師最應該避免的就是所謂的流行趨勢，我想這也是最近這一檔以時裝演出的《哈姆雷特》當中唯一的敗筆吧！我記得在皇后臥室的那個場景，當她嘶喊著：

———

15 二十世紀初劇場服裝設計師。

O Hamlet, thou hast cleft my heart in twain.

And her son answered:

O, throw away the worser part of it,
And live the purer with the other half,

A voice near me whispered, "I wonder if she got that negligee at Bendel's?" And the program told us all that Queen Gertrude of Denmark did, indeed, get that negligee at Bendel's. And, furthermore, that Queen Gertrude's shoes came from the firm of I. Miller, Inc., and that her hats were furnished by Blank and her jewels by Dash, and so on. Think of it. Two worlds are meeting in this play, in this scene—in the night, in Elsinore. And we are reminded of shoes and frocks!

Many of the costumes I design are intentionally somewhat indefinite and abstract. A color, a shimmer, a richness, a sweep— and the actor's presence! I often think of a phrase I once found in an old drama that describes the first entrance of the heroine. It does not say, "She wore a taffety petticoat or a point lace- ruff or a farthingale"; it says, "She came in like starlight, hid in jewels." There she is in that phrase; not just a beautiful girl

噢！哈姆雷特，你已經把我的心撕成兩半了，

她的兒子回答道：

啊！那就把邪惡的一半拋棄，
和那剩下善良的一半共活吧！

　　我身邊突然傳來了一陣耳語：「我猜她的睡袍是 Bandel 公司買的！」的確，因為節目單上說明了丹麥皇后葛楚德（Gertrude）睡袍是由該公司提供，甚至於她腳上的鞋子是由 I. Miller 公司提供，頭上的帽子是 Blank 提供，身上的首飾是由 Dash 贊助。想想看，是怎樣衝突的兩個世界在舞台上同時呈現——在艾辛諾（Elsinore）的夜晚，但我們心裡所想的卻是女主角的鞋子和衣服。

　　在我做過的許多服裝設計裡，有時候我刻意讓它們看起來不那麼絕對，甚至有點抽象，像是一抹色彩、一道閃光、一種濃厚、一股流動——以及演員的丰采。我常常想到我以前在一個劇本當中讀到，作者如何形容女主角的出現，劇本裡並沒有說：「她穿著有皺折的襯裙，或是有著蕾絲披襟的領口，更或者是穿著大大的裙撐。」而是這樣寫著：「她隱藏在珠寶裡，像星光一般的出現。」她可能不只是穿著華美衣

dressed up in a beautiful dress, but a presence—arresting, ready to act, enfolded in light. It isn't just light, it is a stillness, an awareness, a kind of breathlessness. We ought to look at the actors and say, Why! I never saw people like *that* before! I didn't know people looked like *that*!

The subtlety of stage lighting, the far-flung magic of it! When a single light-bulb wrongly placed may revel, as Yeats said, the proud fragility of dreams!

Shakespeare knew more than all of us. How he uses sunlight, moonlight, candlelight, torchlight, starlight! Imagine Hamlet as he stands with Rosencrantz and Guildenstern on the forestage of the Globe Theatre, under the open sky, looking up at the stars, saying:

> *...this brave o'erhanging firmament, this*
> *majestical roof fretted with golden fire...*

I have often wondered whether the Globe Theatre and the Swan Theatre were not oriented towards the east as ancient temples are, in order to take advantage of the lighting effects of nature. Think of the play of *Macbeth*. It begins on a foggy afternoon before sundown. The day goes. The sun sets. Torches

服的漂亮女孩而已，更是一種令人難忘的丰采，在光線的簇擁下，隨時準備表演。而還不只是光的關係而已，那更是一種沉靜、一種警覺、一種讓人屏息的氛圍。我們該看看演員們，而且讚嘆一下：「真是的！我以前從來不知道有人可以看起來像這樣，我想不出來誰可以看起來像你一樣！」

舞台燈光是非常微妙的，但也卻是最偉大的魔術。只要有一個放錯位置的燈泡，就馬上顯露出葉慈所說的「狂妄脆弱的夢幻」。

莎士比亞似乎比我們所有人懂的都多，他完全知道如何去運用陽光、月光、燭光、火炬、和星光，試想當哈姆雷特與羅森格蘭茲（Rosencrantz）和吉登斯坦（Guildenstern）一起站在環球劇院舞台前緣的天空下，仰望著星空，說：

　　……這璀璨高懸的昊空，
　　這鑲嵌金光之雄渾天幕……

我常在猜想，環球劇院和天鵝劇院其實都像古老廟宇一樣利用自然天光。想想看《馬克白》（Macbeth）這齣戲，它是從一個日落前，霧氣濃重的下午開始；長日將盡，日落西

are brought in. We enter deeper and deeper with the play into an extravagant and lurid night of the soul. Or take the trial scene from *The Merchant of Venice*. The scene is played by torchlight. The auditorium is dark. We see the sky overhead. The trial draws to an end. Shylock is defeated. There is a gay little interlude, the byplay with the rings. The stage grows lighter. The torches are carried off. Now the scene is finished. Portia, Nerissa, and Gratiano go away...The full moon rises over the wall of the theatre and touches the stage with silver. Lorenzo and Jessica enter, hand in hand.

> *...on such a night*
> *Did Thisbe fearfully o'ertrip the dew...*

The sole aim of the arts of scene-designing, costuming, lighting, is, as I have already said, to enhance the natural powers of the actor. It is for the director to call forth these powers and urge them into the pattern of the play.

The director must never make the mistake of imposing his own ideas upon the actors. Acting is not an imitation of what a director thinks about a character; it is a gradual, half-conscious unfolding and flowering of the self into a new personality. This process of growth should be sacred to the director. He must be

山，火炬進來了，我們隨著劇情，一步步深入那靈魂中無止盡的陰森夜晚。再看看《威尼斯商人》（*Merchant of Venice*）這齣戲中審判的場景，這場戲是在火把的照耀下演出，審判終了，夏洛克（Shylock）輸了，接著是一段關於戒指的愉悅小插曲，舞台漸漸變亮，火把被帶下場，此幕終了。波西亞（Portia）、妮瑞莎（Nerissa）、葛提亞諾（Gratiano）離場……升起的滿月照在劇場的牆壁上，把舞台面上染成一片銀光，羅倫佐（Lorenzo）和潔西卡（Jessica）手牽著手進場。

> ……正是這樣的一個夜晚
> 提斯柏膽顫心驚地踏著露珠……

我一再說明，舞台、服裝、燈光的設計，是在強化演員天生的力量，而導演的職責，就是把這股力量召喚來，並且驅策這股力量進入演出的形式中。

導演絕不能犯的一個錯誤，是把自己的意念投射到演員身上，表演並不是模仿導演對角色的想法，那應該是讓一個人在半意識狀態中，逐漸地展開綻放成為另一種人格。在這過程中，他必須以神聖謙遜的態度來面對，滋養它、激發它、

humble before it. He must nourish it, stimulate it, foster it in a thousand ways. Once the actors have been engaged, he should address himself to their highest powers. There is nothing they cannot accomplish. In this mood, ignoring every limitation, he fuses them into a white energy. The director energizes; he animates. That is what Max Reinhardt understands so well how to do. He is an animator. A curious thing, the animating quality. Stanislavsky had it; Belasco had it; Arthur Hopkins has it. One feels it instantly when one meets these men. One sees in them what Melville calls "the strong, sustained and mystic aspect." The greatest stage director I ever heard of, incidentally, is Captain Ahab in Melville's *Moby Dick*. Turn to the scene of the crossed lances and read how Ahab incites the crew of the *Pequod* to hunt the white Whale to the death: "*It seemed as though by some nameless, interior volition, he would fain have shocked into them the same fiery emotion accumulated within the Leyden jar of his own magnetic life…*" That is stage-directing, if you please.

Now I come to the playwrights. I am not one of the calamity-howlers who believe the theatre is in a dying condition. On

16 1873–1943，奧裔美國導演與演員。

17 1863–1938，真名 Konstantin Sergeevich Alekseev，俄國戲劇家、演員，著有《我的藝術生活》（*My Life in Art*, 1924）、《演員的自我修養》（*An Actor Prepares*, 1936）等。

18 1853–1931，美國劇作家，導演與製作人。

愛護它。當演員開始參與其中，導演就必須把自己準備好，面對這些無上的能量。沒有什麼演員做不到的。在這樣的基調下不用在乎任何限制，導演把這些力量融合匯聚成一種白熾的光芒，因而賦予充滿了力道的生命，像導演麥克斯・萊因哈德（Max Reinhardt）[16]就深深地了解這種作為賦予生命力的精髓。史坦尼斯拉夫斯基（Stanislavsky）[17]、貝拉斯可（Belasco）[18]、亞瑟・霍普金斯（Arthur Hopkins）[19]都具有這種賦予生命活力的奇妙特質。只要一旦遇見這一類導演，你馬上就會發現他們的特質，一如梅爾維爾（Melville）[20]所稱的，「一種強烈的、持續性的、令人敬畏的面貌。」順帶提一下，我所聽過最優秀的導演指示是梅爾維爾《白鯨記》（*Moby Dick*）裡的亞伯船長，當描寫到交叉魚叉一景時，聽聽看亞伯是怎樣煽動琵告號上的水手去獵殺大白鯨：「一股莫名的意志，叫他不由地，想把那宛如蓄電瓶裡飽滿的生命力化作電能，為他們帶來等同的火熱情感……。」聽聽看！這才叫舞台指示！

　　現在到了編劇的部分。我不是那種誇大其詞，說當今劇場

19　1878–1950，知名百老匯製作人與導演。
20　1819–1891，美國作家，以《白鯨記》一書著稱，該小說為海洋冒險小說之經典。

the contrary. The American Theatre, as the advertisements of the revue, *Americana*, said, is a "star-spangled wow." And at all times we have before us the heartening example of Eugene O'Neill, whose work would be outstanding in any period of the world's dramatic history. But to my way of thinking, many of the playwrights of today are being swamped by their own facility, snowed under by their very cleverness. A kind of tacit conspiracy seems to be on foot to rob the theatre of its ancient mystery and its ancient awe. We seem somehow to have lost the original immediate experience of the theatre. Familiarity has bred contempt. In the dramas of today one feels an odd secondary quality. They are, so to speak, accessories after the fact. Our playwrights give us schemes for drama, recipes for drama, designs for drama, definitions of drama. They explain drama with an elaborate, beguiling ingenuity. But in so doing they explain it away. Instead of trying to raise us to the imaginative level of true dramatic creation, they have brought the theatre down to our own level. And so the ancient audacity has vanished, the danger, the divine caprice. The wonderful wild creature has been tamed. Our theatre has become harmless, and definite, and amiable. The splendid vision has faded into the light of common day.

There is nothing wrong with this recipe-theatre of ours except that it isn't the real thing. There is no dramatic nourishment in it.

將死的那種人。相反的，當今美國劇場正有如那齣時事諷刺劇《美國人》（*Americana*）[21]的廣告詞所說「燦若明星」一般，像是令人激賞的尤金‧歐尼爾（Eugene O'Neill）[22]的劇作，放在世界上任何一個劇場史的時空當中都絕不遜色。但是就我的眼光來看，現下太多劇作家沉溺於技巧，反而被自己的聰明給淹沒了。似乎有一種寂靜的陰謀，一步步的把屬於劇場的原始敬畏與神祕給侵蝕了，我們似乎再也感覺不到那種屬於劇場的親密經驗。要說是「親暱生狎侮」一點也不為過，當今的戲劇充斥著一種奇異的次等特性，劇作家給我們看到了戲劇的概要、戲劇的配方、戲劇的編造、戲劇的定義，如此聲嘶力竭以炫目的技巧來說戲劇，反而讓戲距離我們越來越遠。想要激發我們對戲劇的想像，反而把劇場降低到自我的層面。因此，古老戲劇裡的威脅、放肆、非凡的狂想消失了，這頭奇妙的野獸被馴服了，我們的劇場變得毫無作用，既規矩又溫和，那神妙的視野已經消失在日常的光線下。

中規中矩的戲劇並非不好，只是他不應該是戲劇的全貌。

21　1927 年於美國紐約 Belmont Theatre 首演的音樂劇，原著 J. P. McEvoy，音樂創作 Con Conrad 及 Henry Souvaine.
22　1888–1953，美國二十世紀著名劇作家與導演，得過四次普立茲獎，作品多專注於社會議題之上。

We are hungry, and we are given a cook-book to eat instead of a meal. We expect to go on a journey, and we have to be satisfied with a map and a time table. So long as this secondary art, this substitute theatre, continues to be their image of the theatre, our playwrights will continue to belong not with the artists but with the fabricators of the theatre.

And now I have come to my real point. I know that there are young people in this country who will really create for the theatre of their time, who will bring something into existence there that has never existed before. A few. Not many. The theatre will be fortunate if it can claim a half-dozen of them. But it is this half-dozen to whom we look to lift our common experience into a higher region, a clearer light. We do not want shrewdness or craftiness or adroitness from them. We have had enough mechanism in the theatre, and more than enough. Let them go beyond this; let them give us the sense of the dramatic moment, the immortal moment.

Think of this moment. All that has ever been is in this moment; all that will be is in this moment. Both are meeting in one living flame, in this unique instant of time. This is drama; this is theatre—*to be aware of the Now.*

這一類的劇作缺乏了戲劇的養分，就好像有人肚子餓了，你卻只丟一本食譜給他，而不是讓他飽餐一頓；期望去旅行的人，卻只拿到一本地圖和時刻表。如果像這樣的次等藝術，這樣的冒牌劇場，持續被劇作家當成真正的劇場來看待，那麼這些人永遠都只會是劇場裡的裝配工，不能成為真正的藝術家。

　　現在來談談我的重點。我知道有一些年輕人在創造屬於他們這個時代的劇場，而也是同一批人給劇場帶來一種前所未有的特質，但是這些人實在太少了！如果能留住這其中幾個人，對我們劇場而言也夠幸運了，也正是這少數中的少數，能提升我們平凡的經驗到另一更高的層次，這是令人期待的境界。我們要的不是他們的機巧、伶俐或是匠意，劇場裡已經到處充滿這些沒生命的東西，更重要的是讓他們超越這個皮相，讓他們散播戲劇性的一刻，那永恆的瞬間。

　　試想這樣的一個片刻，所有過去曾經有過的，和未來可能出現的，都在這特殊的同時，存在於一叢跳躍的火焰中，這才是戲劇，這才是劇場，因為這是對存在的驚覺（to be aware of the Now）。

But how is one to come aware? Someone may ask. I answer, Listen to the poets. They can tell you.

Of all people in the world, Sir Philip Sidney said, poets are the least liars. Poets are reporters. They set down what they see. I will give you an example from *Hamlet*:

> *O good Horatio…*
> *If thou didst ever hold me in thy heart*
> *Absent thee from felicity awhile…*

Absent thee from felicity awhile. Here are some of the most beautiful words ever written in the English language. But this is not all. These words are a plain record of fact. Hamlet, drawing his last breath as he spoke them, was not interested in phrasemaking, nor was Shakespeare. Hamlet did not think up an exquisite phrase at that moment. He spoke out of a real vision of felicity, immortal. He saw the clear light, the happy forms. He saw the felicity. He called it felicity.

23 1554–1586，英國廷臣、軍人、文人。作品有*Arcadia* (1590)、*Astrophel and Stella* (1591)、*The Defense of Poesie* (1595)。

　　但是一定會有人問如何才能夠驚覺？聽聽詩人的吧！他們會告訴你！

　　飛利浦・席德尼爵士（Sir Philip Sidney）[23]曾說，世界上最不會說謊的就是詩人，他們像個紀錄者，紀錄了他們眼裡所看到的。我再舉一個《哈姆雷特》的例子：

> 親愛的霍拉旭……
> 如果能讓我留駐在你心裡
> 能否暫時擱置你永恆的幸福……

　　「能否暫時擱置你永恆的幸福」，這是在英語世界中，少數最美麗的詞句之一，但他不只是美麗而已，他也是一個事實的陳述，哈姆雷特在最後的喘息中說出這些話，他無法在意詞句的修飾，莎士比亞也不願意這麼做。哈姆雷特沒有說出細膩的語句，只說出了他對永恆和幸福的願景，他眼裡看到了光明、喜悅，看到了他以為的幸福。

I could give you hundreds of examples. Poets know that what they see is true. If it were not so, they would have told you.

Nothing can stop progress in the American theatre except the workers themselves. To them I say: There are no limitations there except your own limitations. Lift it. Get the personal *you* out of your work. Who cares about *you*? Get the wonder into it. Get your dream into it. Where are your dreams?

Great drama does not deal with cautious people. Its heroes are tyrants, outcasts, wanderers. From Prometheus, the first of them all, the thief who stole the divine fire from heaven, these protagonists are all passionate, excessive, violent, terrible. "Doom eager," the Icelandic saga calls them. If we are meant to create in the theatre—not merely to write a wall-constructed play or supply nice scenery, but to create— we shall imagine ourselves into these heroic mood. They will carry us far. For the soul is a pilgrim. If we follow it, it will lead us away from our home and into another world, a dangerous world. We shall join a band of poets and dreamers, the visionaries of the theatre: the mummers, the mountebanks, the jongleurs, the minstrels, the troubadours.

　　我還可以舉出上百個例子。詩人知道如何陳述他們看到真實，如若不然他們也會據實的告訴你。

　　除了劇場工作者自己之外，沒有人可以阻擋劇場前進的腳步。我想說的是除了你自我設限之外，從來沒有止境。拋開桎梏！把「你」從你的作品中拋開，誰會在乎你是誰？把魔力放進去，把夢想放進去，你的夢想在哪呢？

　　偉大的戲劇從不處理小心謹慎的人物，劇中英雄是暴君、是被驅逐的人、是流亡的人，打從那個將聖火自天堂偷來到人間的普羅米休斯（Prometheus）開始，這些主角都是熱情的、極端的、狂野的、可怖的。冰島的英雄傳奇中稱之為「毀滅的渴望」（Doom eager），如果我們企圖創作——不單是提供結構完整的戲劇，或提供漂亮的佈景——而是創作，我們就必須把自己放到這些英雄的位置上，因為心靈會像一個朝聖者一樣，把我們遠遠的帶領到另一個世界。一個充滿挑戰的世界。我們應該加入詩人和造夢者的行列，以及伶人、江湖術士、吟遊詩人等等對劇場有遠見的人。

　　有多少人在劇場裡還有夢，有多少人忘記了自己的夢。

現代人的延伸思考

　　作者非常認真仔細的將劇場各部門的工作一一分解陳述。確實，幕起燈亮的一剎那，映入觀眾眼簾的第一個畫面就是舞台佈景，對大多數人來說，佈景不就是佈景嗎？有那麼大的學問嗎？要山給山、要水給水，指著客廳就會有沙發。如果真是這樣，為什麼所有演出的節目冊上要有一個「舞台設計」這個職位？今天我們可以原諒觀眾不知道舞台設計是什麼，但是我們劇場工作者裡面，有多少人可以確實的知道身為一個舞台設計的職責？有多少人把自己的工作當成是問題排除者（trouble shooter）？有多少人把設計者當成繪圖師、裝潢工？有多少人把演出當成展現自我的工具？聽聽大師的幾句話 "Players act in a setting, not against it." 或是 "For I come to the theatre to see a play, not to see the work done on a play." 又說 "It says nothing, but it gives everything." 這是對自我工作上多麼深的期許啊！演員只能在已經傳達的訊息中去潤飾一句，傳達出多麼偉大的雄心。作為一個舞台設計者必須肩負多麼大的使命？但又必須保持多麼謙遜心靈？在最後一段隱退之說卻又是多麼謙和的態度！捫心自問我們還有多少人對自己的工作（不管任何行業）有如此深刻的認知？

　　表演是一種冒險的工作，演員是一個危險的行業，身為演員從事表演工作有多少人能夠真的昂首闊步、抬頭挺胸的對人說：「我是一個演員！」似乎並不多見。多少人是以卑微的態

度面對自己的行業，可是作者用了多麼尊貴的詞句來形容演員的工作──「展現」。而戲劇的光和熱也切切實實地必須經由演員才能夠散發給觀眾，否則對觀眾來說到底為什麼要花那麼多錢，去聽一個表演者自己都不懂的劇本？事實上，又有多少次當你我坐在觀眾席裡，心中真有一股怨氣，想要叫台上的演員閉嘴？

　　然而作者以一個設計家的身分，輕而易舉地點出了許多表演工作者心中的迷思，這一個「進入」與「退讓」之間的分際，是多麼精確的描述，卻也是多麼艱鉅的任務。而作者又能夠如此精闢地劃分　「演員」與「表演」之間的分野，又實在無法不令人讚佩他對自己工作之外所投注的關心與注目，這更不難令人想到當今之世又有多少人，對自己工作周圍領域的人投以全然的關注和了解？多少人是劃地自囿？自以為是？作者之所以能有如此精確的見解，全賴於對自身工作的熱愛，因為愛所以關心，因為關心所以了解，因為了解所以更投入。這也是為什麼筆者每在工作遭遇不順之時一再重讀此書，從作者熱情洋溢的文辭當中重拾對劇場的熱能。

　　當然作者所形容的歌劇演員在國內是極為罕見的，要知道國內歌劇的演出多半是由聲樂演唱家兼職演出，而不是由歌劇演唱家來表演，一個歌劇演唱家所要接受的是在聲樂之外，許多

表演相關的專業訓練。事實上，曾經有幸能有機會觀賞由帕華洛帝在大都會歌劇院所演出的歌劇，筆者還是會希望坐在自己家裡，聽由他演唱的歌劇CD，起碼不必忍受西裝、領帶、硬底皮鞋和狹窄座位的煎熬，看一個面無表情的大胖子，用他絕世無雙的嗓音，唱著你聽不懂的歌詞。因為帕華洛帝先生就是聲樂演唱家，表演對於他來說是另外一個世界的事，反而是世界上許多優秀的歌劇演員對國內觀眾來說是完全地陌生。

　作者第三次使用類似召喚、喚醒等的詞句，來針對服裝設計寄予期望。的確，有時候我們所眼見的服裝設計作品，過於追求細節的精緻，以至於忘記第3排以後的觀眾已經看不清車縫線，第10排以後的觀眾完全看不到扣子的式樣。當然，某些必須注重時代考證的演出，這些細節方面精緻度的追求是必然的。但是，我們也必須要提醒自己，我們的工作並不是電影或電視，觀眾沒有機會仔細地審視細節，更重要的應該是一種視覺上的風采吧！展現一個被角色進駐後的演員所散發出來的風采。而不見得一定是精巧的作工、昂貴的布料、甚或是設計的才華，而是角色所散發出來的光芒。這一段最後一句話，完全

點出服裝設計師的另一種功能——心理醫師，要知道最後在舞台上面對觀眾的只有演員，沒有別人，所有的設計師、導演、編劇，全部不是躲在觀眾席，就是在後台某個角落。因此最需要心理建設的，就是這一群既高貴又可憐的演員。而服裝設計師又是諸多設計當中和他們最貼身接觸的人，作為一個設計者，除了讚嘆他們之外，還有什麼更好的鼓勵呢？

作者寫作的年代，燈光在劇場中的發展還相當有限，並不如我們現在所知道的數位操控、電腦調節等等裝置，因此在整篇文章中，針對燈光設計所提建言部分的份量並不重，但是他卻點醒我們燈光在劇場演出中所應該扮有的角色。相反地，現在在軟、硬體設備發達的今天，我們似乎常常忘記了我們原本的職責，反而經常為變化而變化、為炫燿而變化。要知道不管時代和科技如何在進步，劇場永遠是一個由「人」所組合而成的場域，電腦或者說科技永遠只應該是手段，而不是目的，若反其道而行，那麼「人」終將從劇場消失，先是我們的觀眾，接著是我們。

III
The Theatre As It Was and As It Is

劇場古今

Magic may be real enough,

the magic of word or an act,

grafted upon the invisible influences

that course through the material world.

— Santayana

III
劇場古今
The Theatre As It Was and As It Is

魔術看起來似乎相當真實，
但是文字或表演的魔力在於：
他們能透過潛移默化的方式，
逐步融合這個物質世界。
——桑塔耶納[1]

Life moves and changes and the theatre moves and changes with it. By looking at the theatre of the past, we may come to see our own theatre more clearly. The theatre of every age has something to teach us, if we are sensitive enough and humble enough to learn from it.

I am going to ask you to do the most difficult thing in the world—to imagine. Let us imagine ourselves back in the Stone Age, in the days of the cave man and the mammoth and the Altamira frescoes. It is night. We are all sitting together around a fire—Ook and Pow and Pung and Glup and Little Zowie and all the rest of us. We sit close together. We like to be together. It is safer that way, if wild beasts attack us. And besides, we are happier when we are together. We are afraid to be alone. Over on that side of the fire the leaders of the tribe are sitting together—the strongest men, the men who can run fastest and fight hardest and endure longest. They have killed a lion today. We are excited about this trilling event. We are all talking about it. We are always afraid of silence. We feel safer when somebody is talking. There is something strange about silence, strange like the black night around us, something we can never understand.

隨著時間的更迭改變，劇場也隨之變化前進。回顧劇場的過去，可以讓我們更能看清楚我們自己的劇場。如果我們夠敏感、夠謙遜，任何一個時代的劇場發展，總能夠讓我們更認識自己身處的環境。

　　現在我必須要求各位做一件世界上最困難的事——去想像，想像我們回到了石器時代，想像那個人類居住在洞穴和猛獁象以及石窟壁畫共存的日子。夜晚來臨了！我們齊聚在菁火旁——裡面有Ook、Pow、Pung、Glup、Little Zowie和其他人，我們喜歡依偎在火堆旁！萬一有野獸攻擊我們，這樣也比較安全，再說像這樣聚在一起也比較開心，我們害怕孤單！我們這一族的頭目們坐在菁火的對面，這群頭目是族裡面最強壯的人，他們跑得快、打得猛也最有耐力。他們今天獵到了一頭獅子，大家都很興奮。每個人都在談論這件事。我們總覺得只要有人在說話就比較放心，我們害怕沉默，因為沉默像籠罩我們的無邊黑夜一樣奇異，一種我們永遠無法了解的異樣！

1　1863–1952，出生於西班牙的美國哲學家、詩人、批判實在論的代表人物，著有*The Life of Reason* (1905–06)。

The lion's skin lies close by, near the fire. Suddenly the leader jumps to his feet. "I killed the lion! I did it! I followed him! He sprang at me! I struck at him with my spear! He fell down! He lay still!" He is telling us. We listen. But all at once an idea comes to his dim brain. "I know a better way to tell you. See! It was like this! *Let me show you!* "

In that instant drama is born.

The leader goes on. "Sit around me in a circle—you, and you, and you—right here, where I can reach out and touch you all." And so with one inclusive gesture he makes—a theatre! From this circle of eager listeners to Reinhardt's great Schauspielhaus in Berlin is only a step in time. In its essence a theatre is only an arrangement of seats so grouped and spaced that the actor—the leader—can reach out and touch and hold each member of his audience. Architects of later days have learned how to add convenience and comfort to this idea. But that is all. The idea itself never changes.

The leader continues: "You, Ook, over there—you stand up and be the lion. Here is the lion's skin. You put it on and be the lion and I'll kill you and we'll show them how it was." Ook gets up. He hangs the skin over his shoulders. He drops on his hands

獅子的皮就躺在火堆旁，其中一個頭目突然跳起來說：
「獅子是我殺的！我跟蹤它！它撲向我！我用矛刺它！它躺
下了！不動了！」他說，我們聽。在他尚未開化的腦中突然
靈光一現，「我有更好的辦法告訴你們，看！是這樣的！我
做給你們看！」

在這短暫的一瞬間，戲劇於焉誕生了！

他接著說：「坐過來，圍個圈！你、你、還有你，坐過
來！這樣我才跟大家比較接近！」就這樣一個聚集所有人的
動作──劇場就誕生了，從這一群熱切的聆聽者，到現代化
大劇院，在時間的巨輪中其實只有小小的一步。古老時期的
劇場基本上就是座位的聚集和安排，這一種特質讓我們的演
員──也就是頭目──可以接觸，同時掌握我們這一群觀
眾，後來的建築師學會了怎樣把舒適和方便性加入其中，但
也僅此而已，其中的本質並沒有改變。

頭目接著說：「你！Ook！站到那邊去，假裝是獅子，獅
子皮在這裡！把它披上，到時候我假裝殺掉你，他們就知道
是怎麼一回事了！」Ook站了起來，披上獅子皮毛以後，用

and knees and growls. How terrible he is! Of course, he isn't the real lion. We know that. The real lion is dead. We killed him today. Of course, Ook isn't a lion. Of course not. He doesn't even look like a lion. "You needn't try to scare us, Ook. We know you. We aren't afraid of you!" And yet, in some mysterious way, Ook *is* the lion. He isn't like the rest of us any longer. He is Ook all right, but he is a lion, too.

And now these two men—the world's first actors—begin to show us what the hunt was like. They do not tell us. They *show* us. They *act* it for us. The hunter lies in ambush. The lion growls. The hunter poises his spear. The lion leaps. We all join in with yells and howls of excitement and terror—the first community chorus! The spear is thrown. The lion falls and lies still.

The drama is finished.

Now Ook takes off the lion's skin and sits beside us and is himself again. Just like you. Just like me. Good old Ook. No, not quite like you or me. Ook will be, as long as he lives, the man who can be a lion when he wants to. Pshaw! A man can't be a lion! How can a man be a lion? But Ook can make us believe it, just the same. Something queer happens to that man Ook sometimes. The lion's spirit gets into him. And we shall always

四肢在地上行走，同時咆嘯著。他看起來好可怕！我們當然知道他不是真的獅子，真的已經死了！我們今天才殺了它！Ook 當然不是獅子，他絕不是！「Ook 你不用嚇我們！我們知道那是你！我們才不怕你！」但是一種神祕的感覺告訴我們他是獅子，他已經和我們其他人不一樣了，雖然他還是Ook，但他同時也是一隻獅子。

現在這兩個人——世界上最早出現的演員——開始把獵獅這件事做給我們看，他們不再用說的，而是用演的！把整件事變成了一幕戲。獵人躺在一旁埋伏，獅子咆嘯，獵人瞄準他的矛，獅子跳躍起身子，我們跟著驚呼尖叫——第一個整體的歌隊！矛跟著射出！獅子躺下不動了！

戲劇就此結束了。

Ook 脫下了獅子皮，又坐回我們身旁，他又變回和你我一樣的身分，不！也不全然像你我！從今以後他已經是一個只要他想，他就可以變成一隻獅子的人，胡說！人不會變成獅子！人怎麼可能是獅子！但是 Ook 可以讓我們這麼認為，就這麼簡單！在某些時候，有一種奇妙的事會發生在 Ook 的身上，獅子的神采會出現在他身上，我們會用不一樣的眼光看

look up to him and admire him and perhaps be secretly a little afraid of him. Ook is an actor. He will always be different from the rest of us, a little apart from us. For he can summon spirits.

Many thousands of years have passed since that first moment of inspiration when theatre sprang into being. But we still like to get together, we still dread to be alone, we are still a little awed by silence, we still like to make believe, and when an artist like Duse or Chaliapin or Pauline Lord speaks aloud in our midst a thing that is in the minds of all of us and fuses our various moods into one common mood, we are still lost in wonder before this magical art of the theatre. It is really a kind of magic, this art. We call it glamour or poetry or romance, but that doesn't explain it. In some mysterious way these old, simple, ancestral moods still survive in us, and an actor can make them live again for a while. We become children once more. We believe.

Let us glance at another scene, another drama. We are listening to the first performance of the *Antigone* of Sophocles. Again I

2 1859–1924，義大利女演員，成功演出易卜生劇作主角而特別著名。
3 1890–1950，美國女演員，13歲便首次登台表演，1921年在百老匯演出尤金‧歐尼爾的劇作而聲名大噪。

他、羨慕他，甚至私底下會有一點怕他。Ook是個演員，他從此以後就或多或少和我們不一樣了，因為他能展現獅子的神采！

劇場在靈光一現的瞬間誕生之後已經幾千年過去了，但是我們依然喜歡聚集在一起，依然害怕孤單靜默。我們還是喜歡假想，當像是夏里亞賓或是杜絲（Duse）[2]還是寶琳‧路德（Pauline Lord）[3]這些藝術家們，在我們當中大聲的說出我們腦海中的一個映像，然後這個聲音會把我們心底深處各式不同的情緒融合而為一時，我們和千年以前一般，著迷在這神妙的劇場藝術中。不論我們稱它是令人炫目的也好，詩意也好，浪漫也好，其實都不足以說明這種既古老又單純的氣氛。它似乎像遺傳基因一般，以一種神祕的方式深埋在你我內心深處，而一個演員可以把這種氛圍再一次的召喚出來，在這裡我們再一次像稚兒一般，相信我們眼前的一切。

讓我們再看一眼另一齣戲，另一個場景，這是索福克理斯（Sophocles）[4]的《安蒂岡妮》（*Antigone*）[5]首次演出。在

4　496–406 B.C.，希臘悲劇詩人，作品約有120部以上，現僅存《伊底帕斯王》等七部作品。

5　與該劇同名的女主角為 Oedipus 與 Jocasta 之女，不顧其舅父底比斯國王 Creon 的命令，為死去的哥哥 Polynices 營葬，結果被活活埋入地下墳墓。

must rely on your imagination. You have all read this play at one time or another. You all know what Greek actors looked like, with their masks and high buskins. The play has been performed in your own time and perhaps some of you have even acted in it. But we are not in America now, and this is not a revival. We are in a great half-circle of stone seats built into the side of a hill. In front of us is the stage—a long, raised platform backed by a high screen—like wall of marble set with pillars of marble and gold. Something noble, something wonderful will presently happen on this stage. That is what it was made for. That is why we are here. It waits. We wait. We are not restless. We are content to stay in one place. Presently, in its own time, the day will come. The sun will shine upon us once more, as it has always done— the sun, too bright for our mortal eyes to look at. The sky grows lighter, but the stage is still dim and shadowy. Now the morning wind comes. We shiver a little. There is a sound of faraway doors opening "their ponderous and marble jaws." Two great dark figures steal out from opposite sides of the stage and meet in the center. They are Antigone and her sister Ismene. Their voices are lifted in a strange chant:

> *Do you know? Did you hear? Or have you failed to learn? …*
> *There is no grief, no degradation, no dishonor, not to be found*
> *among our woes… What is it then?*

這裡，我還是要再一次請求各位運用你們的想像力，大家也許或多或少都知道這個故事，也大約知道當時希臘演員是如何裝扮的——臉上戴著面具、腳下穿著厚底鞋。這齣戲在各位身處的時代也一定演過，甚至有人還參與過演出。但是我們現在不在美國，這也不是老戲重演，我們坐在依著山坡而建造半圓形劇場裡的石階上，舞台在我們面前——一座長形的平台，背後是一面像屏幕一樣的牆，牆上裝飾著鑲金的大理石柱子。很快地某些壯觀、奇妙的事就馬上要發生。這個劇場也就是為了這些事所建造的，這也是為什麼我們會聚集在這裡。它在靜靜等候，我們也安靜地等待著，一點也不焦躁，我們相當滿足於這樣的期待。不久之後，白日將至，太陽——那令凡人無法直視的金烏——將一如往昔地再一次照耀在我們頭頂。天空逐漸展現亮光，但舞台上幽暗模糊依然，清晨的涼風讓我們微微的發顫。這時候，開啟大理石門的巨大沉重聲音從遠處傳來，兩個黑影從舞台的相對方向悄悄地走向中央。她們是安蒂岡妮和她的妹妹伊思敏妮（Ismene），他們用一種奇特的音調吟唱著：

> 知道嗎？聽到嗎？難道你完全不懂嗎？……在我們的感嘆中你找不到悲傷、沒有落寞、也沒有恥辱……那又是什麼呢？

They breathe a dreadful secret in the darkness. The first beams of the sun smite the stage. There is a fanfare of brass. The chorus enters.

> *Thou hast appeared at last…shining brighter on our seven-gated city than ever light shone before. O, eye of the day of gold!*

And now the dawn has come, calm, serene, merciless as justice, inexorable as law. The drama pursues its course in the light of a new morning, marching steadily toward its climax while the sun marches steadily on toward high noon. All things are to be made clear. All things move from darkness into light. The sentence is pronounced. Antigone must go alive into the tomb. The beautiful masked figure speaks:

> *Men of my land, you see me taking my last walk here, looking my last upon the sunshine. Never more.*

She is standing now in the shadow of the great center portal. She covers her face with her veil. Sorrow, and dread and ruin… the elders of the city answer her:

> *And yet in glory and with praise you pass to the secret places of the dead. Alone among mankind you go to the grave alive.*

在闃黑的暗影裡，她們揭露了一個駭人秘密。第一道陽光浸入舞台。隨著華麗的管樂聲，歌隊進場。

你終於出現了……以前所未有光芒；照耀著我們這座七門之城。喔！金色的白晝之眸！

黎明來到，冷靜、清朗、無情一如正義、嚴酷一如律法，戲劇在一個新的早晨裡，依著它獨有的步驟逐漸展開，當紅日高照的同時，戲劇穩健的邁向高潮。此時所有的事件都必須清明，所有在黑暗中的都必須被攤在陽光下。判決已經宣佈。安蒂岡妮必須被活葬。戴著面具的美麗身影說道：

我的子民啊！這將是你們最後一次看我在這裡行走，再看一眼這照耀在我身上最後的陽光，從此不再的光亮！

她現在站在中央大門的陰影裡，面紗遮住了她那充滿憂傷、恐懼且頹敗的容顏……市民中的長老回答她：

你將帶著讚美與榮耀踏進神祕的死亡殿堂，在人群之中你將孤獨地生生走入墓穴。

Strange shadows stir in the darkness behind her. Her voice seems to come from a great distance:

> *I have heard of the pitiful end of the stranger from Phrygia, the daughter of Tantalus…most like to her, God brings me to my rest.*

She speaks from another world. She is already a memory.

> *Cut off from friends, still living, I enter the caverned chambers of the dead. I who revered the right.*

The great doors close…

If we would recapture the mood of this drama today, we must turn to the music of Bach or Brahms, or to the dancing of Isadora Duncan, or to the high words of Abraham Lincoln's *Gettysburg Address*:

6 1878–1927，美國著名女舞蹈家，創立現代自由舞蹈體系，被譽為現代舞之母。

　　奇異的陰影在她身後的黑暗中搖曳，她的聲音飄邈一如來
自遠方：

　　　　我聽到了來自佛里吉亞的陌生人的悲慘結局，她是丹
　　　　達羅斯的女兒……和她一樣，神引領我安歇。

　　她的聲音來自另一個世界。她彷彿已經變成一種回憶。

　　　　活生生地與我的同胞截斷，我進入死亡的穴腔，我，
　　　　這個尊崇正義的女子。

　　　　巨大的門扉闔上……

　　如果今天我們想要重新掌握這樣的氛圍，我們一定要到
巴哈或布拉姆斯的音樂中找尋，或是在伊莎朵拉・鄧肯
（Isadora Duncan）[6]的舞蹈尋覓，更或者像是林肯的蓋茨堡
宣言（Gettysburg Address）[7]中：

7　1863年美國總統林肯在蓋茨堡發表的演說，其中有「民有、民治、民享」這一表達
　　民主真諦的名句。

But, in a larger sense, we cannot dedicate, we cannot consecrate, we cannot hallow this ground…The world will little note, nor long remember, what we say here; but it can never forget what they did here…

It is our right to be made to feel in the theatre terror and awe and majesty and rapture. But we shall not find these emotions in the theatre of today. They are not a part of our theatre any more.

Let us imagine ourselves now at the Bankside Theatre in London, in the days of Queen Elizabeth. We know today just where this theatre stood and how large it was and how it looked. Let us go there.

We are standing in the middle of a high circular building, open to the sky, with rows of balconies all around us, one above the other. At one end is the stage, a raised platform with entrances at either side and a space curtained off in the center. Above this is a balcony and above this again a kind of tower, high up against the sky. The pit where we are standing is crowded and

就更廣的層面而言，我們無法奉獻，無能貢獻，更不
能使這片土地神聖……世界將不會注意，更不會記得
我們今天在這裡所說的，但是他們會記得在這裡所做
的一切……

　　在劇場裡我們有權利感覺到恐懼、哀憐、莊嚴與狂喜，但
是在今天的劇場裡我們找不到這種感動，他們已經不再屬於
當今的劇場。

　　再讓我們想像一下，回到伊莉莎白女王時代，回到倫敦的
河岸劇場（Bankside Theatre）[8]。現今我們已經知道它的正確
位置，以及它的大小和外觀。讓我們到那走走吧！

　　我們站在一座高聳的圓形建築中央，抬頭可以看到天空。
在我們的周圍是一排又一排的迴廊層層相疊，劇場一端的舞
台高於地面，舞台的兩邊各有一個進出口，中央的部分被一
塊布幕遮住。舞台的上方有個迴廊，再往上看去，直伸天際
的是一座塔型建築。我們現在所站立的凹陷處（pit 指現在

8　即為環球劇場，仿伊莉莎白時期的露天劇場，位在倫敦。

a little dangerous. Life is cheap here at the Bankside Theatre. A stiletto under the ribs and no one is the wiser…It begins to get dark. Lanterns and torches are lighted. A trumpet calls. We quiet down. High up on the platform a sentry moves—

Who's there?
Nay, stand, and unfold yourself.

We are at Elsinore. We are listening to the tragedy of *Hamlet*.

Horatio arrives with Marcellus. A bell strikes. The Ghost appears.

Nowadays, we don't believe in ghosts any more. Or at least we say we don't. But not so very many generations ago our own ancestors were burning witches for trafficking with the spirits of the dead. And I observe that when we are out in the desert, away from home, at night, sitting around a camp-fire, everyone has a mighty good ghost-story up his sleeve. And he always swears it is a true story, too. At any rate, here, in the Bankside Theatre, we do believe, and we are shaken with terror and pity at the sight of this thing out of hell. And now there is a flourish of trumpets and drums. The curtains part. The King and Queen enter in their

的觀眾席）有點擁擠也有點危險，自己小心，好漢不吃眼前虧！在這裡人命不值錢⋯⋯天色漸漸暗下來了，火炬和燈籠一一被點燃了。突然傳來一聲號角，我們全都靜了下來，舞台上的哨兵開始移動。

前面是誰？
不！你先回答我！站住，報上名號來！

我們來到了艾辛諾，即將聽到哈姆雷特的悲劇。

霍拉旭與馬契勒斯（Marcellus）一同來到。一聲鐘響，鬼魂悄然現身。

當今之世好像已經沒有人會相信鬼魂之說了，或者我們起碼嘴上這麼講。但是就在幾個世代之前，我們的祖先還在燒死那些和亡靈交易的女巫。可是我發現一件事，當我們遠離家門，露宿荒郊野外的時候，到了夜晚營火堆旁，大伙總是有一堆說不完的鬼故事，而且人人都發誓說是真人實事。無論如何，在這河岸劇場裡，我們實實地相信。我們也因為這個從地獄來的 「超自然物體」，所帶來的恐懼和哀憐而顫抖。隨著壯盛的鼓號樂聲，舞台中央的布幕拉開了。國王與

glistering apparel, in the midst of their retinue—the counselors, the Swiss guards in bright armor, the ladies-in-waiting, the whole court of Denmark—proud, splendid, unimaginably rich in the glare of the torches. Nowadays royalty doesn't mean much in our lives. Kings and queens are curiosities, something to read about in the newspapers along with some movie Sheba's latest re-marriage. But at the Bankside, Claudius and Gertrude are literally "hedged with divinity." This very morning Queen Elizabeth herself held an audience and laid her hands on us for "king's evil", and this very afternoon we saw her go by on the Thames in her gilded barge—Elizabeth, Gloriana, Belphoebe, Star of the Sea. We know what royalty is. We have seen it. We know what great ladies and gentlemen are. We have seen them. Kings and queens and princes are all real to us; and as we watch the delicate wayward Prince Hamlet, standing there in his black, emotions of awe and affection and adoration come thronging into our minds, all blending into wonder.

What a storm of energy there is in this play! How swiftly it moves! What a rush and whirl! Now on the forestage, now on the balcony, now behind the arras, now high up on the platform. And how these players perform it! They are trained entertainers—singers, dancers, clown—actors. Tomorrow they will do *The Merry Wives of Windsor*, and the next day Christopher

王后以燦爛的容妝出現在我們眼前，簇擁著他們的是——王公大臣、侍從宮女和穿著奪目甲冑的衛士們。整個丹麥宮廷在火炬的照耀下，顯得如此耀眼，如此輝煌，如此難以置信的華美。對今天的我們來說，皇室似乎沒有太大的意義，國王皇后是異數，是在報紙上伴隨著電影豔星再婚消息出現的人物。但是在這河岸劇場中的克勞地（Claudius）和葛楚德事實上是「真實再現」，就在今天早上伊莉莎白皇后才在人群中撫慰我們的瘰癧（淋巴結結核 scrofula），就在今天下午我們才看到她搭乘著鑲金的畫舫在泰晤士河上出現——伊莉莎白號、光榮號、貝爾福號、海洋之星號，我們完全知道皇室是怎麼一回事，因為我們親眼見過。我們知道雍容華貴的紳士淑女是怎麼一回事，因為我們親眼見過。國王、王后、王子是再真實也不過的，所以當我們看到那纖細敏感又剛愎自用的哈姆雷特王子，穿著一身黑站在舞台上時，所有哀傷、執著、愛慕的情緒蜂湧而至，融合成一股驚歎。

這齣戲裡是充滿著如此狂暴的精力啊！動作如此的迅捷！如此的狂暴眩目！一下子在前舞台，一下子在迴廊，一下子在緯絲掛氈後面，一下子又在高台上。看看這些表演者的演出，他們是訓練精良的藝人——歌者、舞者、丑角——和演員。明天他們將演出《溫莎的風流娘兒們》（*The Merry*

Marlow's *Tamburlane* and after that *A Midsummer Night's Dream* or Troilus and Cressida. They have acted these "hits" (for that is what they are, the "hits" of their day) all over England, all over Europe. Sometimes they play before kings and queens, sometimes they play in stable-yards, before audience of plowboys and truck drivers and sailors. They know the ways of courts and they know what it is to go hungry. They have learned their profession in a hard school of experience.

These Elizabethan actors know how to speak poetry. Hear their voices ring out in the tremendous phrases. Nowadays if we want to hear a good voice on the stage, we must go to opera. We do not expect to find one in the theatre. Music is no longer an integral part of drama. Our dramatists write for the eye, for the mind. But Shakespeare wrote for the ear. The soliloquy, "To be or not to be," is nothing more nor less than a great spoken aria. Turn to this play and read it once for the music alone.

So the drama goes on—the play, the murder, the closet-

9 1564–1593,英國劇作家、詩人,成功運用無韻詩體創作英國戲劇,著有*Tamburlaine the Great* (1590)、*The Tragical History of Dr. Faustus* (1604)。因在酒館中與人發生爭執而被刺身亡,時年不到30歲。

10 原劇名為*Tamburlaine the Great*,一齣以十四世紀中亞歷史為背景的劇目,此劇為伊莉沙白時期戲劇發展的重要里程碑。

11 出自希臘神話,中世紀傳說。特洛伊羅斯為 Troy 國王 Priam 之子;克萊西達是特洛伊的一個女子,背叛了自己的情人特洛伊羅斯。莎士比亞亦撰有此一同名悲劇。

Wives of Windsor），後天演出克里斯多福・馬婁（Christopher Marlowe）[9]的《帖木兒大帝》（*Tamburlaine*）[10]，再接下來是《仲夏夜之夢》（*A Midsummer Night's Dream*）或《特洛伊羅斯與克萊西達》（*Troilus and Cressida*）[11]。他們演出這一類熱門劇碼（在那個時代這些的確是熱門劇），足跡遍佈英國與歐洲各處，有時候他們在宮廷裡作御前獻演，有時候他們在牲口棚外的廣場為莊稼漢、馬伕和水手表演。他們明瞭宮廷的禮儀，卻也深深了解飢餓的滋味。他們的專長是經由艱困的經驗累積而成的。

伊莉莎白時代的演員能夠清楚的表達詩韻，聽聽他們的聲音如鐘聲般敲響驚人的語句。但是在今天如果我們想聽一把好聲音，似乎只有去聽歌劇了，在劇場中不再有這種奢望。音樂韻律已經不再是戲劇中不可或缺的一環，我們的劇作家寫作是為了觀眾的眼睛和腦袋，但是莎士比亞還為我們的耳朵寫作。單單就「To be or not to be」這一段獨白而言，它就是一段偉大的口語詠嘆調。把這個劇本翻出來再讀一次，好好的體會它語言裡的音樂吧。

戲劇繼續進行著──戲中戲、謀殺、臥室、裝瘋、決鬥

scene, the mad scene, the duel…mounting to its majestical end. Hamlet's body is borne to the platform. The last peal of ordnance is shot off. *The rest is silence…*

And now the players are gone. What a strange thrill an empty theatre gives us! What echoes it carries, and what memories! Here was a dream, a high, swift, passionate, terrible dream. We have been brought face to face with the majesty and splendor of destiny. Perhaps all the sins and energies of the world are only the world's flight from an infinite blinding beam.

In the early days of the eighteenth century an English playwright named William Congreve wrote a comedy which he called *The Way of the World*. Let us go to London to see this play.

We are in a great hall lighted by crystal chandeliers. How did the drama get indoors? Nobody seems to know. The thing that is going to happen in this playhouse is neither religious ritual nor great popular art. There is a feeling of privacy here. A curtain covers one end of the room. A curtain…? What is behind it?

……一路爬升到它壯闊的結局，哈姆雷特的屍體靜靜地躺在台上，砲聲最後的巨響也停止了。**一切靜了下來**……

　　演員們已經離去。這樣空蕩蕩的劇場，所帶給我們的是一種怎樣的悸動！怎樣的迴響！怎樣的記憶！這裡曾有一個夢，一個高傲的、迅捷的、熱切卻又駭人的夢，我們曾與命運的壯闊及光彩相遇。也許這世上所有的罪惡與能量，僅只是這個世界為了躲避那無垠的炫目光束。

　　在十八世紀初有一位名叫威廉・康格瑞夫（William Congreve）[12]的英國劇作家，寫了一齣名為《如此世道》（*The Way of the World*）的喜劇，讓我們到倫敦看看這齣戲。

　　我們正在一間被水晶吊燈所照亮的大廳裡，劇場從什麼時候被關進房子裡，似乎已經沒什麼人知道了。在這個戲院裡；我們將經歷的不再是宗教儀式或是大眾娛樂，大廳一端的大幕所遮掩的部分，帶來一些隱密感，一道大幕……後面

12　1670–1729，英國風俗喜劇作家，以諷刺當時的上流社會著名，著有 *Love for Love* (1695)、*The Way of the World* (1700)。

Something intimate, something personal, something…a little indiscreet? perhaps… Congreve will tell us. A servant trims the candles that burn in a row at the foot of the curtain. There is a preluding of fiddles. The curtain is lifted. We look at a room that is not a real room, but a kind of thin, delicate, exaggerated echo of a room, all painted on screens of canvas. The actors enter, each one bowing to the audience. They look like nothing human, like nothing ever seen on this earth. The ladies' cheeks are rouged with a high hectic red. They wear frail iridescent dresses of silk and lace. They are laden with jewels. They carry masks and fans. The men wear periwigs and rapiers. Their heels click on the polished floors. Their hands are covered with long lace ruffles and they glitter with diamonds. The sense of luxury has come into the theatre. The players float and waver in the warm air that streams up from the tapers, like butterflies, like ephemera, born to shine a moment for our pleasure, for our humor, for our distinguished indulgence. *Et puis – bon soir!* Life? Don't come too near it! Life is just something that effervesces for a moment and goes flat. Life is a nuance, a gesture, a flicker…rouge…blood…ashes…Love? Who ever said there was such a thing as love in the world? We know better. But while we are here we will keep up the show. And a brave show it is, a dazzling show. Distinguished manners, effrontery, phrases like fireworks…But here comes Mistress Millamant, i'faith, full sail, with her fan spread and her streamers out, and a shoal of fools for tenders:

是什麼？有點親暱？有點私密？有點⋯⋯不檢點？更或許是
⋯⋯康格瑞夫會告訴我們。出現了一個僕人，他把在大幕前
燃燒的燭火調整好。提琴演奏的序曲響起。大幕升起。我們
看到一個房間，但不是真實的房間，所有的東西都是畫在
帆布上，讓它看起來有點脆弱、虛假、誇張。演員一個個對
觀眾行禮進場，他們看起來相當不真實，假到不像是地球上
的生物。女人們臉上的腮紅像發著高燒，細緻的絲質蕾絲服
裝，讓她們發出珍珠般的光芒。身上堆金砌玉，手上拿著面
具和扇子。男人們戴著假髮身佩長劍，高跟鞋敲響了光潔的
地板，閃耀著鑽石光芒的蕾絲荷葉袖口遮住了他們的雙手。
一種奢華感進入了劇場。演員們的身影在燭光的溫暖搖曳
下，有如蝴蝶、蜉蝣一般，一生只為了我們而短暫存在，我
們的歡娛，我們的滿足，我們尊貴的陷溺。然後──即道晚
安！生命啊？千萬別想太多！它不過是一閃即逝的泡沫，生
命是一種曖昧、一種姿態、一道閃光⋯⋯胭脂⋯⋯血色⋯⋯
灰白⋯⋯愛？是誰說世界上有愛這種東西？你我都清楚。但
是只要你我都還在這裡，沒必要不繼續跟著戲走。好一齣五
色繽紛光彩耀眼的表演，高貴的儀態、厚顏無恥、如煙火
般絢爛的語句。《如此世道》劇中的米蘭蒙夫人（Mistress
Millamant）上場，儀態萬千、張開的扇子、飛揚的飄帶、伴
隨著一群丑角侍從：

*You seem to be unattended, Madam—you used to have the beau
monde throng after you; and a flock of gay fine perukes hovering
round you.*

*O, I have denied myself airs today, I have walked as fast through
the crowd—*

As a favorite just disgraced; and with as few followers.

*Dear Mr. Witwoud, truce with your similitudes; for I am as sick
of 'em—*

*As a physician of a good air.—I cannot help it, Madam, though
'tis against myself.*

Yet, again!—Mincing, stand between me and his wit.

*Do, Mrs. Mincing, like a screen before a great fire.—I confess I
do blaze today, I am too bright.*

Flutes and hautboys in the air around us...

There is a remarkable actress in London, Miss Edith Evans,
who can speak lines like these with the precision and variety of a
Heifetz. It is a very special pleasure to listen to her, and you have
only to hear her go through an act of *The Beaux' Stratagem* to

夫人！看起來似乎沒人在照料您。以前不是有一堆上
流人士蜂擁在您身邊，一大群花花綠綠的漂亮男人簇
擁著您嗎？

喔！我今天不想裝派頭了，我努力的穿過人潮……

像您這樣受人歡迎，身邊沒有跟隨者似乎不好看吧？

親愛的衛特沃先生！別再指桑罵槐了！我也快被那些
人煩死了，我想……

就一個排場能手而言——我實在是忍不住，夫人！但
您也知道這可是完全違反我的本意！

看吧！又來了——茗欣！站到我和他那張利嘴之間！

快點站過來吧，茗欣太太！像個隔板站在大火前一樣
——我承認我今天像火焰一樣！我太耀眼了！

　　兩人的語音如長笛和雙簧管的重奏飄揚在我們周圍的空氣
中……

　　倫敦有個了不起的女演員——伊迪絲·艾文斯（Edith
Evans），她能夠用有如海非茲（Heifetz）一般精確又多變的
聲音，將這些台詞呈現給觀眾。欣賞她的聲音表情是一種極
度的享受，也唯有在聆聽完她表演《求婚者的計謀》（The

realize that she has perfected an art of musical speaking that is almost unknown in our day. When a playwright begins to awaken the music that lies in the spoken word, and when an actor begins to give this music its value, a new theatre springs into being.

Plot? Oh, yes, to be sure, there is a plot. But if it should ever chance to obtrude itself too much, someone on the stage will cry out, "Come, I have a song for you, and I see one in the next room who will sing it."

And then Congreve will carelessly toss us an incomparable lyric like this:

> *I tell thee, Charmian, could I time retrieve,*
> *And once again begin to live and love,*
> *To you I should my earliest offering give;*
> *I know my eyes would lead my heart to you,*
> *And I should all my vows and hopes renew;*
> *But to be plain, I never would be true...*

13 作者為 George Farguhar (1678–1707)，描寫兩名男子構陷一名女繼承人再嫁，以瓜分她的財產。

Beaux Stratagem）[13] 中的一幕後，才能夠了解她已經將這種音樂性的語調藝術鍛鍊至純熟完美，是一種當今幾乎無人能企及的聲音。劇作家喚醒語言中的音樂性後，再加上演員賦予這些音樂語言所應有的價值——一種新的劇場於焉誕生。

情節？那當然是不可或缺的，因為一旦語言的音樂性過於喧賓奪主時，演員得在台上對著觀眾大喊：「嘿！我這邊有一首曲子要獻給你們聽，不過是隔壁那一個人要唱！」

也就在這個時候，康格瑞夫不經意的丟出了像這樣無與倫比的詞句：

> 聽我說，恰弭恩，如果我可以讓時光倒流
> 讓我重活一次；再愛一次
> 我早該做出我的退讓
> 我知道我的雙眼會將心牽引到你身邊
> 我會重新許下我的誓言與願望
> 但事實上，我將不再真實……

There is a moral lesson in this play, too thrown in for good measure. Certainly, there is a moral lesson. Virtue triumphs in the end, as virtue should. But we shall not take it too seriously. It is all a part of the graceful ephemeral dance. The epilogue is spoken. The players bow themselves out in a minuet. We shall meet them a little later in the evening at one of the fashionable chocolate-houses. *As for living, our servants can do that for us*, a Frenchman said, a century and a half later.

Somewhere around 1840 a very strange thing happens. A man named David Hill discovers how to make a thing he calls a photograph. It is a picture made on a sensitive plate of metal by rays of light, a picture of things exactly as they are. All art is profoundly influenced by this discovery. We all become fascinated by actuality. We want to see everything just as it is. We want people on the stage to walk and talk just as they do off the stage. Soon afterward the first real Brussels carpet makes its appearance in the theatre. Scene-painting becomes realistic, acting becomes casual, dialogue is modeled after the speech of everyday life. Let us drop in at a performance of Ibsen's *Hedda Gabler* in the early '90's.

The curtain goes up. We are looking at a room. At first glance it seems just like a real room with one wall taken off. It is a tasteful, agreeable room, furnished, exactly as a real room would

　　這齣戲裡穿插著品德標準的道德教訓，在這個時代當然要有道德教條，美德到最後一如預期的必須戰勝一切。但我們也不必太嚴肅的看待它，這一切不過是優雅的薄命之舞其中一部分。全劇的尾聲朗讀完了，演員們很快的謝完幕。也許晚一點，我們可以在某一個時髦的咖啡店裡碰見他們端著盤子，一如在一個半世紀後的某個法國人說的：「為了過活，我們得做服務生這些事！」

　　約莫在1840年左右發生了一件奇妙的事，一個叫做大衛‧西爾（David Hill）的人發明了照相術，那是利用光線投射在感光金屬板上所呈現的畫面，一個完全真實的畫面。所有的藝術型式都被這一項發明所深深影響，我們開始對肖真著迷，我們希望看到和真實一樣的東西，我們希望舞台上人物的一言一行，就和他們在台下時一模一樣。沒多久我們就看到真正來自布魯塞爾的地毯出現在舞台上，舞台繪景開始趨近寫實，表演變得生活化，對白也以日常對話為基礎。讓我們來看一眼1890年代初期易卜生的《海達‧蓋伯勒》。

　　幕已升起。眼前呈現的是一個房間，乍看之下它就如同只被拆掉一面牆一樣真實，一個具品味又格調統一的房間。有

be, with tables and chairs and sofas and bric-a-brac. We might have taken tea here this very afternoon. This room has been lived in. It has an atmosphere. We can tell what the people who live here are like. The room has taken on something of their quality, just as an old coat gets molded to the person who wears it, and keeps the impress of his body afterward. See, there is General Gabler's portrait in the room beyond, and there are his pistols on the old piano, and the room is filled with flowers, and over there is a stove with a fire in it.

The play begins. How odd! Here is no solemn public ritual, no spoken opera, but a kind of betrayal. We are all eavesdroppers, peering through a keyhole, minding other people's business. We look in at the private affairs of the Tesmans, and we listen to them with the same eager, shocked, excited interest with which we might read the details of some court-room revelation. We see a spoiled, hysterical woman, dressed in the latest fashions from Paris. She pokes fun at Aunt Julia's bonnet. She pulls Mrs. Elvsted's hair. She burns Lovborg's manuscript. She is going to have a baby and she doesn't want it. She plays the piano and shoots herself. The characters talk like this:

Well, well, then…My hat—? My overcoat—?
Oh, in the hall—I do hope I shan't come too
late, Hedda! Eh?…Oh, if you run—

桌子、椅子、沙發、古董文玩，它的陳設一如真實，也許我們曾和主人在這裡喝過下午茶。有一種氣氛告訴我們這個房子住著人，我們可以感覺到是什麼樣的人住在這裡，這房間裡留有他們的特質，正如一件舊大衣留下他主人的身體印記一般。看到了嗎？蓋伯勒將軍的畫像在隔壁的房間，他的手槍放在舊鋼琴上，房間裡充滿了鮮花，另一邊壁爐裡的火正燃燒著。

　　戲正上演。多奇怪啊！現在進行的不是莊嚴的儀式，不是歌劇式的語調，反而是一種背叛。我們都變成了偷窺者，好像從鑰鎖孔裡去管閒事一般。我們看到泰斯門（Tesmans）的私密情事，我們用一種好像聽法庭辯論一樣熱切、訝異、激烈的情緒在聆聽他們的對話。我們看到了一個驕縱又歇斯底里的女人穿著巴黎最新的時裝，她戲弄茱利亞姑媽（Aunt Julia）的小帽，拉扯艾爾福斯特太太（Mrs. Elvsted）的頭髮，焚燒勒伏伯格（Lovborg）的手稿，她懷孕了可是她並不想要這個孩子，她彈完琴之後便舉槍自盡。劇中人物是這樣說話的：

　　　嗯！嗯！那……我的帽子——？我的大衣——？
　　　喔，在大廳——我想我沒到的太晚吧，海達……喔！
　　　如果你趕快——

*Mrs. Elvsted…Oh, yes, Sheriff Elvsted's wife
…Miss Rysing that was…that girl with the irritating hair that
she was always showing off… an old flame of yours, someone
told me.*

It is all given to us in the language of everyday life. Just like
a living picture. We might be listening to people on the street…
Little by little we become aware of a strange deep tragic play and
interplay of motives behind the conventional surface. We are
overcome by an inescapable sense of fatality. The ancient terror
spreads its shadow over the drama. The pistol shot at the end is
the finale of a great tragic symphony.

And here we are back again. Our theatre is concerned with
Little Theatre Movements and talking pictures and censorship
and unions and interlocking dimmer-boxes. Fashions change.
In *Uncle Tom's Cabin*, written not so long ago, little Eva's father
clasps her to his heart and murmurs:

14 一種當時新興的燈光控制器。

艾爾福斯特太太⋯⋯喔！對了，是艾爾福斯特警長的
夫人
⋯⋯萊欣小姐，就是那個⋯⋯那個女的整天頂著一頭
討人厭的頭髮走來走去⋯⋯是你的老情人吧，有人跟
我說⋯⋯

　　所有的語言聽起來都像日常生活的對話，就有如我們會在
街上聽到的對談，一切像活生生的圖片⋯⋯但是我們逐漸發
現，隱藏在慣常表面下的深沉悲劇和相互影響的動機，一場
無可逃避的宿命感蔓延在我們之間。遠古的恐懼感在這齣戲
劇裡再一次張開它的羽翼，劇終最後的槍聲，正有如一首悲
愴交響曲的最後休止符。

　　再讓我們回到當下吧！我們的劇場關心的是小劇場運
動，是動態影音、潛意識開發、工會機制、連動調光機組
（interlocking dimmer-box）[14]。風尚在改變。就好比前不久才
發表的《湯姆叔叔的小屋》（Uncle Tom's Cabin）當中，小伊
娃（Little Eva）的父親把她緊抱在胸前低聲的說：

O Evangeline, rightly named? Thou art indeed an Evangel to me!

In Maurice Watkin's *Chicago*, a sensational success in New York, the show-girl heroine yells:

You Goddamned louse!

and drops her man with a pearl-handled revolver.

Fashions do, indeed, change. We are not living in the Stone Age any more, nor the time of the Renaissance, nor the time of the Restoration, nor in the Mauve Decade. These are the days of the candid camera and the comic strip and television and reducing diets and strange new dance-steps. We have to work in the theatre of our own time with the tools of our own time…I will tell you now why I have made these images of the theatre of other days. In all these dramas of the past there is a dream—an excitement, a high, rare mood, a conception of greatness. If we are to create in the theatre, we must bring back this mood, this excitement, this dream. The plain truth is that life has become so crowded, so hurried, so commonplace, so ordinary, that we have

　　艾雯潔琳，多好的名字啊！妳就是我的福音啊！

　　又或者像在紐約轟動一時，莫里斯・瓦金（Maurice
Watkin）的《芝加哥》（*Chicago*）當中女主角大吼：

　　你他媽的癟三！

然後用一把珍珠柄的手槍殺了她的男人。

　　風尚的確是會改變的，我們不再是石器時代的穴居人、不
再是文藝復興，不可能回到復辟時代、更不可能再回到紫色
的十年（Mauve Decade）[15]。現在是電視、漫畫、偷拍的時
代，是節食和學習奇特新舞步的日子。我們得在我們的時
代、用我們的方法，在我們的劇場裡工作⋯⋯。現在，我來
告訴你我為什麼要說這些過去的事，這些過去的戲劇裡充滿
著一種悸動、一種罕見的情操、一種宏偉的思潮，如果我們
要創造我們的劇場，我們就要把這種情操、這種悸動、這個
夢找回來。實實地說，生活如此擁擠匆忙、如此平凡無奇，

───────

15　指美國社會和文化繁榮興旺的 1890 年代。

lost the artist's approach to art. Without this, we are nothing. With this, everything is possible. Here it is, in these old dramas. Let us see it. Let us learn it. Let us bring into the theatre a vision of what the theatre might be. There is no other way. Indeed, there is on other way.

以致於我們失去了身為藝術家對藝術的探索。沒有了探索，我們什麼也不是。有了它，我們可以達成所有事。就在這裡，這些古老的戲劇，它們就在我們面前。讓我們讀它、學習它，讓我們把劇場帶往它所應有的視野，只有這樣，真的，只有這樣。

現代人^的延伸^{思考}

　　整篇文字在乍看之下似乎包比先生絮絮叨叨地在訴說著劇場流變，但是字裡行間對亙古以來的劇場熱情卻在看似激動的文字裡一再流瀉。從遠古時期的分享、到希臘時期的參與、到伊莉莎白時期莎劇的撼動，以及於十八世紀語言音韻的交流，甚至到寫實主義興起後的窺視心情，無一不在訴求著舞台上下的水乳交融。

　　是的，水乳交融。這個在當今劇場的演出中，似乎已經成為最不重要的環節了。多少創作者的中心思想都是「我」作為主題，「我」想要表現的主題是……「我」訴說的重點是……「我」企圖表現的是……似乎都忘了除了「我」之外，還有那成百上千的觀眾，「他們」看的是什麼？「他們」的感受是什麼？「他們」的心情是什麼？

　　劇場藝術之獨特於其他藝術，即在於它是一門溝通的藝術，它有創作者、有觀賞者，但是沒有導覽員或解說員。作品的本身就必須兼具導覽解說的功能，不能如某些純藝（美）術工作者所言："My work speaks for itself."。以一個劇場工作者而言，這種態度未免失之於過度自大與驕傲。畢竟，劇場從古至今始終是一門「人」所組合的藝術，失去了人與人之間的溝

通、交流、互動，那我們的劇場還剩下什麼？一群自我耽溺的自大狂？在一群不知所以的群眾面前進行一場無法高潮的自慰儀式？

　　退一萬步來說，一幅畫、一件雕塑的欣賞者只有少數一群人暫時存在，而劇場藝術創作的完成卻在於觀眾的即時存在。觀眾是成就劇場藝術的充分必要條件，我們要用怎樣的語彙來理解作品？用怎樣的肢體傳達作品意念！怎樣的舞台光景去擴散感動？這一切的一切都是在企求著讓觀眾與我心有戚戚焉的感同身受。我常喜歡說：「觀眾是我們的衣食父母啊！」但探索與觀眾的溝通，並不意味著諂媚觀眾，而是在於我們用怎樣的香火來供養他們。讓你我遇合的這樣一個特別夜晚，有著共同的呼吸心跳，一樣的哀憐、恐懼與愉悅。

　　極度喜愛作者最後一段話：「……我來告訴你我為什麼要說這些過去的事，這些過去的戲劇裡充滿著一種悸動、一種罕見的情操、一種宏偉的思潮，如果我們要創造我們的劇場，我們就要把這種情操、這種悸動、這個夢找回來。實實地說，生活如此擁擠匆忙、如此平凡無奇」……我們還要讓觀眾平凡的生活更乏味嗎？

IV
To a Young Stage Designer
給設計新鮮人

Beauty is the purgation of superfluities.

— Michelangelo

Behind the words and movements,
imperturbable, Withdrawn,
slumbered a strange smoldering power.

— Henry Brocken

IV
給設計新鮮人
To a Young Stage Designer

美能洗滌奢華。

　　——米開朗基羅

在語言和動作之下，

安靜地、孤獨地、如火山休眠般；

潛藏著一股抑鬱的力量。

　　——亨利·布坎[1]

A stage designer is, in a very real sense, a jack-of-all-trades. He can make blueprints and murals and patterns and light-plots. He can design fireplaces and bodices and bridges and wigs. He understands architecture, but is not an architect: can paint a portrait, but is not a painter: creates costumes, but is not a couturier. Although he is able to call upon any or all of these varied gifts at will, he is not concerned with any one of them to the exclusion of the others, nor is he interested in any one of them for its own sake. These talents are only the tools of his trade. His real calling is something quite different. He is *an artist of occasions.*

Every play—or rather, every performance of a play—is an occasion, and this occasion has its own characteristic quality, its own atmosphere, so to speak. It is the task of the stage designer to enhance and intensify this characteristic quality by every means in his power. The mastery of this special art demands not only a mastery of many diverse techniques but a temperament that is peculiarly sensitive to the atmosphere of a given occasion, just as the temperament of a musician is peculiarly sensitive to the characteristic qualities of a musical composition. Stage designers, like musicians, are born and not made. One is aware of atmospheres or one isn't, just as one has a musical ear or

具體說來，舞台設計應該是個樣樣通，卻樣樣不專精的人。這個人會晒藍圖、懂壁畫、懂款式、繪製燈圖，他們可以設計壁爐、也可以設計束腹，可以設計橋樑、也可以設計假髮。了解建築，卻不是個建築師；可以繪畫，卻不是畫家；能夠設計戲服，卻不是時裝設計師。縱使他能夠任意運用某些甚或是全部的才能，但他並不對其中任何一項付予徹底的關心，更不會對任何一樣作全面深入的了解。這些才能只是他謀生的工具，這是一個相當特殊的行業。他是一個**機遇藝術工作者**。

　　每一齣戲——更確切說來是每一齣戲的演出——都是一個機遇，這個機遇具有它獨特的性格、獨特的氛圍，舞台設計師的任務是將這獨特的個性和氛圍，以他所有的技能予以強化、激化。想要掌控這一門特殊的藝術工作，不只要能夠熟悉各種不同的技巧，更重要的是對於所給予的特定時機，能夠敏銳掌握其氛圍的特質。正如音樂家對於音樂作品特色的敏銳度一般，舞台設計和音樂家一樣，是生就的，無法製造。一個人是否能夠驚覺這種氛圍，也和他是否能分辨器樂

1　英國詩人及小說家華特・德拉瑪（Walter de la Mare, 1873–1956）的著作 *Henry Brocken: his travels & adventures in the rich, strange, scarce-imaginable regions of romance* 當中的主人翁，為一名成天窩在圖書館的少年，在夢境中與書中角色相遇。

one hasn't.

A stage setting has no independent life of its own. Its emphasis is directed toward the performance. In the absence of the actor it does not exist. Strange as it may seem, this simple and fundamental principle of stage design still seems to be widely misunderstood. How often in critics' reviews one comes upon the phrase "the settings were gorgeous!" Such a statement, of course, can mean only one thing, that no one concerned with producing the drama has thought of it as an organic whole. I quote from a review recently published in one of our leading newspapers, "Of all the sets of the season, the only true scenic surprise was…" The only true scenic surprise, indeed! Every stage designer worth his salt out-grew the idea of scenic surprises years ago. If the critics only knew how easy it is to make a scenic surprise in the theatre! Take two turntables, a great deal of—But, no. Why give away the formula? It is not surprise that is wanted from the audience; it is delighted and trusting acceptance. The surprise inherent in a stage setting is only a part of the greater surprise inherent in the event itself.

And yet a stage setting holds a curious kind of suspense. Go, for instance, into an ordinary empty drawing-room as it exists normally. There is no particular suspense about this room. It is just—empty. Now imagine the same drawing-room arranged and decorated for a particular function—a Christmas party for

之美的能力是一樣的。

　　舞台上的設計作品並不具有獨立的生命，它的特殊性在於針對單一演出。沒有了表演者，設計的存在將不具意義。聽起來也許有點奇怪，但這樣一個簡單又基本的舞台設計觀念卻廣受誤解。我們經常聽到評論家說：「舞台設計得太美了！」這樣的說法只證明了一件事，也就是沒有把整體的演出製作視為一個有機的整體。我現在引述最近刊登在知名報紙上的一篇評論「在整個演出季當中，唯一讓人驚奇的佈景是……」是的！唯一給人驚奇的佈景。一個舞台設計者早就該從給觀眾佈景上的驚奇刺激當中走出來，評論家似乎不知道其實要製造舞台驚奇有多麼容易，比方說用兩個旋轉舞台，或是一大堆……哦！不！我為什麼要告訴你們這些方法。我們要的不是來自觀眾的驚奇，而是一種可信的欣然接受，所有舞台佈景的驚奇，只是整個演出所要呈現的更大驚奇中的一環而已。

　　事實上，舞台佈景其中蘊藏著一種奇妙的懸疑性。這麼比方吧，假如你走進一間普通的客廳，這客廳中不會有任何的懸疑性，它只是一個空的房間。現在，假想一下這客廳的佈置是為了某一個特殊場合，比方說是孩子們的聖誕派對，

children, let us say. It is not completed as a room, now, until the children are in it. And if we wish to visualize for ourselves how important a part the sense of expectancy plays in such a room, let us imagine that there is a storm and that the children cannot come. A scene on the stage is filled with the same feeling of expectancy. It is like a mixture of chemical elements held in solution. The actor adds the one element that releases the hidden energy of the whole. Meanwhile, wanting the actor, the various elements which go to make up the setting remain suspended, as it were, in an indefinable tension. To create this suspense, this tension, is the essence of the problem of stage designing.

The designer must strive to achieve in his setting what I can only call a high potential. The walls, the furniture, the properties, are only the facts of a setting, only the outline. The truth is in everything but these objects, in the space they enclose, in the intense vibration they create. They are fused into a kind of embodied impulse. When the curtain rises we feel a frenzy of excitement focused like a burning-glass upon the actors. Everything on the stage becomes a part of the life of the instant. The play becomes a voice out of a whirlwind. The terrible and wonderful *dynamis* of the theatre pours over the footlights.

A strange, paradoxical calling, to work always behind and around, to bring into being a powerful non-being. How far

但除非孩子們進來以後，否則這房間還不算是一個完整的客廳。如果我們想把對這個房間的期待視覺化，那麼請再假想一下外面下著暴風雪，而這群孩子沒辦法前來，那麼這個場景和舞台就充滿著同樣的期待感。這就像幾個化學元素存在於溶液中，而演員就是那個釋放整體潛在能量的一個要素。在等待演員的同時，這些不同的元素以一種無法言喻的張力構成了令人期待的場景，創造這樣的懸疑與張力是舞台設計這個議題所探討的核心。

　　一個設計者必須用極大的努力，在他的作品中傳達我所稱之為高度的潛力。牆壁、傢俱、道具，這些只是佈景中存在的實體，只是輪廓。更重要的是在這些表象之外的一切，在於被這些東西所包覆的空間，在於它們所創造出來的強烈震撼，所有的一切融合成一股具體的衝擊。大幕升起的那一刻，我們感覺到令人悸動的激盪，像凸透鏡一樣聚焦在演員身上，舞台上所有的東西在這一瞬間都變成整體事件生命的一部分，戲劇的張力有如颶風所發出的吼叫，劇場中一切恐懼與美好的**爆發力**都順著演員腳前的燈光流洩出來。

　　永遠在看不到的周圍和背後努力，把無生命物件中強大的生命力召喚出來，這似乎是一種奇異又矛盾的定義。但是我

removed it all is from the sense of display! One is reminded of the portraits of the Spanish noblemen painted by El Greco in the Prado in Madrid, whose faces, as Arthur Symons said, are all nerves, distinguished nerves, quieted by an effort. What a phrase for stage designers to remember! *Quieted by an effort…*

It is to the credit of our designers that they have almost made a fetish of abnegation. But let me remark parenthetically that it is sometimes difficult to go into the background when there is nothing in front of you. These pages are hardly the place in which to perpetuate the centuries-old squabble between playwrights and stage designers begun by peevish old Ben Jonson, who scolded Inigo Jones so roundly for daring to make his productions beautiful and exciting to look at. This kind of petty jealousy makes sorry reading even when recorded in verse by the great Ben himself. It is enough to say that the jealousy still persists and is as corroding in the twentieth century as it was in the seventeenth. The error lies in our conception of the theatre as something set aside for talents that are purely literary. As if the experience of the theatre had only to do with words! Our

2　1541–1614，出生於希臘克里特島的西班牙畫家，作品呈現人物身形特別拉長的矯飾主義風格。
3　1865–1945，英國詩人、評論家，將法國象徵主義引入了英國。

們必須體認，要達到這一目的必須花多大的力氣來去除所謂
展示性的觀念。這讓我想起在馬德里布拉多（Prado）美術館
當中，有一幅葛列格（El Greco）[2]所畫的西班牙貴族肖像，
它的臉上，一如亞瑟・塞蒙斯（Arthur Symons）[3]所說，充滿
了膽識，不平凡的膽識，刻意地保持平靜。對一個舞台設計
者來說是一句怎樣的話啊！刻意保持平靜……

　　其實這一切多半要歸功於設計者對於自我引退的一種執
著，但是我不得不在這裡再附帶說明一下，有時當你眼前看
不到意象時，而要企圖走進它的內在是一件極其困難的事。
本文的篇幅實在不足以討論幾個世紀以來存在於編劇與舞台
設計師之間的長久爭論，這一切都開始於脾氣暴躁的班・強
生（Ben Jonson）[4]嚴厲指責英哥・瓊斯（Inigo Jones）[5]，竟然
把他的劇本設計成為優雅又充滿活力的作品，從班・強生所
留下像這樣器量狹小的猜忌性文字，在今天閱讀起來，他對
於二十世紀劇場的傷害一如十七世紀。這個錯誤完全來自於
我們對劇場藝術的體認，似乎除去文字之外一切都不存在，

4　1572–1637，英國詩人、劇作家。作品有 *Every Man in His Humour* (1601)、*Volpone or the fox* (1607)、*The Alchemist* (1612)。
5　1573–1652，英國畫家、建築師及設計師，1605 年起為班・強生及其他劇作家設計舞台服裝及佈景。

playwrights need to learn that plays are wrought, not written. There is something to be said in the theatre in terms of form and color and light that can be said in no other way.

The designer must learn to sense the atmosphere of a play with unusual clearness and exactness. He must actually live in it for a time, immerse himself in it, be baptized by it. This process in by no means so easy as it seems. We are all too apt to substitute ingenuity for clairvoyance. The temptation to invent is always present. I was once asked to be one of the judges of a competition of stage designs held by the Department of Drama of one of our well-know universities. All the designers had made sketches for the same play. The setting was the interior of a peasant hut on the west coast of Ireland. It turned out that these twenty or thirty young designers had mastered the technique of using dimmers and sliding stages and projected scenery. They had also acquired a considerable amount of information concerning the latest European developments of stagecraft. Their drawings were full of expressionism from Germany, constructivism from Russian, every kind of modernism. They were compilations of everything that had been said and done in the world of scenery in the last twenty years. But not one of the designers had sensed the atmosphere of the particular play in question.

劇作家必須了解到一齣戲是被製作（wrought）出來的，而不僅僅是被寫出來（written）而已，在劇場中很多的訊息是經由形式、色彩、光影來傳達，而這些元素都是無法取代的。

　　身為一個設計師，必須學習如何明白精確地去體悟一齣戲的氛圍，他必須置身其中、沉浸其中、沐浴其中。我們通常有一種把巧思匠心取代洞察力的傾向，想要去發明創新的誘惑無所不在。我曾經受邀擔任一所知名大學戲劇系所舉辦的舞台設計競賽評審。這齣戲的背景是愛爾蘭西部海邊的一座貧窮小屋，所有的設計者都為同一齣戲做了素描，結果是這二、三十位年輕設計者純熟的運用了移動式舞台、投影設備、調光設施，同時他們也相當程度的掌握了這些年來歐洲舞台技術的發展趨勢，他們圖面所呈現的是德國的表現主義、蘇俄的構成主義……各式各樣的現代藝術風潮，這些圖像匯集了過去二十多年來在世界劇場中，曾被討論過或是呈現過的各種樣式，但問題是卻沒有一個設計者去感受到整齣戲的氛圍。

I recalled for them my memory of the setting for the same play as produced by the Abbey Theatre on its first visit to America. This setting was very simple, far simpler and far less self-conscious than any of their designs. Neutral-tinted walls, a fireplace, a door, a window, a table, a few chairs, the red homespun skirts and bare feet of the peasant girls. A fisher's net, perhaps. Nothing more. But through the little window at the back one saw a sky of enchantment. All the poetry of Ireland shone in that little square of light, moody, haunting, full of dreams, calling us to follow on, follow on….By this one gesture of excelling simplicity the setting was enlarged into the region of great theatre art.

Now here is a strange thing, I said to the designers. If we can succeed in seeing the essential quality of a play others will see it, too. We know the truth when we see it, Emerson said, from opinion, as we know that we are awake when we are awake. For example: you have never been in Heaven, and you have never seen an angel. But if someone produces a play about angels whose scenes are laid in Heaven you will know at a glance whether his work is right or wrong. Some curious intuition will tell you. The sense of recognition is the highest experience the theatre can give. As we work we must seek not for self-expression or for performance for its own sake, but only to establish the dramatist's intention, knowing that when we have succeeded in doing so audiences will say to themselves, not,

　　我對他們說，我回想起當愛比劇團（Abbey Theatre）第一次到美國來演出這齣戲時，舞台佈景相當的簡單，遠較於他們任何一個矯揉造作的設計更為單純。淡色調的牆面、一個壁爐、一扇門、一扇窗、一張桌子、幾把椅子、紅色手工織造的裙子、幾個赤足的鄉下女孩。也許還有一張魚網，再也沒有其它多餘的東西了。但是透過舞台後方的窗子，我們看到了一片迷人的天空，所有愛爾蘭的詩意，都呈現在那小小的一方天光，它的抑鬱、它的詭魅，充滿了幻想，引領著我們跟隨前進。就這麼一個簡單卻卓越的呈現，使得這個舞台設計的力量擴展到整個劇場藝術的領域。

　　我和設計師們說，這樣看來似乎是一個比較奇怪的想法，但是如果我們能看到某一個演出的內在本質，別人也一樣能夠看到，我們知覺真實的存在，是當我們看到它的剎那。一如愛默生所認為，當我們覺醒時我們才醒覺。舉例來說，我們沒人去過天堂，也沒人看過天使，但是如果有人製作一齣場景在天堂，關於天使的戲，在幕起燈亮的一瞬間，一種莫名的直覺馬上可以讓你分辨舞台上所呈現的景象是對或錯，認同感是劇場藝術所必須提供的終極經驗。在我們的工作中要求的不是自我表現，或是提供演出服務，而是確立劇作家的終極目的，唯有承繼這樣的意圖，觀眾才會在心中說：這

This is beautiful, This is charming, This is splendid, but—This is true. This is the way it is. So it is, and not otherwise…. There is nothing esoteric in the search for truth in the theatre. On the contrary, it is a part of the honest everyday life of the theatre.

They energy of a particular play, its emotional content, its aura, so to speak, has its own definite physical dimensions. It extends just so far in space and no farther. The walls of the setting must be placed at precisely this point. If the setting is larger than it should be, the audience gets a feeling of meagerness and hollowness; if smaller, a feeling of confusion and pressure. It is often very difficult to adjust the physical limits of a setting to its emotional limitations. But great plays exist outside the categories of dimension. Their bounty is as boundless as the air. Accordingly we need not think of a stage-setting, in a larger sense, as a matter of establishing space relations. Great plays have nothing to do with space. The setting for a great play is no more subject to the laws of space composition than music is. We may put aside once and for all the idea of a stage-setting as a glorified show-window in which actors are to be exhibited and think of it instead as a kind of symphonic accompaniment or obbligato to the play, as evocative and intangible as music itself. Indeed, music may play a more important role than we now realize in the scenic evocations of the future.

是真實的，它就該這樣，也唯有這樣不可能是其它的樣貌。
而不是說：好美的佈景、迷人的陳設、豪華的視覺，在劇場
中追尋真理真實並不是什麼不傳之密，相反的，這是劇場中
真誠平凡的日常生活。

　這麼來說吧，某一齣戲的能量、它的情感真意、它的氣
息，都有其本質上的確實份量，它在空間中所延展的界限有
其明確性。舞台佈景中的一堵牆必須被安置在某一特定尺
寸，如果這佈景超過了它所應有的大小，觀眾會覺得舞台空
洞和貧乏。相反的，如果過小，觀眾則會感到困惑與壓力。
評斷及調整一個舞台設計的自然限制以及如何與演出情緒範
疇的契合，是一件相當不容易的事。但是偉大的戲劇往往超
越了度量的限制，它的氣度像空氣一樣的廣大無邊，於是從
一個更寬廣的角度來說，這時候我們腦子裡先不需要思考舞
台佈景，偉大的戲劇和音樂一樣，並不臣屬於空間構築的定
律，在這個時候我們必須揚棄舞台佈景是展示演員的華麗櫥
窗，而必須把自己的工作想像成是交響樂曲中不可或缺的伴
奏，這樣的戲劇也正如音樂般的不可捉摸又發人深思，事實
上音樂在未來將會比舞台佈景更能夠引發觀眾情緒。

In the last analysis the designing of stage scenery is not the problem of an architect or a painter or a sculptor or even a musician, but of a poet. By a poet I do not mean, of course, an artist who is concerned only with the writing of verse. I am speaking of the poetic attitude. The recognized poet, Stedman says, is one who gives voice is expressive language to the common thought and feeling which lie deeper than ordinary speech. I will give you a very simple illustration. Here is a fragment of ordinary speech, a paraphrase of part of Hamlet's soliloquy. *To be or not to be*: I wish I were dead! I wish I could go to sleep and never wake up! But I'm afraid of what might happen afterward. Do people dream after they are dead? …But Hamlet does not express himself in this way. He says, *to die, to sleep; to sleep: perchance to dream: ay, there's the rub; for in that sleep of death what dreams may come…*Here are two ways of saying the same thing. The first is prose. The second is poetry. Both of them are true. But Shakespeare's way—the poetic way—is somehow deeper and higher and truer and more universal. In this sense we may fairly speak of the art of stage designing as poetic, in that it seeks to give expression to the essential quality of a play rather than to its outward characteristics.

6 1833–1908，美國十九世紀晚期的知名詩人、評論家和編輯，亦是一名活躍於華爾街的掮客。

　　從以上的分析來說，一個舞台設計所需要解決的問題並不同於建築師、畫家、雕塑家甚或是音樂家，而是一個詩人所要面對的。當然，在這裡我所指的詩人並非單指從事韻律文字創作的藝術工作者，而是一種詩意的態度。著名的詩人史戴德門（Stedman）[6] 曾指出，詩文是將聲音用具表現性的語句呈現給一般人，但它所能引發的情感反應卻遠超過一般的語言。在這裡舉一個很簡單的例子，下面是一段很平常的語句，*To be or not to be* 哈姆雷特獨白的一部分釋義：我希望我能死去！我希望能一睡不醒！但我害怕接下來會發生的事！人死後還會作夢嗎？……但是哈姆雷特卻是這樣說的：死了，睡著了！睡眠中尚或有夢！唉！難啊！在死之眠中，會有何等的夢……這是兩種不同的方式表達同一種意思，前者是散文，後者是詩，兩者都如此的真實，但莎士比亞所使用的方式──詩意的表現方式，感覺上似乎更深沉、更高尚、更真實、也更具普世價值。從這個角度來看我們可以明白的說，舞台設計的工作是詩意的追求，在我們的工作中，我們企求表達屬於演出所不可或缺的本質，而不僅只是其外在的特徵。

Some time ago one of the younger stage designers was working with me on the scenes for an historical play. In the course of the production we had to design a tapestry, which was to be decorated with figures of heraldic lions. I sent him to the library to hunt up old documents. He came back presently with many sketches, copies of originals. They were all interesting enough, but somehow they were not right. They lacked something that professionals call "good theatre." They were not *theatrical.* They were accurate and—lifeless. I said as much to the designer. "Well, what shall we do about it?" he asked me. "We have got to stop copying," I said. "We must try something else. We must put our imaginations to work. Let us think now. Not about what this heraldic lion ought to look like, but what the design meant in the past, in the Middle Ages.

"Perhaps Richard, the Lion-Heart, carried this very device emblazoned on his banner as he marched across Europe on his way to the Holy Land. Richard, the Lion-Heart, *Coeur de Lion*... What memories of childhood this name conjures up, what images of chivalry! Knights in armor, enchanted castles, magic casements, perilous seas, oriflammes, and gonfalons. Hear the great battle-cries! See the banners floating through the smoke! *Coeur de Lion*, the Crusader, with his singing page Blondel...Do

前不久一位年輕的舞台設計師和我一起為一齣歷史劇工作，製作中我們需要設計一幅飾有獅子紋章的掛氈。我派他去圖書館裏尋找歷史文獻，他很開心的帶回來大堆的速寫和原稿影本，每一件都相當有意思，但似乎都不太對勁。它們缺乏了專業人所謂的「好的劇場」（good theatre），它們都沒有**劇場性**。這些東西都很正確——但缺乏生命，我這麼對這位設計師說。「那我們該怎麼辦？」他問。「我們必須停止仿製！」我說，「我們得試試別的方法，我們必須把我們的想像力放到工作中，不要去想這個獅子紋章該長成什麼樣子，而要去想這獅子圖樣的設計在中世紀時的意義。」

「也許理查—獅心王帶著繡有這樣紋章的旗幟穿越歐洲前往聖地；**獅心王理查**……這個名字像魔咒一樣讓你追想起孩提時代騎士的想像、穿著盔甲的武士、令人心醉的城堡、魔力的窗櫺、危機四伏的大海、耀眼的旗幟、飛舞的旌旗、聆聽戰爭的狂嘯，看看飄揚在煙霧中的旗幟。帶領十字軍東征的獅心王和他的吟唱侍從布朗多（Blondel）……你還記得布

you remember Blondel's song, the song he sang for three long years while he sought his master in prison? *'O Richard, O mon Roi! L'Univers t'abandonne!…'*

"And now your imagination is free to wander, if you will allow it to do so, among the great names of romance. Richard, the Lion-Heart, King Arthur, Sir Percival and the mystery of the Holy Grail, the Song of Roland, the magic sword, Durandal, Tristan and Isolde, the love-potion, the chant of the Cornish sailors, the ship with the black sail; the Lady Nicolette of whom Aucassin said, *Beau venir et bel aller*, lovely when you come, lovely when you go; the demoiselle Aude, who died for love; the Lady Christabel; the Ancient Mariner with the Albatross hung about his neck; the Cid, Charlemagne, Barbarossa, the Tartar, Kubla Khan, who decreed the pleasure-dome in Xanadu, in the

7 《圓桌武士》（*Knights Of The Round Table*）中一名角色，故事描寫找尋聖杯的種種冒險旅程。傳說中的聖杯，中世紀最著名的傳奇故事，一般而言，聖杯被指涉為最後晚餐中使用的酒杯，以及盛了耶穌基督在臨終所流下之鮮血的容器。

8 都蘭朵，羅蘭的寶劍。羅蘭為法國史詩《羅蘭之歌》（*La Chanson de Roland*）中歌頌的英雄，查理曼大帝手下十二勇士中的最勇猛者，西元778年遠征西班牙時，在Roncesvalles 山口戰役中戰亡。

9 一部關於中古世紀凱爾特民族（Celtic）的浪漫傳奇，崔斯坦亦為圓桌武士中的騎士英雄，主要敘述他和愛爾蘭公主伊索德之間的愛情故事，兩人誤飲愛情魔藥而使感情更具戲劇性。

10 崔斯坦載著伊索德回康瓦爾（位於英國南部），將獻給崔斯坦的叔父馬可王為妻，航程上康瓦爾水手們吟唱出伊索德的憂心絕望。故事最後兩人相約見面，約定若伊索德願意前來就在船上掛白帆，若已不愛崔斯坦則掛上黑帆，但崔斯坦的妻子嫉妒他倆的愛情，欺騙崔斯坦前來的船是掛著黑帆，崔斯坦因而傷痛而亡。

11 出自於十三世紀初的法國傳說 Aucassion et Nicolette，伯爵之子歐卡森愛上年輕女奴僕尼可萊特而被禁止，兩人歷經一連串考驗最後發現尼可萊特原來是一位公主。

12 法國史詩《羅蘭之歌》中羅蘭的未婚妻，查理曼大帝告訴她羅蘭之死，她因而哀痛欲絕，心碎而亡。

朗多唱的歌嗎？那首為了尋找被監禁的主人而唱了整整三年的歌：噢！理查！噢！我的王！這世界遺棄了你……」

「現在如果你願意，請奔放你的想像，回想一下傳奇故事中那些偉大的名字，獅心王理查一世、亞瑟王、波賽佛爵士（Sir Percival）和傳說中的聖杯[7]、《羅蘭之歌》（Song of Roland）中騎士羅蘭和他的魔法之劍——都蘭朵（Durandal）[8]、崔斯坦（Tristan）和伊索德（Isolde）以及愛情魔藥[9]、康瓦爾（Cornish）水手們的吟唱及張著黑帆的船隻[10]、歐卡森（Aucassin）對著少女尼可萊特（Lady Nicolette）[11]說：妳來也優美，妳去也可愛、為愛而死的少女奧德（Aude）[12]、克莉斯塔貝兒夫人（Lady Christabel）[13]、被懲罰而脖子掛上信天翁屍體的老水手[14]、席德（Cid）[15]、查理曼大帝（Charlemagne）[16]、赤鬚王巴爾巴羅薩（Barbarossa）[17]，韃靼人（Tartar）、忽必烈汗（Kubla Khan）頒佈命名仙那

13 出自英國詩人柯爾律治（Samuel Tayler Coleridge）未完成的詩作 Christabel，描述女主角克莉斯塔貝兒在森林遇見陌生人之後的奇特際遇，極富神祕與暗示性，影響 Edgar Allan Poe的創作，且甚至影響之後吸血鬼小說的發展。

14 出自於《古舟子詠》（The Rim Of The Ancine Mariner），柯爾律治的作品，描寫一名水手一段長遠的冒險旅程，因射殺幸福象徵的信天翁，其他水手為懲罰他而將死去的信天翁掛在他的脖子上。

15 約1040–1099，原名Rodrigo (or Ruy) Díaz de Vivar，中世紀英勇騎士及西班牙民族英雄，力抗摩爾人及回教徒的入侵，但也曾因被放逐而對抗基督教，史詩《席德之歌》敘述了他許多傳奇故事。

16 742–814，Charles the Great or Charles I，法蘭克王國的國王（768–814），並由教宗加冕，封為聖羅馬皇帝（800–814）。

17 神聖羅馬帝國皇帝 Frederick 一世的綽號。

poem Coleridge heard in a dream…And there are the legendary cities, too, Carcassonne, Granada, Torcello; Samarkand, the Blue City, with its façades of turquoise and lapis lazuli; Carthage, Isfahan, Trebizond; and there are the places which have never existed outside a poet's imagination—Hy Brasil, Brocéliande, the Land of Luthany, the region Elenore, the Isle of Avalon, *where falls not hail, or rain, or any snow, where ever King Arthur lyeth sleeping as in peace*…And there is the winged Lion of St. Mark in Venice with the device set forth fairly beneath it, *Pax Tibi, Marce, Evangelista Meus*; and there are the mounted knights in the windows of Chartres, riding on, riding on toward Our Lady as she bends above the high altar in her glory of rose.

18 出自 *Kubla Khan, A Vision In A Dream: A Fragment*，英國浪漫時期作家柯爾律治作品，描述作者在恍神狀態閱讀關於忽必烈汗的冒險，悠然間進入一段夢中旅程，靈光乍現寫下數百行詩句，卻又在清醒之時完全遺忘。

19 1772–1834，英國詩人和批評家。主要作品有《古舟子詠》（收錄和 Wordsworth 合著的 *Lyrical Ballads*，1798）、《忽必烈汗》（*Kubla Khan*, 1816）、*Christabel* (1816)、*Biographia Literaria* (1817)。

20 法國西南部一城市，殘存有中世紀的城墻。

21 有二種說法，一為1238至1492年摩爾人建立的回教王國，位於西班牙南部 Andalusia 地區；另一說為中世紀格拉那達王國的首都，或該省首府，回教徒的聚居地。

22 羅馬帝國時期建造，位在威尼斯一處潟湖區。

23 烏茲別克一城市，為中亞最古老的城市之一，古稱 Maracanda，十四世紀末至十五世紀為帖木兒（Timur）帝國的首都。

24 即印度西部的古城 Jodhpur，圍著其中 Mehrangarh 古堡周圍的房屋牆外都塗成靛藍色而有青色之城之稱。

25 古代最著名的城市國家之一，由腓尼基人創建，在非洲北岸，現在的突尼西亞東北部，布匿戰爭（264–146 B.C.）中被羅馬滅亡，成為阿非利加省的省會。

26 伊朗中部第二大城市，波斯舊都。

27 黑海東南岸屬於拜占庭帝國的一希臘人帝國（1204–1461）。

度（Xanadu）為歡樂宮（pleasure-dome）[18]，那是柯爾律治（Coleridge）[19]在夢中聽到的詩篇……還有那些傳說中的城市喀卡孫（Carcassonne）[20]、格拉那達（Granada）[21]、托切羅（Torcello）[22]、撒馬爾罕（Samarkand）[23]、有著土耳其石和天青色琉璃外牆的青色之城（Blue city）[24]、迦太基（Carthage）[25]、伊斯法罕（Isfahan）[26]、特立勃森（Trebizond）[27]、還有一些只存在於詩人幻想中的地方——迷霧之島（Hy Brasil）[28]、布羅塞利安德森林（Brocéliande）[29]、路德尼淨土及艾琳諾聖地（he Land of Luthany, the region Elenore）[30]、**當亞瑟王平靜沉睡時，天上不會降下冰雹、雨珠或任何雪花打擾他**……的阿瓦隆之島（the Isle of Avalon）[31]，還有那威尼斯聖馬克（St. Marks）能展翅飛翔的翼獅，腳下踏著聖經詩篇：賜你平安，馬可，我的福音傳播者，以及在夏特勒（Chartres）[32]彩繪玻璃上騎著駿馬的騎士，奔向在聖壇上被榮光的玫瑰所環繞的聖母馬麗亞。」

28 愛爾蘭神話中一座抵達不了的島嶼，總是受雲霧籠罩，傳說每七年才有一天清朗，但仍可能無法輕易抵達。
29 法國西北邊不列塔尼區的一座森林，是許多中世紀與文藝復興時期作品的故事場域，裡頭有一座古老的魔法泉水。
30 英國詩人Francis Thompson的詩作多有宗教義涵，這兩個地方是求道朝聖者尋覓想到訪之處。Luthany有Lutheran之隱含，Elenore-Eleanore意味光明燦爛、皆神聖的光明淨土之意。
31 即西方樂土島，塞爾特傳說，據說亞瑟王及其部下死後屍體移去該島。
32 法國西北部城市，以擁有十三世紀所建的哥德式大教堂聞名。

"These images of romance have come to our minds—all of them—out of this one little symbol of the heraldic lion. They are dear to us. They can never fade from our hearts.

"Let your fancy dwell and move among them in a kind of revery. Now, in this mood, with these images bright in your mind, draw your figure of the lion once more.

"This new drawing is different. Instead of imitating, describing what the artists of the Middle Ages thought a lion looked like, it summons up an image of medieval romance. Perhaps without knowing it I have stumbled on a definition of art in the theatre; all art in the theatre should be, not descriptive, but evocative. Not a description, but an evocation. A bad actor describes a character; he explains it. He expounds it. A good actor evokes a character. He summons it up. He reveals it to us…This drawing is evocative. Something about it brings back memories of medieval love-songs and crusaders and high adventures. People will look at it without knowing why. In this drawing of a lion— only a detail in a magnificent, elaborate setting—there will be a quality which will attract them and disturb them and haunt them and make them dream. Your feeling is in it. Your interest is in it.

「這一切傳奇浪漫的印象都從這小小的一方獅子紋章上，如此鮮活的從我們腦海裡召喚出來，如此親切；這些記憶不可能從我們腦海中消失。」

「現在讓你天馬行空的幻想逗留，讓如此豐富的意像充滿在你腦海中，用一種幻想曲式的思考來流動，然後在這樣一種基調下重新畫一張獅子的圖樣。」

「這張新的圖樣是全然不同的，不再去描繪中世紀藝術家心中所以為的獅子形象，它反而召喚起一種中世紀浪漫情懷的意像。也許我對劇場藝術的解釋有人無法認同，我認為所有劇場中的藝術不應該是一種描述性的，而是一種召喚性的，它絕不描述，而是喚醒。一個糟糕的演員會敘述一個角色，解釋他、描述他，但是一個好的演員能夠召喚出一個角色，他把角色展現在我們面前……這圖樣也是一種召喚，在它裡面有一種力量，把我們帶回到中世紀的情歌、十字軍戰士以及種種奇幻冒險的記憶，這樣一個獅子紋章在宏偉精巧的佈景當中只是一個細節，但是當觀眾看著它的時候，有一種莫名的氣質吸引著他們的眼光、攪動著他們的心緒、留連在他們腦海，你帶領著他們和你一起夢想，這夢裡有你的情

You have triumphed over the mechanics of the theatre and for the time being you have become a poet."

The poetic conception of stage design bears little relation to the accepted convention of realistic scenery in the theatre. As a matter of fact it is quite the opposite. Truth in the theatre, as the masters of the theatre have always known, stands above and beyond mere accuracy to fact. In the theatre the actual thing is never the exciting thing. Unless life is turned into art on the stage it stops being alive and goes dead.

So much for the realistic theatre. *The artist should omit the details, the prose of nature and give us only the spirit and splendor.* When we put a star in a sky, for example, it is not just a star in a sky, but a "supernal messenger, excellently bright." This is purely a question of our point of view. A star is, after all, only an electric light. The point is, how the audience will see it, what images it will call to mind. We read of Madame Pitoeff's Ophelia that in the Mad Scene she handled the roses and the rosemary and the rue as if she were in a Paradise of flowers. We must bring into the immediate life of the theatre—"the two hours' traffic of our stage"—images of a larger life. The stage we inhabit is a chamber of the House of Dreams. Our work on this

感、你的投入！在這一刻你的工作超越了劇場的工匠，在這一刻你變成了一個詩人！」

這樣一個詩意的概念和現在已成既定傳統的寫實佈景沒什麼關聯，事實上這兩件事可以說背道而馳。像許多劇場界的大師所公認的，劇場中的真實是凌駕並超越虛弱的表像肖真，在劇場裡真實的事物從來無法令人動容，除非生命變成一種不再延續而走向死亡的舞台藝術。

寫實戲劇是該停下腳步了！**藝術家們應該省略掉繁瑣的細節、乏味的擬真，我們要看到的是心靈與光彩！**例如，當我們在天上安排一顆星星的時候，我們不只是放上一顆星星而已，它應該是「上天的信使，獨特的光芒」！雖然舞台上的星星也不過就是幾個燈泡作成的。但這完全關乎於我們的觀點是什麼？重要的是觀眾會如何看待它？它又能引發觀眾腦海裡的哪些意像？當我們看到皮托耶芙夫人的奧菲莉雅在她發瘋的場景中，奧菲莉雅手捧著玫瑰、迷迭香和芸香時，自以為身處於花的天堂裡的時候，我們馬上會直覺地想到劇場中的現實──「舞台上兩小時的混亂」！但是從一個更廣闊的生命角度思考，我們所承繼的這個舞台，是一個夢想之屋

stage is to suggest the immanence of a visionary world all about us. In this world Hamlet dwells, and Oedipus, and great Juno, known by her immortal gait, and the three witches on the blasted heath. We must learn by a deliberate effort of the will to walk in these enchanted regions. We must imagine ourselves into their vastness.

Here is the secret of the flame that burns in the work of the great artists of the theatre. They seem so much more aware than we are, and so much more awake, and so much more alive that they make us feel that what we call living is not living at all, but a kind of sleep. Their knowledge, their wealth of emotion, their wonder, their elation, their swift clear seeing surrounds every occasion with a crowd of values that enriches it beyond anything which we, in our happy satisfaction, had ever imagined. In their hands it becomes not only a thing of beauty but a thing of power. And we see it all—beauty and power alike—as a part of the life of the theatre.

中的廂房，舞台上的工作是傳達我們所有人無所不在的奇想世界，在這個世界裡住著哈姆雷特、伊底帕斯、還有踩著不朽步態的女神朱諾（Juno）[33]、更有那在受詛咒的石楠樹上的三女巫。我們必須要學會用極大的意志，以極其謹慎的努力，才能走在這令人著迷的領域中。也惟有用想像力才能讓我們進入它的浩瀚中。

這裡有一個偉大的劇場藝術工作者的作品之所以發光發熱的秘訣。以我們這樣一群庸庸碌碌、易於自滿的人來說，似乎很難想像這些人似乎永遠比我們警覺、永遠比我們清醒、永遠比我們有生命力，以致於使我們所謂的生活完全不構成意義，反而倒像是一種沉睡。他們的智識、他們豐沛的情感、他們的魔力、他們的意氣風發、他們有能力迅捷地看穿在一堆被外在價值所包裝的事物當中的本質。他們手中所創造的事物不僅只是美而已，更是一種力量。就是這樣——美與力量——也正是劇場生命的一部分。

———

33 羅馬神話中Jupiter之妻；相當於希臘神話中的Hera。

現代人^的延伸^{思考}

說是給設計新鮮人的話，可是在過去十多年的閱讀中卻一直有如醍醐灌頂般的澆醒著我，提示著「舞台上的設計作品並不具有獨立的生命。」劇場作品抽離了演出者、抽離了觀眾，它也不過就是一堆材料的組合而已。而我們所要呈現的驚奇「只是整個演出所要呈現的更大驚奇中的一環而已」。不記得哪位建築師曾經說過類似的話：「建築所要處理的空間，並不是被我們處理過的牆面樑柱和地板，而是被我們留下來沒有處理的空間。」的確，抽離了佈景的表象，戲劇依然存在，而我們工作的目的又是何在？除了具有提示場域空間的功能外還有什麼？「永遠在看不到的周圍和背後努力，把無生命物件中強大的生命力召喚出來。」這是一句多麼令人動容的話！點出了做為一個設計者在設計生涯中所追求的最高理想和目標──一切在有形世界中的努力，是為了那無形力量的凝聚和迸發。

從「身為一個設計師，必須學習如何明白精確地去體悟一齣戲的氛圍」─直到「……事實上，音樂在未來將會比舞台佈景更能夠引發觀眾情緒」之間，這五大段文字一再的提示著我們，身為一個設計者怎樣回歸到文本，如何被感染、如何被文字驅動、如何知所舉措。無怪乎這存留近七十年的文字，成為二十世紀以來許多設計者奉為圭臬的金科玉律。而接下來所提到詩意的部份，更令設計者的思考層面有了高度提升，如何以我們的專長在空間中寫下詩境、描繪浪漫，讓人──尤其是年輕朋友們──對這個行業充滿了鼓舞和憧憬，知道我們所做的工作其實應該超脫於鐵鎚與釘子的敲敲打打之外。

因此對作者來說，外在的真實並不足以代表戲劇本質的所有，如何以「心靈之眼」來洞察文字背後的真實才是他思考設計的前提，如何把心中的真實呈現在觀眾面前才是他所關切的重心。誠如他所說，他的觀念不一定被所有人贊同，而我們身為設計是否曾經思考過要呈現怎樣的真實（或不真實）在觀眾眼前？

我想對很多的設計者而言（甚至包括我自己），經常在面對演出（劇本）時，第一個念頭都會是直接開始問有多少場景？年代是什麼？多少大小道具？多少進出口？平台？景片？布幕？解決問題經常變成我們設計工作的重心，已經很難像讀完一本小說後，闔上書頁靜靜回味書中情節和所有情緒的起伏。到底這是不是停留在「見山是山、見水是水」的困境其實很難回答，但是要跳躍到「見山又是山、見水又是水」的純美境域，確實需要不斷的充實和反思。

我常在課堂中詢問同學：「為什麼這個沙發是紅色的？那個窗簾是藍色的？」很多時候設計者必須相信自己的直覺，但是很多時候設計者忘記分析自己的直覺，是哪一句話打動我讓這沙發成為紅色的？是哪個情結渲染我讓窗簾是這樣的藍？直覺是個兩面刃，它同時可靠也不可靠，可靠是因為你有堅強厚實的學養讓這樣的直覺噴薄而出，不可靠是因為你僅以單點的判斷企圖去涵括全面的真實。因此獅子紋章的一大段正是引領我們從外在的描繪，到思想、文化、涵養的豐厚之後，所推演出的直覺，從引經據典當中跳出、從博物館畫冊超脫，展現出一個從不存在的浪漫真實。

V
Some Thoughts on Stage Costume
關於劇場服裝的思維

Let us have a glimpse of incomprehensibles:

and thoughts of things,

which thought but tenderly touch.

— Sir Thomas Browne

V
關於劇場服裝的思維
Some Thoughts on Stage Costume

讓我們一瞥無法理解的事物：

以一種敏感，

來思考他們。

──湯瑪士・布朗爵士[1]

In learning how a costume for the stage is designed and made, we have to go through a certain amount of routine training. We must learn about patterns, and about periods. We have to know what farthingales are, and wimples, and patches and calèches and parures and godets and appliqués and passementerie. We have to know the instant we see and touch a fabric what it will look like on the stage both in movement and in repose. We have to develop the brains that are in our fingers. We have to enhance our feeling for style in the theatre. We have to experiment endlessly until our work is as nearly perfect as we can make it, until we are, so to speak, released from it. All this is a part of our apprenticeship. But there comes to every one of us a time when the problem of creating presents itself.

If we are to accomplish anything in any art we must first see what our problem is before we can proceed to solve it. What we do in the theatre depends upon what we see. If we are to design for the theatre we must have the clearest possible image in our minds of the nature and the purpose and function of

1 1605–1862，英國醫師、作家、百科全書編纂學者，重要作品為 *Religio Medici* (1642)、*Browne's Vulgar Errors* (1646)，其著作極力融合科學與宗教。"Ready to be anything in the ecstasy of being ever." 為他的格言之一。
2 十六、十七世紀女性穿著，現代新娘禮服依然沿用類似做法。
3 中世紀女性之包頭巾，現為修女所用。
4 十七世紀貼在臉上的裝飾，類似唐代之花鈿，亦稱 beauty spot。

如果要了解舞台上的服裝是如何設計和製作，必須要經過一定的訓練程序。我們得了解一些和打版相關的事和不同年代服飾的特色，要懂得什麼是裙撐（farthingale）[2]？什麼是包頭巾（wimple）[3]？什麼是貼片（patch）[4]？或是連頸帽（calèche）[5]？整套的珠寶首飾（parure）[6]？和檔布（godet）[7]？還有貼布繡（appliqués）[8]？更或者是金銀花飾（passementerie）[9]？我們必須在接觸布料的一瞬間，同時能夠感受到它在舞台上動靜之間所能產生的姿態，也就是說有時候我們需要能用手指思考。我們要能夠因為劇場的距離，而將心目中的形式放大。我們必須經過不斷的嘗試，以期望達到心目中的完美，或者我們可以功成身退的那一刻。這一切都是我們工作歷程的部分，但是我們每個人都難免會面臨到一個創造本質的問題。

　　如果我們想要在任何藝術領域中成就一些事業，那麼在我們開始解決難題之前要先學會正視它。我們在劇場中所做的，端賴於我們眼中所見的。如果我們打算在劇場中從事設計工作，最好在心中能夠對於劇場的本質、目的和功能有清

5 十八世紀女用可向後摺疊的連頸帽，形似馬車篷。
6 法文，指一組互相搭配的珠寶飾品。
7 加貼於活動量大部位的布料，以增加活動空間。
8 貼布繡，先繪製圖樣再以類似拼布方式繡成。
9 以金銀繩所編之花飾。

the theatre.

Now this theatre we are working in is a very strange place. It deals, not with logic, but with magic. It deals with witchcraft and demoniac possession and forebodings and ecstasies and mystical splendors and legends and playthings and parades and suspicions and mysteries and rages and jealousies and unleashed passions and thrilling intimations and austerity and elevation and luxury and ruin and woe and exaltation and secrets "too divinely precious not to be forbidden,"—the shudder, the frisson, the shaft of chill moonlight, the footfall on the stair, the knife in the heart, the face at the window, the boy's hand on the hill…The air of the theatre is filled with extravagant and wheeling emotions, with what H.L. Mencken calls "the grand crash and glitter of things."

In the theatre, the supernormal is the only norm and anything less is subnormal, devitalized. If we try to bring the theatre down to our own level, it simply ceases to be. When we see *Oedipus Rex* in the theatre, when we hear *Pelléas and Mélisande*, when we examine a stage design by Adolphe Appia, we realize that great

10 1880–1956，美國著述家、編輯，*The Smart Set* 以及 *American Mercury* 的編者，著有 *The American Language* (1919)，*Happy Days* (1940)。

楚完整的認知。

　　要知道我們所工作的劇場是一個相當奇異的場域，它牽涉
的不是邏輯而是魔力。它訴說的是巫術、著魔般的附身和不
詳的預言；激昂的情緒、神祕的光彩；傳奇與被玩弄的人；
偽裝、猜疑和祕密；憤怒、忌妒；不羈的狂情、恐怖的暗
示；禁慾與崇高、奢華和頹敝；狂悲、狂喜；神聖卻無法禁
絕的珍貴祕密──瑟縮、顫慄、一道冰冷的月光、樓梯上的
腳步、插在心口的匕首、窗戶上的臉孔、土塚上男孩的手掌
……劇場的空氣中流轉揮霍著極度的情感，如同門肯（H. L.
Mencke）[10]稱之為「宏大的撞擊與充滿光輝」般。

　　在劇場中一切超越常理的才是唯一的常規，任何低於這
個準則的都會被視為低能、沒有生機的，如果我們試圖把
劇場拉低到一般的水平，那麼劇場將不復存在。當我們在
劇場裡看到伊底帕斯王或聽到佩里亞斯與梅莉桑德（Pelléas
and Mélisande）[11]；更或者是欣賞到阿道夫·阿琵亞（Adolph

11 德布西作曲作品《佩里亞斯與梅莉桑德》（*Pelléas et Mélisande*）中的角色，劇本原
　著為比利時劇作家 Maurice Maeterlinck。故事大綱為佩里亞斯的兄長 Golaude 與梅
　莉桑德相遇結婚，梅莉桑德卻與佩里亞斯相愛，Golaude 憤而殺了佩里亞斯。

artists like Sophocles and Debussy and Appia create as they do, not only because they are more skilled, more experienced than the rest of us, but because they think and feel differently from the way the rest of us do. Their orientation is different from our own. When we listen to what artists tell us in their work—when we look at what they look at and try to see what they see—then, and only then, do we learn from them.

There is no formula for inspiration. But to ask ourselves, why did that artist do that thing in that particular way instead of in some other way? is to take the first step toward true creation.

Nature has endowed us all with a special faculty called imagination, by means of which we can form mental images of things not present to our senses. Trevisa, a seer of the late fourteenth century, defined it as the faculty whereby "the soul beholds the likeness of things that be absent." It is the most precious, the most powerful, and the most unused of all human faculties. Like the mantle of rainbow feathers in the Japanese No drama, *Hagoromo*, it is a treasure not lightly given to mortals. Many people confuse imagination with ingenuity, with

12 1862–1928，瑞士日內瓦出生的劇場空間設計先驅，以為華格納的歌劇從事設計聞名。

Appia）[12]的舞台設計作品時，我們體認到像是索福克理斯、德布西或阿琵亞這些藝術家，並不僅只是比我們有更多的技巧和經驗而已，而是他們對事物的感知能力超越了一般人，他們的定位完全不同於你我。當你聆聽藝術家在他們作品中的話語時——當我們凝視他們所關注的對象時，嘗試以他們的眼睛洞察時——也唯有這樣，我們才能從他們身上學習。

靈感是無跡可循的。但我們必須自問，為什麼藝術家用這樣的形式創作？而不以其他的方式呈現作品？這才是進入真正創作的第一步。

大自然賦予人類一種特殊的才能，那就是想像力，也就是能將不在實際感知範圍內的事物，在腦海中予以形象化。十四世紀末的預言家崔微紗（Trevisa）將之定義為：「靈魂能看見不存在眼前事物的模樣！」這是人類所具有最珍貴、最有力，卻也是最被罕用的才能之一。就有如日本能劇《羽衣》（_Hagoromo_）[13]中，那一件以彩虹之羽所製成的斗篷，不輕易地賦予俗世人類。但是很多人把想像力跟匠心獨具或創造力混

13 日本傳統能劇中廣受歡迎的演出之一，故事描述漁夫偷走神女的神奇羽衣，使她無法返回天庭，而需答應漁夫要求跳天舞，於是神女翩翩起舞最終高飛消失。

inventiveness. But imagination is not this thing at all. It is the peculiar power of seeing with the eye of the mind. And it is the very essence of the theatre.

Many of you are familiar with the region of the Ardennes, in Belgium. Now this countryside, charming and poignant though it is, may seem no more beautiful than many parts of our own country, nearer and dearer to us. But Shakespeare once went there. And in his drama, *As You Like It*, the familiar scene is no longer the Ardennes we know, but the Forest of Arden, where on every enchanted tree hang the tongues that show the beauties of Orlando's Rosalind.

Atalanta's better part, sad Lucretia's modesty.

Shakespeare's imagination joins with our own to summon up an ideal land, an image of our lost paradise. Or let us take another example: King Lear had, I dare say, a life of his own outside the limits of Shakespeare's play, a daily life of routine very much like our own. He got up in the morning and put on his boots and ate his breakfast and signed dull documents and yawned and grumbled and was bored like everyone else in the world. But the drama does not give us those moments. It gives us Lear at his highest pitch of living. It shows him in intensest

為一談，事實上想像力和這些事完全無關，它是一種能以心靈之眼觀察的特殊力量，這力量也正是劇場的唯一真髓。

或許很多人都知道比利時的亞登尼地區（Ardennes），這鄉間景色一如往昔美得令人心痛，看起來和我們自己親切宜人的鄉間景致似乎並無差異。但是當莎士比亞去過一次之後，在他筆下這片大家熟悉的風景就幻化成為《皆大歡喜》（*As You Like It*）一劇當中的「亞登之林」（Forest of Arden），在這裡每一株魔幻之樹都開口頌讚奧蘭多（Orlando）的愛人羅瑟琳（Rosalind）之美：

　　如阿塔蘭特美女的柳腰款擺，有魯克提亞貞女的節操。

莎士比亞的想像和我們的想像結合，勾勒出一幅理想之地，一個我們曾失去的天堂。更或者讓我舉他的另一齣戲《李爾王》來說，我相信李爾王一定有莎士比亞劇作情節侷限之外的一面，一個和我們大多數人相似的日常生活。早晨起床、套上長靴、吃早餐、簽發無趣沉悶的公文、打呵欠、發牢騷、和世上其他人一樣的感到無聊，但是在戲劇中他並不把這樣的時刻呈現在我們眼前。莎士比亞讓我們看到生命最高峰的李爾王；讓我們看到他最飽滿的動作，一個瘋狂的

action, a wild old man storming at heaven, bearing his daughter Cordelia, dead in his arms.

In these examples we may divine Shakespeare's own intention toward the theatre. His attitude—the true dramatic attitude, the mood, indeed, in which all great art is created—is one of intense awareness, of infectious excitement. If we are to create in theatre, we must first learn to put on this creative intention like the mantle of rainbow feathers. We must learn to feel the drive and beat of the dramatic imagination in its home. We must take the little gift we have into the hall of the gods.

A stage costume is a creation of the theatre. Its quality is purely theatrical and taken outside the theatre, it loses its magic at once. It dies as a plant dies when uprooted. Why this should be so I do not know. But here is one more proof of the eternal enchantment which every worker in the theatre knows and feels. The actual materials of which a stage costume is made count for very little. Outwardly it may be nothing more than an arrangement of shabby velvets and cheap glass "glits." I remember Graham-Robertson's description of a costume worn

老人，在天堂裡製造風暴的老人，驅逐自己的女兒考蒂莉亞（Cordelia）的老人，卻又讓孝順的女兒死在他懷裡的老人。

　　這兩個例子我們可以窺見莎士比亞對於劇場意圖——一種真正的劇場心態與情愫，事實上這也是所有偉大藝術誕生的源頭——一種強烈的醒覺，一種有渲染力的悸動，如果我們想要在劇場中創作時，我們的創作意圖就要像披上那彩虹之羽所製成的斗篷一般，我們必須學習去感受這樣具有戲劇性的想像力，在它的根源處對我們的衝擊與拍打，在眾神的殿堂中我們必須細心呵護如此小小的天賦。

　　舞台上的服裝是劇場創作中的一環，它的特質是純劇場的，一旦被搬移出了劇場，它就完全失去了魔力，一如被連根拔起的花木失去生命。我不知道要如何解釋這樣的現象，但是這裡有一個例子，我想每一個劇場工作者都能夠深深體會到的永恆魅力。製作舞台服裝的實際材料也許值不了幾個錢，搞不好只是一些絲絨碎布和玻璃假鑽的搭配，我記得葛拉罕・羅勃遜（Graham Robertson）[14]對艾倫・泰瑞（Ellen

14　1866–1948，英國劇作家及畫家，師承拉斐爾前派（Pre-Raphael）畫家Albert Moore，深好戲劇並在30歲開始設計舞台服裝。

by Ellen Terry as *Fair Rosamund*:

> *She looked her loveliest in the rich gown of her first entrance, a*
> *wonderful Rosettian effect of soft gold and glowing color veiled in*
> *black, her masses of bright hair in a net of gold and golden hearts*
> *embroidered on her robe…The foundation was an old pink gown,*
> *worn with stage service and reprieved for the occasion from the*
> *rag-bag. The mysterious veiling was the coarsest and cheapest black*
> *net, the glory of hair through golden meshes was a bag of gold*
> *tinsel stuffed with crumpled paper, and the broidered hearts were*
> *cut out of gold paper and gummed on. The whole costume would*
> *have been dear at ten shillings and was one of the finest stage*
> *dresses that I have ever seen.*

The wardrobes of our costume-establishments are crammed with hundreds of just such costumes. I can see them now, with their gilt and their fustian and their tinsel and their bands of sham ermine. You all know them—the worn hems, the sleeves shortened and lengthened and shortened again, the seams taken in and let out and taken in, the faded tights, the embroidery hastily freshened with new bits from the stock-room, the

15 約1847–1928，英國女演員，演技精湛，常擔任莎士比亞劇作中的要角。

16 本名Rosamund Clifford，以美貌著稱，是英王亨利二世的女伴，常出現在英國民間文學之中。

17 源自拉斐爾前派代表畫家羅賽提（Dante Gabriel Rossetti, 1828–1882），其創作風格細膩唯美。

Terry）[15]所扮演的美人羅莎蒙德（Fair Rosamund）[16]服裝的
描述：

> 穿著華麗的長袍登場亮相，她簡直美得不可方物！柔
> 和的金和閃耀的色彩被罩在黑紗底下，完美的呈現了
> 羅賽提式唯美風格（Rossettian）[17]的效果。她明亮的髮
> 色被束在金色的髮網中，而她的外袍上繡滿了金色心
> 形圖樣……這件衣服的基底是一件粉紅色的舊長袍，
> 以前應該也被拿來當做戲服過，也許是為了這個演出
> 又從箱子底下翻出來。神祕的面紗只是便宜又粗糙的
> 質料，而她頭髮上金質的髮網，只不過是抽皺了的金
> 蔥布裡面塞上一些廢紙，刺繡的心形圖樣，也不過是
> 從金紙剪出來的花樣再粘上去罷了。整件衣服加起來
> 大概不超過10先令，但卻是我見過最精巧的舞台服裝
> 之一。

在我們服裝的儲藏室裡面，像這樣的戲服無以計數，我閉
上眼都可以看到——鑲金邊的、粗斜紋布的、金蔥布的、
成條的假貂皮。被磨損的布邊、袖子收了又放、放了又收，
下擺縮了放、放了再縮，褪了色的緊身衣、加點新裝飾匆忙
翻新的舊繡片，這一切我們都清楚的了解。昨日的流行，今

fashions of yesterday gone flat like stale champagne…But in the theatre a miracle takes place. The dramatic imagination transforms them. They become dynamic. They become a surprise, an adventure, a reminder of things we once knew and now remember with joy. The actors wearing them become ambassadors from that bright other world behind the footlights.

But a stage costume has an added significance in the theatre in that it is created to enhance the particular quality of a special occasion. It is designed for a particular character in a particular scene in a particular play—not just for a character in a scene in a play, but for *that* character, in *that* scene, in *that* play—and accordingly it is an organic and necessary part of the drama in which it appears. One might say that an ordinary costume, an ordinary suit or dress, is an organic and necessary part of our everyday living. And so it is. But—and here is the point!—drama is not everyday living. Drama and life are two very different things. Life, as we all live it, is made up of troubles and blunders and dreams that are never fully realized. "The eternal ever-not-quite," William James called it. We go on from day to day, most of us, beset by uncertainties and frustrations, and try to

18 早期劇場中安排在舞台前緣的燈光設備，因其在演員腳前故稱腳燈。
19 1842–1910，美國心理學家和哲學家，著有 *The Varieties of Religious Experience* (1902)。

天就像是走了氣的香檳……但是在劇場裡奇蹟卻發生了，戲劇性的想像力讓它們產生了變化，它們變得有力量，它們成為了一個驚奇、一個旅程、一個讓我們充滿喜悅時所回想起來的美好記憶。當演員們穿上它們之後，似乎變成在腳燈（footlight）[18]後另一個明亮世界的信使。

　　但是舞台上的服裝有其重要的意義，因為在劇場中，它是為了強化某一個特殊需求的獨特質地所創造的；它是為了某一齣**特定**的戲，當中某一個**特定**場景裡，那一個**特定**角色所設計的──並不只是為了任意的演出、任意的場景、任意的演員所製造，而是那獨特的角色、獨特的場景、獨特的劇情──事實上它的出現是戲劇當中基本且必然存在的一個部分。也許有人會認為平常的穿著，好比說普通的套裝或禮服，是生活當中基本且必要的部分。但是──我們要討論的是，戲劇並不是日常生活，戲劇和生活是兩碼子事。我們每天的生活是由錯誤、煩惱以及從未完全實現的夢想所組成的，威廉・詹姆士（William James）[19]稱之為「永恆的不足」。我們大多數的人整日被不確定、挫敗感所包圍，努力將自己表現到最好，卻又無法知道為什麼，更無法看清前

do the best we can, not seeing very clearly, not understanding very well. And we say, Life is like that! But drama is not in the least like that. Drama is life, to be sure, but life seen through the eye of a dramatist, seen sharply and together, and given an arbitrary form and order. We see our own lives reflected as in a magic mirror, enlarged and simplified, in a pattern we had not perceived before. Everything on his stage becomes a part of that other order—the words, the situations, the actors, the setting, the lights, the costumes. Each element has its own particular relation to the drama and plays its own part in the drama. And each element—the word, the actor, the costume—has the exact significance of a note in a symphony. Each separate costume we create for a play must be exactly suited both to the character it helps to express and to the occasion it graces. We shall not array Lady Macbeth in pale blue organdie or Ariel in purple velvet. Mephistopheles will wear his scarlet and Hamlet his solemn black as long as the theatre continues to exist. A Hamlet in real life may possess a wardrobe of various styles and colors. But in the theatre it is simply not possible for Mr. John Gielgud or Mr. Maurice Evans to say,

20 歌德所著《浮士德》中的惡魔,浮士德即是將自己的靈魂賣給麥菲斯多斐。
21 1904–2000,英國演員和導演,以扮演莎劇中的人物著稱。

路，但我們卻可以說生活就是這樣。但戲劇可一點都不是如
此。沒錯，戲劇就是生活，但是這樣的生活是透過戲劇家精
準、統一的眼光，以其獨斷的形式和秩序呈現出來，我們似
乎透過一面魔鏡，看到自己的生活以一種我們從未察覺到的
秩序反映出來，是被放大、被簡化的。在這個舞台上所呈現
的一切都是這個新秩序的局部──語言、情境、演員、佈
景、燈光和服裝，每一個元素都和這齣戲有特殊的關係，卻
又各自扮演著獨立的角色，同時每一個元素──語言、表演
者和服裝都像是交響曲中的每一個音符一般，具有其嚴謹
的重要性。我們所設計製作的每一套戲服，都必須既能幫
助角色的詮釋，又能增添當下場合的光彩，我們不會讓馬
克白夫人（Lady Macbeth）穿著水藍色的薄紗，或是艾麗兒
（Ariel）穿著紫色的絲絨；只要劇場存在一天，麥菲斯多斐
（Mephistopheles）[20] 的衣服就得是緋紅色，哈姆雷特就得穿
莊嚴的黑色，真實生活中的哈姆雷特可能擁有一櫃子各色
衣服，但在劇場裡他卻不可能用得著。因為約翰‧蓋爾格
（John Gielgud）[21] 或是莫里斯‧艾文斯（Maurice Evans）[22] 在
演出時簡直不可能說出這樣的台詞：

22　1901–1989，英國戲劇、電影演員，1935 年之後到美國發展，因演出莎劇聞名百
　　老滙。

'Tis not alone my tawny cloak, good mother, nor customary suits
of tender green…

With these two essentials of stage costume in mind—
theatricality and appropriateness—let us consider a particular
illustration of the problem of costume designing. I have
purposely chosen an example that is as remote as possible
from our everyday experience, in order that it may give more
scope for our imaginations. Let us go back three hundred years
in history, to another theatre altogether. John Milton wrote a
poetic tragedy, *Samson Agonistes*, thought by many to be the most
sublime example of drama in this or any language. As we read
this tragedy, we presently come upon the following curiously
evocative passage of description:

But who is this, what thing of Sea or Land?
Female of sex it seems,
That so bedeckt, ornate, and gay,
Comes this way sailing
Like a stately ship
Of Tarsus, bound for th' Isles

它不僅是我的黃褐色斗篷，親愛的母親，也不僅是我
慣常穿著的淡綠色套裝……。

有了劇場性和適切性這兩項舞台服裝所不可或缺的本質之
後，讓我們開始勾勒服裝設計上面一個比較特殊的命題。在
這裡我特意選擇一個離我們日常生活經驗比較遙遠的例子，
這樣可以使我們想像力的視野更寬廣。讓我們一同回到歷史
上的三百年前，約翰・彌爾敦（John Milton）[23] 寫了一部被公
認為極為傑出的詩劇《大力參孫》（*Samson Agonistes*），當我
們在閱讀這部悲劇時，我們會碰上像這樣一段引起我們好奇
的敘述：

這是什麼人？她來自海洋或陸地？
似乎是位女性，
修飾的如此華麗耀眼，
向著這裡航行過來
像一艘莊嚴的船艦
來自塔瑟斯，航向愛爾蘭海的

23　1608–1674，英國詩人、政治評論家。作品有*Paradise Lost* (1667,1674)、*Paradise Regained* (1671)、*Samson Agonistes* (1671)，被視為啟蒙思想的先驅，對十八世紀英國詩壇有重要影響，因勞累過度於1652年雙目失明，因而創作出感人的十四行詩《論失明》（*Sonnet: On His Blindness*）。

Of Javan or Gadier
With all her bravery on, and tackle trim,
Sails fill'd, and streamers waving,
Courted by all the winds that hold them play,
An amber scent of odorous perfume
Her Harbinger...

Here is an example of the dramatic imagination in action, full blown, at the top of its bent. This Titan among dreamers, the man who could write lines like *And now on earth the seventh evening arose in Eden*, is describing a costume. A stage costume, if you please. Let us try to visualize this costume.

Fortunately we all have—or at least we ought to have—a reasonably clear idea of what a woman's costume looked like in Milton's day. We have all seen pictures of the tight bodices and the full stiff skirts and the ruffs and the jewels. And we can find plenty of documents, if we need them, on the shelves of our libraries. But documents will not help us, or at most they will serve only as a starting-point from which to proceed. What we are after at the moment is not erudition, but evocation. We are to evoke a mental image of this costume. We are to allow it to appear to us of itself, to manifest itself to us, to occur to us, as it were. We shall find this exercise a difficult one, entirely outside

雅旺或迦地耶

帶著華美的裝備，齊整的轆轤

飽滿著帆，飄揚著彩帶

伴隨著舞動它們的風，

琥珀般的芬芳氣息

是她的開路先鋒……

　　這是實踐戲劇性想像力的一個範本，活生生有若盛開在枝頭的花朵。這位夢想家中的巨擘，曾寫下「現在，在這大地，第七日的黃昏，伊甸園裡……」這偉大詩作──《失樂園》的詩人，他所描述的是一件服裝，沒錯是一件舞台服裝，現在讓我們把它呈現出來吧！

　　我們對彌爾敦那個時代女性的穿著所幸都有──或者說至少有一點概念，許多人都看過畫像當中的女人穿著緊身束腹、寬廣的蓬裙、圓盤皺摺的領子和各色珠寶。如果有必要的話，我們可以在圖書館的架子上找到成堆的文獻資料，但是在這裡文獻資料是幫不上忙的，或者說它們只能提供作設計的一個起始點。在這個時候我們所追求的不是對服裝史上的博學多聞，而是一種召喚，喚醒我們腦海中對這一套服裝的想像，讓它以它所應有的面貌呈現、展示在我們眼前。我們會發現這樣的做法其實是一種相當困難的練習，因為他

of our usual routine, but in the end strangely rewarding. We shall discover that our imagination possesses a curious focusing and projecting power. I have often inquired in vain as to the precise nature of this visioning faculty. Does the costume we are about to discuss already exist in some ideal platonic world of images? Have our imagination bodies? I do not know. I only know that this faculty of strong inward viewing functions in accordance with an old, old law. I cannot pretend to explain it. I can only affirm it. It simply is so. Perhaps this is what Leonardo da Vinci had in mind when he declared that the human eye not only receives but projects rays of light.

Our first step is to visualize this costume in relation to Milton's own time. We know that the costumes of any period in history are typical of that period. For example, let us think of the costumes of today in relation to the life of today. Here are a few catch words chosen almost at random out of the daily papers: television, airplane, jitterbug, streamline, New Deal, A.F. of L., C.I.O., C.C.C., P.W.A. And so on. As we read them we instantly get an impression—broad, general, rough, to be sure, but still an impression—of the characteristic quality of our own

完全超乎我們平常的工作習慣，但是結果常會是意想不到的
豐厚，我們將會發現我們的想像力是兼具了匯聚和投射的力
量。我一直在追尋這視覺能力的珍貴本質但都徒勞無功，是
我們將要討論的這套服裝，在想像的領域中已經有了理想的
典範嗎？我們的想像被體現了嗎？我不知道！我只知道這種
強烈的向內審視能力，和古老的法則功能一致，我無法假裝
解釋它，我只能肯定它的存在，就這麼簡單！也許就和達文
西當年在沒有先進的科學輔助下，他就能斷言人類的眼睛在
接收光線的同時也投射光線是一樣的。

　　我們的第一步是先將這服裝和彌爾敦的時代予以視覺化。
大家知道歷史上每一個年代的服裝，都是那個時代的典型。
舉例來說，從我們每天的報紙上隨機抽取一些標語，讓我們
想一想現在的服裝和我們生活的關係：電視、飛機、吉特巴
舞（jitterbug）、流線型、新政（New Deal）[24]、A. F. of L.、
C.I.O.、C.C.C. 和 P.W.A 等等，當我們讀到這些文字的時候就
能得到一個印象——廣泛的、一般的、粗略的、明確的，但
起碼是一種印象——對於我們這個時代性格的描寫，快速、

24 美國羅斯福總統於1930年代所推動的經濟復甦與社會重建政策。

epoch, swift, direct, inclusive, brilliant, staccato. Now what could be more expressive of this quality than the snappy chic nervous little tailored suits we see by the dozens in our fashion magazines and in our shop windows? Look at the tight little sweaters and coats and skirts and the closely wrapped turbans, all so simple and practical, all made, not to charm, but to surprise and excite, all like quick bold sketches, to be rubbed out tomorrow. They are creations of—and for—this unique moment in time. Seen in retrospect, they may give the historians of the future as clear an idea of this particular era in the world's history as a sixteen-millimeter camera or the Grand Coulee Dam. They are an inseparable part of our own special idiom.

In the same way a costume of Milton's own time will inevitably express the characteristic qualities of life at that time. Let us bring to mind what we know of these qualities. Great names rise in the memory: England: Elizabeth the Queen, the sovereign who once said, I could have wept but that my face was made for the day: Sir Francis Drake, the defeat of the Spanish Armada, the streets of London all hung with blue, like the sea: William Shakespeare, author and player, the greatest

25 美國華盛頓州中部哥倫比亞河的峽谷，北端有大古力水壩。

直接、概括的、出色的、簡潔的，那又有什麼比得上現在我
們在雜誌和櫥窗裡面，所看到成堆成打合身、瀟灑、帥氣的
套裝，更能顯示這個時代的特質？看看那些緊身窄小的套頭
衫、外套、裙子和緊緊包覆的無邊帽，都是如此的簡單、實
際，不是用來增添魅力，而是用來製造驚奇和刺激，都像是
快速粗略的草稿，明天隨時可以被擦掉修改。它們都是因為
我們這個時代才產生的服飾，也唯有這樣一個時代才能有
這樣的產品。未來的歷史學者追憶起這個時代的時候，這
樣的服裝和16厘米攝影機或是大古力水壩（the Grand Coulee
Dam）[25]一樣，都能幫他們勾勒屬於這個時代的容顏，它們
的風格和我們這個時代的特性密不可分。

　　相同地，在彌爾敦那個時代的服裝，一定表現出在那個年
代的性格特質。讓我們試著回憶一下，我們所知道那個年
代的特質。偉大的名字浮現在我們腦海中：英格蘭，曾發下
「我可是會哀悼的，但我的顏臉可都上了妝！」如是豪語
的伊莉莎白女王；擊敗西班牙無敵艦隊的法蘭西斯・垂克
（Sir Francis Drake）爵士，他的勝利讓全倫敦街道懸滿了如
海一般的藍色旗幟；作家兼演員的威廉・莎士比亞，是世所
公認最偉大的公眾藝術創作者；馬婁有這麼一句簡短有力的

master of public art the world has ever known: Marlowe, with
his "might line" —Kit Marlowe, stabbed in the Mermaid Tavern
in Southwark over across the bridge; Sir Walter Raleigh, with
his cloak and his sea-knowledge and his new colony, Virginia,
in the west, on the other side of the world; Spenser and Sir
Philip Sidney, Ben Jonson, Inigo Jones; Bacon, Leicester, Essex:
Mary of Scotland, whose skin was so fair, men said, that when
she drank red wine you could see the red drops running down
in her throat like fire...These names out of history, stirring,
blood-swept, passionate, mingle and blend in our minds in an
overpowering sense of splendor and reckless adventure and
incredible energy and high fantastical dreams. And then we
see John Bunyan's Christian, accompanied by Ignorance and
Faith and Hope and Mistrust, on his way to the Celestial City,
his soul intent on cherubim and seraphim. And Sir Thomas
Browne admonishes us in his echoing cadences to be ready to be
anything in the ecstasy of being ever. And we hear John Milton
as he dictates the "Sonnet on His Blindness"— *God doth not*

26 約1552–1618，英國軍人、探險家、政治家。受伊莉莎白一世的寵幸，試圖建立北
美殖民地未果，在獄中寫有 *The History of the world* (1614)。

27 1552–1599，傑出的英國詩人，最著名的作品是其長篇諷喻詩 *The Faerie Queene*
(1590–1609)，有「詩人中的詩人」美譽。

28 1561–1626，英國作家、哲學家、政治家，英語語言大師，提出「知識就是力
量」。主要著作 *The Advancement of Learning* (1605)、*Novum Organum* (1620)、*Essays*
(1597–1625)。

29 約1532–1588，原名Robert Dudley，伊莉莎白一世的寵臣。

臨終之言：馬婁在那橋南端的「美人魚酒館」被刺身亡。華
特・羅萊爵士（Sir Walter Raleigh）[26]，他的斗篷、海洋知識
以及在西方、在世界的另一端，被稱為維吉尼亞（Virginia）
的新殖民地為人所樂道；斯賓塞（Spenser）[27]、飛利浦・席
德尼爵士（Sir Philip Sydney）、班・強生（Ben Jonson）、英
哥・瓊斯、培根（Bacon）[28]、萊斯特伯爵（Leicester）[29]、埃
塞克斯（Essex）[30]；蘇格蘭女王瑪麗（Mary of Scotland）[31]人
們說她的肌膚如此晶瑩剔透，使得她在喝下紅酒的瞬間，那
鮮紅的液體有如火焰一般順著她的喉管滑下……是這些熱血
奔騰、狂野激情、轟動世代的歷史人物，以一種不可思議的
力量，將壯麗又狂妄的冒險、過人的精力、極度奇幻的夢想
融入了我們的心靈，然後我們看到了班揚（John Bunyan）[32]
的基督教精神，在通往天國的求道歷程中，有「無知」、
「信念」、「希望」、「疑惑」伴隨，他的靈魂寄予天使基
路伯（cherubim）和撒拉弗（seraphim）這兩位首要天使護
衛。湯瑪士・布朗爵士（Sir Thomas Browne）以他蘊含節奏
的語調提醒我們：準備好到極樂天堂去吧！然後我們再聽到
約翰・彌爾敦口述他的十四行詩《論失明》（*Sonnet on His*

30　1566–1601，本名Robert Devereux，英國軍人、宮廷大臣。伊莉莎白一世的寵臣，
　　後因反叛罪被處決。
31　指瑪麗一世（Mary Stuart, 1542–1587），為蘇格蘭女王及法國王后。
32　1628–1688，英國散文作家、清教徒傳教士，因違抗英國國教派而入獄，在獄中完
　　成其代表作*Pilgrim's Progress* (1678)，此一宗教寓言故事中的人物多有特殊命名，如
　　Ignorance、Faith、Hope、Mistrust或Envy、Talkative、Mr. Great–Heart等等，以呼
　　應角色個性。

need either man's work or His Own gifts. The Reformation is here, with its fervors and its exaltations and its solemn preoccupations with moral grandeur.

As we dwell upon these things, the dramatic imagination begins to sketch in our minds the first vague outlines of a costume. It is bold and fantastic and elaborate and ceremonious and splendid, a typical expression of the Age of Daring. So much we see. Let us pause for a moment and consider the costume from another point of view, this time in relation to the quality of Milton's own poetry. The chief trait of any given poet, Walt Whitman reminds us, is always the mood out of which he contemplates his subjects. Milton's mood is mature, noble, grand. His season is autumn, splendid and serene, a "season of mellow fruitfulness." And we find in his poetry a great elegance, a slightly rigid elegance perhaps, like the elegance which is at times almost a constraint in the music of Handel or Purcell. It is often gay, jocund, buxom, one might say; hearty, with a great natural health coursing through it; but it is never merely funny, as Will Shakespeare is funny, for instance, when he makes Juliet's Nurse say, *Now, afore God, I am so vexed that every part about me quivers.*

33 1819–1892，美國詩人。著有 *Leaves of Grass*（初版1855）。
34 約1659–1695，英國巴洛克時期作曲家。作品有 *Dido and Aeneas* (1689)，*The Fairy Queen* (1692)。

Blindness）：「上帝無需世人為其勞動，亦不需祂禮。」宗
教改革便歷歷在目了，有著狂熱、欣喜和帶著高尚情操的
全身投入。

　　當我們沉浸在這些人與事的同時，戲劇性的想像力也開
始為我們勾勒出這套服裝的模糊輪廓，它必須符合「冒險紀
元」（Age of Daring）的典型表徵──同時兼具大膽奇想，但
又不失精緻隆重與華麗。這是目前我們所能夠想像的。到這
裡先讓我們暫停一下，再回頭看看這套服裝又怎樣和彌爾敦的
詩作特質相互輝映。華爾特・惠特曼（Walt Whitman）[33]曾指
出任何一個詩人的作品所散發的特質，完全反映了詩人在凝
視他的創作對象時的心境，彌爾敦的心境是成熟、高貴和壯
麗的，像一個「豐饒且芳醇的季節」一種屬於秋的氣韻，輝
煌又清朗。在他的詩作當中充滿了優雅，對某些人來說，也
許是過於刻板的優雅，有時候不免讓人和韓德爾（Handel）
或普塞爾（Purcell）[34]音樂中的工整規矩聯想在一起。他的
作品經常以一種渾然天成的完整性，依序呈現歡快、愉悅、
活潑，或者說熱情洋溢，但絕不會和莎士比亞一樣的滑稽搞
笑，像是他會讓朱麗葉的奶媽說「皇天在上，我實在氣到全
身發抖！」（Now, afore God, I am so vexed that every part about

Nothing so frivolous here. Milton's verse is all in the noble heroic vein, in the Dorian mode. It is ordered, splendid, a great pavane, a gorgeous pageant, a concert of organ and orchestra led by a master of sound. It is laid out like a formal garden, all glowing in autumn sunlight, along whose enchanted avenues we may wander for hours. Until the tempest comes, and lightning splits the sky, and the earth reels, and we hear the voices in heaven chanting, *Of Man's first disobedience and the Fruit.*

In the light of these "solemn planetary wheelings" our imaginary costume takes on new qualities. It is more triumphant, more astonishing, than we had originally thought. But there is a certain elegant sobriety about it which we had not sensed at first. It is a Miltonian costume, the creation of an adult mind.

Let us imagine that we see it in its own proper surroundings. It is a stage costume; let us see it on a stage, then—in Whitehall, perhaps, or in one of the theatres designed by Inigo Jones. A figure appears before us like something seen between sleeping

35 原文中 vexed 可解釋為盛怒，但古字中有另一解為波濤洶湧，意指奶媽上圍豐滿，
 生氣時不斷抖動如波濤。
36 十六、十七世紀的一種優美宮廷舞。
37 英國政府機關的集中地區，英哥‧瓊斯在這裡設計了著名的建築 Banqueting House
 (1619–1622)。

me quivers）[35]。但是這裡的文字一點也不讓人感覺輕浮，彌
爾敦的文風尊貴高雅一如古希臘多利安（Dorian）列柱的樸
實，嚴謹、壯麗、優雅有如孔雀舞（pavane）[36]，像一場華麗
的遊行、一場由音韻大師所指導的交響曲，也像是個井然有
序的花園在秋天的陽光下閃閃生輝，引導我們流連忘返於他
音韻的幽徑中，直到暴風雨來臨、直到閃電劃過天際、直到
大地搖撼，我們聽到了來自天庭反覆的詠唱著：「那罪惡的
果實和人類的首次反抗。」

在這樣如「行星莊嚴運行」的光芒照耀之下，我們想像中
的服裝多了一些新的特質。它似乎比我們想像的更誇耀、更
令人驚奇，但是它又有一種典雅的自制蘊含其中，是我們原
先所不曾體會到的，它是一襲專屬於彌爾敦式的戲劇服裝，
是一個成熟思想的產物。

讓我們試著在這套衣服所適合的時空下來欣賞它，既然這
是一套舞台服裝，那就把它放在舞台上——也許是倫敦官府
大道（Whitehall）[37]上某個劇院裡，或者是英哥‧瓊斯所設
計的眾多劇院之一，一個像是白日夢中、又像是在半夢半

and waking, or in a daydream, vague, arresting, unfamiliar. It moves in a quivering amber twilight, a romantic dusk made by hundreds of tiny tapers placed about the proscenium. You will note that our imaginary Miltonian theatre has not the benefit of our modern mechanisms for lighting the stage, our Leicas and Fresnels and interlocking dimmer-boxes. Yet the old theatre lighting, in spite of its crudeness, had a quality which our modern lighting sadly lacks, a quality which I can only describe as *dreaminess*. Our plays are case-histories, not dreams and for the most part they are played in the pitiless light that beats down upon an operating table. But in that low shadowless amber radiance the unusual, the extraordinary, the fabulous, came into its own.

Accordingly the stage costumes of those times were made to catch and drink up every stray wandering beam of light and reflect it back to the audience. They gleam and flash and glitter. *Glister* is the real word. They sparkle and twinkle and blaze with gold and silver and color and spangles and jewels. They transform the actor into a being of legend.

38 德國光學產業公司，產品涵蓋三大領域，包括攝影、運動光學以及實地探勘，以高品質亦高價位著稱。

醒間的人影，出現在我們眼前，朦朧、引人注目卻又陌生。佈置在鏡框周圍幾百支細小蠟燭構成的昏黃浪漫，使它在搖曳的琥珀色微光中逍遙。各位也許會發現在彌爾敦時代的劇場，並沒有像是萊卡（Leicas）[38]、佛氏聚光燈（Fresnel）[39]、連動式調光裝置等等，這一類現代劇場的燈光設備。但是撇開它的原始感不談，這一種老劇院的照明有一種我們現代燈光所缺乏的特質，這種特質我除了用**夢幻感**來形容之外無以名之。我們的戲劇都是「特別個案」而不是夢想，而且多半時間是在經由控制台所操控的無情光束下演出。但是在這晦暗的澄黃光芒之下，所有的不平凡、所有的變幻莫測、所有的不可思議、都已經完全的自我滿足了。

　　由於那個時代的舞台服裝製作，是為了要捕捉和汲取每一道零星的光束，所以他們必須閃亮、發光，或者用**熠熠生輝**來形容更為貼切，這些明亮閃耀的光芒和色彩，在金銀光澤閃亮的飾品以及珠寶的燃燒下，把演員們幻化成活生生的傳奇。

39　柔光聚光燈的一種。

We have examined our costume in the light—figuratively speaking—of the wonderful period in history we call the Reformation, and in the light of Milton's own solemn poetic imagery. We see that it has—indeed, that it must have—the qualities of boldness, fantasy, dignity, formality. Now, as we look at it in the light of the theatre of that earlier day, we add to it the qualities of glamour and luster. Step by step it becomes clearer in our minds. It becomes iridescent, becomes radiant. It glows and shines.

And now let us be specific, and ask in Milton's own words, *But who is this?*

It is Delilah, the wife of Samson, the woman whom he knew and loved in the valley of Sorek. This curious figure, this living shell, this incredible puppet encased in its elaborate dress, so stiff it almost stands alone, is Delilah. In the argument of the sixteenth chapter of Judges we may read her story:

> *Delilah, corrupted by the Philistines, enticeth Samson. Thrice she is deceived. At last she overcometh him. The Philistines take him and put out his eyes. His strength recovering, he pulleth down the house upon the Philistines, and dieth.*

　　所以說我們已經在歷史上偉大的宗教改革年代，和彌爾敦莊嚴詩意的光芒照耀下仔細審視了這套服裝，我們理解到這套衣服應該——或者說必須——兼具大膽、奇幻卻又尊貴、正式，接著我們也在當年劇場的光源下思考過這一套服裝，我們又為它加上了光澤和魅力的特性。這套衣服在我們的腦海中逐漸明朗，它開始如珍珠一般在我們眼前隱隱閃現，如朝露般閃耀著華采。

　　讓我們更明確一點，用彌爾敦自己的文字來確認一下**這是什麼人？**

　　她是狄萊拉（Delilah），參孫的妻子，那個他在索瑞克山谷（valley of Sorek）相識相戀的女子。她的服裝像一枚裝飾浮誇的貝殼，僵直的衣服似乎不需輔助就可以自行站立。是的，這個穿著如此誇張僵硬的服裝的女子就叫狄萊拉。在聖經舊約《士師紀》（*Judges*）的16章我們可以讀到她的故事：

　　　　受到菲力士人的收買，狄萊拉三次誘惑參孫，最後終於制服了他。菲力士人將他捕捉，並挖出了他的雙眼。當他的神力恢復後，他扳倒菲力士人的房舍，然後死去。

We are apt to look at such a story today too exclusively from an analytic point of view. We take the cue from our doctors of psychology, with their flair for definition, and we call Delilah a vampire, or an anima-figure, it may be. Or we take the cue from Kipling and think sentimentally of a fool and a rag and a bone and a hank of hair. Or we take the cue from Hollywood and call Delilah simply "the menace." The fact is, however, that in so doing we divest the story of the emotional values that have crowded about it ever since our infancy. We analyze it, delimit it, and dismiss it from our minds. But it is precisely these emotional values that should interest us most. Our aim here is to recapture our childhood memories and the mood they bring with them, the atmosphere of nobility and betrayal and vengeance and divine justice that broods over them like a cloud. These memories, still so compelling, have become a part of the old story, inseparable from it. One might almost say, they *are* the story. In the mood of awe with which we first pored over the pages of the Doré Bible—if we can but re-live it for an instant!—Delilah is no longer a figure familiar to us, a human being like ourselves. She is Delilah herself, straight out of the pages of the Old Testament, the "Fury with the abhorréd shears."

40 1865–1936，英國短篇小說家、詩人。著有 *The Light that Failed* (1890)、*Barrack-Room Ballads* (1892)、*The Jungle Book* (1894)、*Kim* (1901)，獲1907 年諾貝爾文學獎。

今天當我們重讀這個故事的時候，太容易從分析的觀點出發，我們引用心理醫師的定義，把她當成一個吸血鬼讓人覺得恐怖又激情，或是讓男人盲目迷戀的女性角色，或者跟隨吉卜林（Kipling）[40]的思路，多愁善感地把她想像成是骨瘦如柴，掛著一絡亂髮、穿著破爛受人愚弄的可憐人，更或者我們依循好萊塢的詮釋，簡單的把狄萊拉稱之為「惡女」。然而當我們這麼做的同時，我們等於剝奪了這故事中，自我們孩提時代就充滿的情感價值。我們分析、界定之後就從此將這角色置之不理，但其實是這些情感價值，才能真正地引起我們最深的興趣。我們的任務是重新拾回這童年的記憶，和這記憶中曾有的感動，故事的魅力在於像烏雲一樣籠罩其中的貴族、背叛、復仇以及神聖的律法。這些記憶如此強勢地變成這個老故事中不可分割的一部份。也許有人會說故事**就是這樣**，但是如果時光倒流，讓我們再一次回到兒時，想想當年帶著敬畏的心翻開聖經閱讀的心情，我們會發現，狄萊拉已經不再是我們熟悉的形象，她將變成一個和我們不一樣的人，**她**就是狄萊拉，活生生從舊約聖經裡跳出來一個「拿著可憎的大剪刀的復仇女神」[41]。

41 出自彌爾敦的田園輓歌詩作 *Lycidas* (1637)，Comes the blind Fury with the abhorred shears, And slits the thin-spun life。Fury 為希臘神話中復仇女神之一。

Now the dramatic imagination invests our costume with wonder and awe and a kind of dark glory. It is a costume for Delilah. She—Delilah the enchantress—is to wear it in her moment of triumph over the husband whom she has betrayed and blinded. Another light is thrown upon it, the light of childhood recollection. Images of Circe and Hecate and "dark-veiled Cotytto" come thronging into our minds, with their philters and their potions and their magic spells.

Our exercise draws toward an end. Now, finally, let us see what Milton himself tells us. He compares the figure of Delilah to a ship. A stately ship of Tarsus. Not an English ship, you will note, but Oriental, such a ship, perhaps, as the one that brought Shakespeare's Viola to the stormy coast of Illyria. *And what should I do in Illyria? My brother, he is in Elysium...*The ship of Milton's dreams, sailing on, sailing on, toward the islands of myrrh and cinnamon—! This is not the only time we have seen a woman compared to a ship in dramatic literature. The comparison is a happy one always. The image holds us, whether it is the image of this stately galleon moving slowly athwart our fancy or of the brisk little pleasure-boat, Mistress Millamant,

42 荷馬所著《奧德賽》（*Odyssey*）中能將人變為豬的女巫。
43 希臘神話中司月、地和冥界的黑夜女神。

　　這樣一來，戲劇性的想像力為這套服裝投注了更多的莊嚴與奇幻，還有一點晦暗的光芒。這是一件屬於狄萊拉的服裝，這位充滿魅力的女子將在背叛丈夫的勝利時穿著它。這時另一道靈光點亮了這套服裝，那是屬於童稚記憶的光耀，色琦（Circe）[42]、赫卡蒂（Hecate）[43]和黑暗蒙面的科提托（Cotytto）[44]，她們的愛情靈藥和魔術咒語，如排山倒海地湧入我們童稚的腦海。

　　我們這個練習即將結束，最後，讓我們看看彌爾敦自己是怎麼說的。他將這個狄萊拉的形象比喻成一艘船艦、一艘來自塔瑟斯（Tarsus）莊嚴的船，並不是英國的船，而是來自東方的船隻，也許就和把莎士比亞筆下的薇歐拉（Viola）[45]送到伊理瑞亞（Illyria）海邊的船是一樣的。「我在伊理瑞亞幹什麼呢？我哥哥已經到極樂世界去了……」彌爾敦的夢想之船不斷向前航，航向那沒藥和肉桂的香料島嶼——！這不是我們第一次在戲劇文學中看到將女性比喻作一艘船，而這種比喻通常是令人愉悅的。不論是在這齣戲裏緩緩橫越我們奇想的莊嚴巨艦，或是像一葉輕盈小艇的米蘭蒙夫人

44 色雷斯人（Thracian）的女神，或傲慢女神，通常以瘋狂儀式為她舉行祭典。以上色琦、赫卡蒂和科提托皆出現於彌爾敦的宮廷舞劇詩作 *Comus* (1634)。
45 《第十二夜》（*Twelfth Night*）女主角之一，熱戀男主角奧西諾公爵（Duke Orsino）。

sweeping in with all sails set and a shoal of fools for tenders. Or of the tight vessel, Mistress Frail, well-rigged an she were but as well manned. There is something feminine, as every man knows, about all sailing-ships, with their bendings and glidings and swayings. How they set sail for an occasion and float and veer and turn and take the air and bow and hesitate and advance and dissemble! Beautiful ships, beloved of mariners, beautiful women, who charm our hearts away...

A costume of the Reformation: a Miltonic costume: a gleaming costume: a Biblical costume: a costume for Delilah: and, finally, a costume that reminds us of a stately ship. A strange mingling of images...All at once we see it. The figure—I had almost said figurehead—draws near and in our imagination we watch its majestic progress across the stage. It towers above us on its high chopines. There is a gleam and a moving of rich stuffs and shapes and above all a countenance—is it a mask?—topped by a high jeweled headdress and bent down ever and again to catch the lights from below. We have a sense of a thing

46 十八世紀初威廉‧康格瑞夫所著《如此世道》一劇之女主角。
47 同樣出自威廉‧康格瑞夫的作品 *Love for Love* (1695)，為一部大膽滑稽的鬧劇。

（Mistress Millamant）[46]，拖曳著伴隨的侍從丑角一如飽滿的船帆；更或者是費瑞爾夫人（Mistress Frail）[47]像一艘勻稱優美的大船，配備齊整操控得宜，這樣的形象在在都吸引著我們的注目。每個男人都知道船所帶給他們對女性的聯想，她們的曲線、她們的搖曳和她們的款擺，看著她們揚帆啟航；緩緩漂浮前行、慢慢移動；飽滿的風帆、遲疑的暫頓、輕盈地前進前進……漸漸地消逝，美麗的船艦，水手們的最愛！美麗的女子，迷惑了我們的心扉……

　　一套宗教改革年代的服裝、一套彌爾敦式的服裝、一襲隱隱含光的服裝、一件聖經裡的服裝、狄萊拉專屬的服裝，同時它還得讓我們聯想到氣派的船艦，各種意象的融合……最後，我們終於看見了這個形體緩緩地走向我們眼前。在想像的世界中，我們看到她雍容華貴的穿越舞臺，踏著蹺底鞋（chopines）[48]，高高在上地朝著我們駛來。豐富的素材和樣式，使得她閃動著幽幽的光芒，更重要的是那容顏——那頂著滿頭珠玉釵鈿的容顏，難道是個面具嗎？——一次又一次緩緩傾身，以迎接來自腳前的光源。我們感覺到金色的光

48　十七世紀前後婦女穿的厚底鞋，用以增加身高並保護腳下不沾污泥。

all golden, a gilded galleon riding the waves. Golden, carved, overlaid, crusted with gold on dark gold, so heavy it can move with a gliding step, a slow, measured approach. The billowing folds of the stiff brocaded Oriental silks make a whispering sound like the sound of waves breaking on the shore. There is a rippling of light and a soft rustling and a foam of lace on the purfled sleeves and a sheen of gems over all, a mirage of sapphires and moonstones and aquamarines and drops of crystal. Great triple ruffs float upon the air, and veils—"slow-dropping veils of thinnest lawn"—droop and fall with the figure's stately dippings and fillings and careenings over the smooth floor of the sea. We see it for an instant, plain and clear.

Now it has vanished.

We saw it. And now we must make it.

芒，像一艘鎏金巨艦破浪而來，緩慢而精確的朝著我們前
進。不同成分的黃金層層堆疊，以至於沉重到好像必須用滑
車才能將她移動。華貴的東方錦緞所構成如巨浪般的皺折，
在她緩步輕移時的唏嗦聲有如海浪輕拍著沙灘；颯颯作響的
衣服摩擦聲，讓鑲滿蕾絲的袖口有如浪頭留下的泡沫，波光
瀲灩。燦爛的寶石包圍著她，一個像是由藍寶石、月長石、
藍晶和點點水晶所築成的海市蜃樓。輪狀皺領高高地浮在空
氣中，還有那面紗──「上等細麻所製成，緩緩滴落的面
紗」，伴隨著她的起伏、伸展、傾側而飄揚滑落在如海的舞
台上。在那一瞬間，我們清楚又明白的看見了這套衣服。

在這一瞬間，它又從我們眼前消逝。

既然我們曾和它相遇，就讓我們把它呈現給觀眾看吧！

現代人^的延伸^{思考}

　　服裝設計的定位可以説是多重的。在劇場中可説是與演員及角色工作最為親密的，設計者是演員完成角色塑造的關鍵人物。他必須清楚的認知到角色所有歷史以至於反映在外貌上，同時也必須了解每個演員身體的特質以形塑設計者心目中的角色。而面對著上台前緊張又無助的演員們，他無形中又變成一個撫慰者。這一多重性更突顯出劇場工作「人與人」的特殊。

　　這一章表面上似乎在談服裝設計，但是作者更深一層的目的，其實還是在延伸前一篇To A Young Designer的思緒——如何讓想像力奔馳，以及劇場中「人」和「人文精神」的重要。我們也可以再次看到包比先生如排山倒海的思緒洶湧而來，急切地想告訴我們如何體現自己腦中的畫面，一次又一次地讓我們看到作者從劇本的文字背後，閱讀到一幅又一幅的舞臺風景，跟隨著他的文字，所有的構圖在我們腦海裡成形。包比先生字裡行間完全沒告訴你該怎麼去執行設計，但是他用流暢且詩意的文采帶領我們的想像飛躍。我們可以再一次的看見作者任由其豐富的學養，來建構出屬於那特殊場域下的一襲容妝。然而反躬自省身為設計的我們，可曾在動手設計之時有著一絲絲的惶惑不安？多少時候我們在浮面與表象之間飄移？根據照片搭出一堂景就是寫實嗎？根據古典版型製作一件衣服就能説明時代嗎？無論時裝古裝、無論西洋東方，我們到底要怎樣才能進入一個演出的世界？所謂寫實與非寫實的定義究竟如何區分？而寫實究竟是寫外貌之實？抑或是內在之實？如何

由內在的真實體現到外在的形式？非寫實的基礎又從何而來？外表的非真實又如何反映到內在的悸動？在我們的劇場裡看過多少天馬行空但不知所以的服裝在舞台上出現？多少美侖美奐但無法與演出契合的服裝造型在劇場飄移？我們無法否認他們的創意與才華，但我們也無法同意他們把劇場當成伸展台，把演員當成模特兒的光耀自我手段。

　　現代的劇場中已經充斥著太多的自我意識，自我意識的高漲導致對於週遭事物的漠然，但身為一個以人的聚合為本質的劇場工作者，怎麼可以不關心？不關心自己的根、自己的本、自己的生活、自己的週遭、自己曾經有的歲月？以至於整個國家社會的來龍去脈？而漠然的結果就是一切顯得虛華與表象，所有的超現實必然來自現實，所有的抽象必然來自具象，所有的跳脫之前必先有框架，在任由想像翱翔之前必先有底蘊的高枝可棲。這一切在沒有底蘊的基礎下，所有的外在都顯得虛無不實。

　　「底蘊」這兩個字看起來古老、說起來容易，卻正是我們這個世代從事設計工作者（非但是劇場工作者而已）最大的致命傷。看看坊間有多少足以存留超過三年的設計作品或藝術創作？有多少作品五年以後回顧依然餘韻猶存？快速與表象的追求應該是這個世代必須戒除的毒癮，沉靜穩重的學習方能建立屬於我們這個世代的風華。

VI
Light and Shadow
in the Theatre

光與影

Put out the light and then—

put out the light!

— Shakespeare

The artist...will give us the gloom of gloom

and the sunshine of sunshine.

— Emerson

VI
光與影
Light and Shadow in the Theatre

把燈滅了；

然後⋯⋯滅了燈吧！

——莎士比亞

藝術家⋯⋯能讓我們看到幽微中的幽微；

陽光中的陽光。

——愛默生

Professor Max Reinhardt once said, "I am told, that the art of lighting a stage consists of putting light where you want it and taking it away where you don't want it." I have often had occasion to think of this remark—so often, in fact, that with the passage of time it has taken on for me something of the quality of an old proverb. Put light where you want it and take it away where you don't want it. What could be more simple?

But our real problem in the theatre is to know where to put the light and where to take it away. And this, as Professor Reinhardt very well knows, is not so simple. On the contrary, it demands the knowledge and the application of a lifetime.

Future historians will speak of this period in theatrical history as the spotlight era. Spotlights have become a part of the language of the theatre. Indeed, it is hardly too much to say that they have created our contemporary theatre idiom. Once upon a time our stages were lighted by gasjets and before that by kerosene lamps, and before that by tapers and torches. And in the days to come we may see some kind of ultra-violet radiation in our theatres, some new fluorescence. But today our productions are characterized—conditioned, one might almost say—by conical shafts of colored electric light which beat down upon them from lamps placed in the flies and along the balconies of the theatre. Lighting a play today is a matter of arranging and

麥克斯‧萊因哈德教授曾說過：「有人告訴我劇場中的燈光藝術包含：在需要光的地方給光，在不需要光的地方把它拿掉。」我經常有機會思考這個說法，經常到隨著時間的流逝，它已經變成某種古老的諺語。該亮的地方亮，不該亮的地方不要亮，還有什麼比這樣的說法更簡單呢？

但是我們在劇場中所面對的真正難題，正是明確知道哪裡該亮哪裡不該亮，正如萊因哈特教授所清楚理解的，這一個課題絕不如表面所說的單純，它需要一輩子的學習與實踐。

未來的歷史學家在為我們這個時代的劇場下註腳時，會將我們稱為聚光燈（spotlight）的時代。聚光燈已經變成劇場語彙的一部份，事實上，要說它已經變成我們當代劇場的風格，是一點也不為過的。曾經有過那麼一段日子，我們的舞台是由瓦斯燈所照亮，在這之前呢，是煤油燈，在煤油燈之前是蠟燭和火炬。在未來的日子裡我們也許可以看到一種新的螢光──紫外線的放射。但是當今劇場的特徵──或者可以被定義成是劇場生存所絕對必需的──正是那來自舞臺上方的懸吊系統；或是觀眾席上一道又一道錐形彩色光束。

rearranging these lamps in an infinite variety of combinations. This is an exercise involving great technical skill and ingenuity. The craft of lighting has been developed to a high degree and it is kept to a high standard by rigorous training in schools and colleges. It has become both exacting and incredibly exact. The beam of light strikes with the precision of a *mot juste*. It bites like an etcher's needle or cuts deep like a surgeon's scalpel. Every tendency moves strongly toward creating an efficient engine behind the proscenium arch. Almost without our knowing it this wonderful invention has become a part of the general *expertise* of Broadway show-business. We handle our spotlights and gelatines and dimmers in the theatre with the same delight and the same sense of mastery with which we drive a high-powered automobile or pilot an aeroplane.

But at rare moments, in the long quiet hours of light-rehearsals, a strange thing happens. We are overcome by a realization of the *livingness* of light. As we gradually bring a scene out of the shadows, sending long rays slanting across a column, touching an outline with color, animating the scene moment by moment until it seems to breathe, our work becomes an incantation. We feel the presence of elemental energies.

戲劇燈光在乎於以無盡的組合方式，將這些燈具一次次地安置及再安置，而這樣的工作需要極大的技能和巧思，燈光的技術已經高度發展，同時在各個學校中也有嚴格的訓練。燈光變得既嚴苛又無比精確。光束像**精準的言詞**直直地命中目標，像外科醫生手術刀般的精準、又像蝕刻版畫家的針尖般銳利，所有的趨勢都強烈地走向於在舞臺鏡框後，製造一個具有高度效率的機器。我們在不知不覺中，讓這令人讚嘆的機器變成百老匯演出事業中普遍的**專有技術**。我們在劇場中愉悅地處理燈具、色紙和調光器，一如我們駕駛高速汽車或是操控飛機所帶來的駕馭感一樣。

　　但是就偶而有那麼些瞬間，在漫長又安靜的燈光技術排練中，有些奇妙的事情會發生。我們被燈光所具有的**生命力**征服了。當我們把場景從闇影中提現出來，讓光束斜斜地掃過一根柱子，用色彩去框出輪廓。我們的工作好像咒語一般，讓場景一步接一步地活了起來，直到它似乎在你面前呼吸。我們感覺到巨大能量的存在。

There is hardly a stage designer who has not experienced at one time or another this overwhelming sense of the livingness of light. I hold these moments to be among the most precious of all experiences the theatre can give us. The true life of the theatre is in them. At such moments our eyes are opened. We catch disturbing glimpses of a theatre not yet created. Our imaginations leap forward.

It is the memory of these rare moments that inspires us and guides us in our work. While we are studying to perfect ourselves in the use of the intricate mechanism of stage lighting we are learning to transcend it. Slowly, slowly, we begin to see lighting in the theatre, not only as an exciting craft but as an art, at once visionary and exact, subtle, powerful, infinitely difficult to learn. We begin to see that a drama is not an engine, running at full speed from the overture to the final curtain, but a living organism. And we see light as a part of that livingness.

Our first duty in the theatre is always to the actors. It is they who interpret the drama. The stage belongs to them and they must dominate it. Surprising as it may seem, actors are sometimes most effective when they are not seen at all. Do you remember the impact of Orson Welles' broadcast of a

　　我想幾乎沒有一個舞台設計師不曾體驗過像這樣驚人的燈光活力，我個人將它視為所有劇場經驗中最為珍貴的一種，劇場的真實生命就存在於此。在這一剎那我們的眼開了，我們的想像向前飛躍，我們抓住了那紊亂靈光，一個從未展現過的劇場。

　　也正是這些少數瞬間的記憶啟發了我們，同時引領我們的工作向前，當我們在學習主控複雜的劇場燈光機械時，我們同時也在學習如何超越它。逐漸地，我們會發現到劇場燈光不只是一樣令人興奮的技術，而同時也是一種藝術，霎時間奇幻的、精準的、微妙的、強而有力的……無盡的課題。我們才體悟到戲劇不是一具從序曲到落幕都全速前進的機器，而是一種生命有機體，且燈光是這實體存在中的一個環節。

　　我們在劇場中的首要任務對象是演員，他們是詮釋戲劇的人，舞臺屬於他們，也因此他們必須主宰舞臺。說起來也許奇怪，有時候演員沒有現身但演出反而更讓人印象深刻，還記得在奧森・威爾斯（Orsen Welles）[1] 的廣播劇中，聽到火

1　1915–1985，美國電影演員、製片人，知名作品為《大國民》（*Citizen Cane*）。1938年製作廣播劇 *The War of the Worlds*，由於太過逼真，讓許多聽眾誤以為火星人確實入侵地球而倉皇奔逃。

threatened Martian invasion? A voice out of darkness…But this, of course, is an exception. In nine cases out of ten our problem is simply that of making the actors and their environment clearly and fully visible.

Visible, yes. But in a very special way. The life we see on the stage is not the everyday life we know. It is—how shall express it?—*more so*. The world of the theatre is a world of sharper, clearer, swifter impressions than the world we live in. That is why we go to the theatre, to dwell for an hour in this unusual world and draw new life from it. The actors who reveal the heightened life of the theatre should move in a light that is altogether uncommon. It is not enough for us to make them beautiful, charming, splendid. Our purpose must be to give by means of light an impression of something out of the ordinary, away from the mediocre, to make the performance exist in an ideal world of wisdom and understanding. Emerson speaks of a divine aura that breathes through forms. The true actor-light—the true performance-light—is a radiance, a nimbus, a subtle elixir, wherein the characters of the drama may manifest themselves to their audience in their inmost reality.

Perhaps the word *lucid* best describes this light. A lucid light.

星人攻擊地球的播出嗎？一個來自黑暗的聲音……但這當然是特例，我們需要處理的工作有百分之九十是要讓演員和他們所身處的環境清楚、完整的被看見。

　被看見。是的，但是以一種特殊的方式被看見。舞台上的生活和我們的日常生活並不對等，它——我該怎麼說呢？——更**超越**吧！劇場世界比我們所認知的世界更為敏銳、清澄、迅速。這也是為什麼我們願意走進劇場，花幾個小時把自己沉浸在這個非比尋常的世界，然後從中獲得新的生命。而揭示這被強化了的生命的演員們，也必須在非比尋常的光線中動作。我們不只要讓他們看起來美麗、迷人或者光彩動人，我們主要的任務應該是如何照亮已經跳脫平凡的事物，遠離平庸，使演出呈現在一個智慧與理性的理想世界中。這在愛默生認為是透過形式所傳達的絕妙氣息。真正的「演員燈光」——或者說真正的「表演燈光」——應該像是光彩、幻雲、點金石，在其中它可以讓演員們對觀眾顯露最內在的真實。

　也許用**清朗**來形容是最適切的，清朗的光。這讓我想到日

I think of the exquisite clarity in the prints of Hiroshige. A light of "god-like intellection" pervades these scenes. They are held in a shadowless tranquility that cannot change. The peace of the first snowfall is in them. Everything is perceived here; everything is understood; everything is known.

Or I might use the word *penetrating*. If we look at a portrait by one of our fashionable portrait-painters and then at a portrait by Rembrandt, we see that the one is concerned mainly with the recording of immediate surface impressions. His approach is that of a journalist who assembles a number of interesting and arresting facts for his leading article. The other penetrates beneath the surface into the inner life of his subject. In the portrait by Rembrandt we see not only the features but the character of the sitter; not only the character, but the soul. We see a life that is not of this moment but of all moments. We sense "the ultimate in the immediate." The portrait of an old man becomes a portrait of old age.

Or I might use the word *aware*. When we see a good play well performed we are brought to the quivering raw edge of experience. We are caught up into the very quick of living. Our senses are dilated and intent. We become preternaturally aware

本安藤廣重（Hiroshige）[2]版畫中的細膩清澈，一種「如神思維」的光感瀰漫在所有的場景中。他們被包圍在一種不可更動的無影寧靜之中，一如初雪乍落時的祥和，在這裡面一切是如此清晰明白。

　　或者我該用**穿透**這個詞。如果我們比較一下林布蘭特（Rembrandt）和當今熱門的畫家所繪製的人像，我們會發現後者所關心的是紀錄瞬間的表面印象，他作畫的方式就像記者為了頭條新聞，彙集一堆引人注目的事件一樣；而前者卻穿透了表面，深入畫作對象的內在生命。在林布蘭特的肖像畫中，我們不只看到模特兒的外貌，更看到了他的特質，除了特質，我們更看到了心靈，我們看到的不只是當下、更看到了永久，一種「瞬間的永恆」。一幅老人的肖像裡，我們讀到了老年的心靈。

　　更或者我要用**醒覺**這個詞。當我們欣賞了一齣精緻的好戲，我們會體驗到原始敏銳的感受所帶來的顫動，我們被極度旺盛的生命力所深深吸引，我們的感官會因專注而擴張，

2　1797–1858，日本版畫家，日本江戶時代著名的浮世繪大師，擅描繪大自然風景畫，並影響歐洲多位印象派畫家如梵谷、莫內等。

of each instant of time as it passes. In this awareness we see the actors more clearly, more simply, than we have ever seen human beings before. They seem, in some strange way, more *unified*. We no longer appraise them or criticize them or form opinions about them. We forget all that we have ever heard or read about them. We gaze at them as we gaze at long-lost loved ones or at those we look upon for the last time. *Forever and forever, farewell, Cassius…*And we see them in a different light. It is this *different* light that should be given in the theatre.

But more than all these necessary qualities, the lighting of a play should contain an element of surprise, a sense of discovery. It holds the promise of a new and unforgettable experience. I will give you an illustration. We are all familiar with the lines from Keats' sonnet, *On First Looking into Chapman's Homer—*

> *Or like stout Cortez, when with eagle eyes*
> *He stared at the Pacific—and all his men*
> *Looked at each other with a wild surmise—*

3 出自於莎士比亞作品《凱撒大帝》（*Julius Caesar*）。
4 1795–1821，十九世紀英國浪漫詩人；與拜倫、雪萊齊名。其十四行詩《初讀查普曼譯荷馬有感》（1816）描述閱讀了伊莉莎白時期劇作家George Chapman所譯的荷馬史詩後，因其譯文直率無拘的詮釋而大為驚訝。

我們將不可思議地驚覺到隨著時間流逝的每一個剎那。在這
樣醒覺中，我們比平常看任何人都清楚明白地看見演員。很
奇妙的，他們看起來似乎更**一致**，我們不再讚美他們、批評
他們或是對他們有意見，我們會忘記我們曾聽過或是讀過有
關他們的事。我們凝視著他們一如我們凝視著重逢的舊愛，
或是即將永別的摯愛。再會吧！永遠的不再相會了！凱西堊
斯[3]……我們在獨特的光下與他們相遇，在劇場裡就是需要
這**獨特**的光。

　　除了前面說的這些必然的特質外，劇場的燈光更應該具有
一種驚喜的元素、一種感知的探索，是對嶄新又難忘的體驗
的一種許諾。舉個例子來說吧，很多人對濟慈（Keats）[4]這首
十四行詩很熟悉《初讀查普曼譯荷馬有感》（*On First Looking
into Chapman's Homer*）：

　　　　……或者像勇敢的科提茲[5]，用他如鷹隼般的雙眼

　　　　凝視著太平洋……而他的隊員們

　　　　以一種猜疑的眼光互相對望著……

5　1485–1547，十六世紀西班牙探險家及墨西哥征服者。

Let us put out of our minds for a moment the accustomed music of these lines and allow the poet to take us with him on his high adventure. Imagine this little band of explorers, lost in wonder, on the shore of an unknown ocean. See their faces as the vision of a new world bursts upon them. A scene on the stage should give us the same sense of incredulity and wonder and delight. As we enter the theatre we too are on the threshold of a new experience. The curtain rises. The vision of a new world bursts upon us as it burst upon these voyagers of an earlier day. A new powerful life pervades the theatre. Our hearts beat with a wild hope. Is this what we have waited for? We ask. Shall we see at last? Shall we know?

Lighting a scene consists not only in throwing light upon objects but in throwing light upon a subject. We have our choice of lighting a drama from the outside, as a spectator, or from the inside, as a part of the drama's experience. The objects to be lighted are the forms which go to make up the physical body of the drama—the actors, the setting, the furnishings and so forth. But the subject which is to be lighted is the drama itself. We light the actors and the setting, it is true, but we illuminate the drama. We reveal the drama. We use light as we use words, to elucidate ideas and emotions. Light becomes a tool, an instrument of expression, like a paint-brush, or a sculptor's chisel, or a phrase

　　讓我們暫時忘記原本這些詞句中豐富的旋律感，讓詩人帶領我們一同進入他的偉大冒險。試想這一小隊探險家，充滿狐疑地迷失在不知名的海岸邊，看看他們的臉上，我們看到一個新世界在他們的眼前迸現。舞台上的任何一個場景，都應該讓我們感覺到同樣的不可思議、狐疑和愉悅。當我們走進劇場時，我們同時也是進入一種全新體驗的開端。大幕升起，在我們眼前展現的世界，應該和多年前展現在那些旅人眼前的世界一樣新鮮，一個嶄新而又強烈的新生命瀰漫在劇場中，我們的心，因強烈的企望而急劇跳動著，我們會問：這就是我們期待的嗎？我們終於看到了嗎？我們能理解嗎？

　　舞台燈光所含括的不只是對**被照體**（object）的照明，同時還是對**被照主體**（subject）的照明。我們可以選擇有如旁觀者一般，從外在照亮這齣戲，或者選擇以戲劇體驗的方式從內在來照亮這個演出。所謂的被照體是指所有構成一齣戲的外在條件──演員、佈景、傢俱等等，但是所謂的主體則是戲劇的本身。沒錯，我們照明（light）的對象是演員和佈景，但是我們必須照亮（illuminate）戲劇、揭示戲劇。燈具對於我們一如文字用來闡述理念和情感，燈光變成一種工具，用來表現的器材就如同畫家的畫筆、雕塑家的鑿刀、樂

of music. We turn inward and at once we are in the company of the great ones of the theatre. We learn from them to bathe our productions in the light that never was on sea or land.

One afternoon many years ago I was taken into the inner room of a little picture gallery and there I saw, hanging on the wall opposite me, Albert Pinkham Ryder's painting of *Macbeth and the Witches*. I knew then in a sudden flash of perception that the light that never was on sea or land was reality and not an empty phrase. My life changed from that moment. Since then I try with all the energy of which I am capable to bring this other light into the theatre. For I know it is the light of the masters.

I find this light of other days in the paintings of Ryder and Redon and Utrillo, in the etchings of Gordon Craig, in Adolphe Appia's drawing of the Elysian Fields from the third act of the *Orpheus* of Gluck. Here it is for everyone to see, achieved once and for all, so clearly stated that no one can escape it. I find it implicit in certain scenes from Shakespeare. It casts its spell upon the lovers, Miranda and Ferdinand, as they meet for the

6 1847–1917，美國畫家，其風景畫富含詩意及寓意而有如視覺詩；《馬克白與三女巫》為其名畫之一，創作約開始於1895年且花費14至20年才完成。
7 1840–1916，法國象徵派畫家，繪畫具神祕與幻想意境。

章中的樂句。我們自內在尋求，才能和劇場中的宏偉並存，我們從中受教，把我們的演出浸淫在那從不曾在海天之間存在的光裡。

　　多年前的一個下午，我被邀請到一間小畫廊的內室，我看到面前懸掛著一幅平克漢·萊得（Pinkham Ryder）[6]所繪製的《馬克白與三女巫》（*Macbeth and the Witches*），我突然體悟到，所謂從不曾在海天之間存在的光的真實性，它並不是一句空話。就在那瞬間我的生命改觀了，此後我盡一切的努力把這樣的光感帶進劇場，因為我知道那是大師們眼中的光。

　　這樣的光感，後來我在魯東（Redon）[7]和郁特里洛（Utrillo）[8]的作品中、在葛登·克雷格的蝕刻版畫裡、在阿道夫·阿琵亞為《奧菲士》（*Orpheus*）[9]一劇第三幕所繪製的極樂世界設計稿當中，都同樣感受到。它是如此清楚明白的展現在我們眼前，沒有人能夠逃避如此明晰的陳述。我也發現在莎士比亞劇作的某些場景中，也隱含著相同的意味，它對米蘭達（Miranda）和佛第南（Ferdinand）[10]這對愛侶，

8　1883–1955，法國畫家，創作題材多為巴黎街景，尤其描繪其出生地蒙馬特更為著名。
9　希臘神話中豎琴高手，其音樂能感動鳥獸木石。
10　《暴風雨》（*The Tempest*）一劇中男女主角。

first time on Prospero's magic island. Miranda speaks—

> *What, is't a sprit?*
> *Lord, how it looks about: Believe me, sir,*
> *It carries a brave form. But 'tis a sprit...*
> *I might call him A thing divine, for nothing natural*
> *I ever saw so noble...*

And Ferdinand—

> *Most sure the goddess*
> *On whom these airs attend...my prime request,*
> *Which I do first pronounce, is, O you wonder,*
> *If you be maid or no?—*

And again, when Prospero by his art calls down the very gods and goddesses from Olympus to celebrate their marriage, Ceres,

11 《暴風雨》劇中女主角米蘭達的父親，也是魔術師，政爭失敗被流放小島，佛第南是其對頭的兒子。
12 羅馬神話中耕作女神；相當於希臘神話中之 Demeter。

當他們在普洛士帕羅（Prospero）[11]的奇異之島上初遇的那一
刻灑下魔咒。米蘭達說——

　　這是什麼，是個神仙嗎？

　　天啊！看他四下張望的樣子！相信我，父親，

　　他的身型多麼魁梧啊！他一定是神仙……

　　我可以這麼說如此神聖，在人間

　　我所不曾見過如此高貴的……

佛第南說——

　　一定是的，這位女神

　　讓樂聲伴隨著她……我最大的疑惑，

　　讓我先問了吧！那就是，喔！你是仙子；

　　還是你是個女孩……

　　再一次，當普洛士帕羅用他的魔法，從奧林帕斯召喚各路
神明，像是席瑞斯（Ceres）[12]、偉大的朱諾和披著彩虹的艾

and great Juno, and Iris with her rainbow—

>—and thy broom-groves,
>Whose shadows the dismisséd bachelor loves,
>Being lass-lorn: thy pole-clipt vineyard,
>And thy sea-marge, sterile and rocky-hard,
>Where thou thyself dost air, the Queen o' the sky,
>Whose watery arch and messenger am I…

A rare light of the imagination is poured over the scene, fresh and disturbing and strangely tender. A new theatre draws near, bathed in "the nameless glow that colors mental vision."

Lucidity, penetration, awareness, discovery, inwardness, wonder… These are the qualities we should try to achieve in our lighting. And these are other qualities too. There is a quality of luster, a shine and a gleam that befits the exceptional occasion. (It would be hard perhaps to make the water-front saloon setting of *Anna Christie* lustrous, but I am not so sure. It is the occasion

13 希臘神話中彩虹女神。
14 作者尤金·歐尼爾。

瑞斯（Iris）[13]，來參加他女兒的婚禮——

> ……在你的林子裡，
>
> 失戀男子最愛徜徉在你的樹蔭下，
>
> 孤單的女孩，你為他們備下了繞架纏柱的葡萄園，
>
> 還有你那海崖，怪石巉巖
>
> 你快意翱翔於天際，而那穹蒼之后，
>
> 我是她的信使，也是那霧渺渺的虹彩……

一道罕見的想像之光灑落在這個場景之中，清新又惱人，卻又那麼奇妙的溫柔，一種浸淫在「為心靈之眼著色的無名光輝」的新劇場向我們靠近了。

不管是說清澈的、有穿透力也好，或者說醒覺的、探索的、內在的、奇幻的都好。這些都是我們在從事燈光設計必須追求的某些特質，但是還有其他的質地也是我們工作中所必須的，那是一種光輝，是合適於某一個特殊事件或機遇所隱隱閃現的光芒（也許要讓《安娜‧克麗絲蒂》〔*Anna Christie*〕[14]一劇當中，河畔沙龍的場景看起來閃耀動人似乎

and not the setting which should be lustrous.) There is a quality which I can only describe as racy, a hidalgo quality, proud, self-contained. And last of all, there is a quality of security, a bold firm stroke, an authority that puts an audience at its ease, an assurance that nothing in the performance could ever go wrong, a strength, a serenity, flowing down from some inexhaustible shining spring. Here, in a little circle of clear radiance, the life of the theatre is going on, a life we can see, and know, and learn to love.

But creating an ideal, exalted atmosphere, an "intenser day" in the theatre is only a part of our task, so small a part that at times it seems hardly to matter at all. However, beautiful or expressive this light may be, it is still not a dramatic light. Rather, it is a lyric light, more suited to feeling than to action. There is no conflict in it: there is only radiance. Great drama is given to us in terms of action, and in illuminating dramatic action we must concern ourselves not only with light, but with shadow.

How shall I convey to you the meaning of shadow in the theatre—the primitive dread, the sense of brooding, of waiting,

15 出自於亞里斯多德（Aristotelis）之《詩學》（*Arte Poetica*），照亞氏的說法，動作的模擬能激發情感，依動作的性質之不同而引發不同的情緒反應，如嚴肅的動作引發哀憐、恐懼、憤怒、友善、敵意等等反應；低俗的動作則引發喜悅與大笑。此等情緒效果的引發與洗滌正是戲劇詩的機能或目的性所在。

有點不太可能，但也不盡然，因為我所指射的是一個時刻而
不是場景本身）。這種特質我只能名之為精力充沛的、尊貴
的、輝煌的和全然完備的。最後它必須要提供一種安全感，
像是一道強力堅實的筆觸，成為安定觀眾心緒的憑藉；像是
從一道永不止歇的光之泉中，汩汩流出的祥和力量，撫慰著
觀眾不安的心。在這小小的一圈光暈中，劇場生命不斷地向
前推移，那是一個我們能夠目睹、了解，同時熱愛的生命。

　　創造一個理想且典雅的氛圍，或者說是在劇場中製造一個
「印象濃烈的日子」，只是我們工作中極小的一部分，有
時候小到幾乎不佔任何重要性。無論我們所創造的光感是多
麼的美麗，或是具表現性，這樣的燈光還不能稱之為戲劇燈
光，只能說是一種抒情的燈光。這樣的燈光對感官的訴求，
更勝於對戲劇動作（dramatic action）本身的表達。這兩者之
間其實並沒有衝突，有的只是戲劇本身所散發出來的光輝。
偉大的戲劇所呈現在我們眼前的是動作（action）[15]，對於戲
劇動作的照明，我們需要同時考慮的應該不只是光，還有影。

　　我應該怎樣表達陰影在劇場裡的意義呢？——那種原始的
畏懼，一種被籠罩覆蓋、一種靜待、一種災厄的感覺，畏

of fatality, the shrinking, the blackness, the descent into endless night? *The valley of the Shadow.... Ye who read are still among the living, but I who write shall have long since gone my way into the region of shadows...Finish, bright lady, the long day is done, and we are for the dark...* It is morning, the sun shines, the dew is on the grass, and God's in His Heaven. We have just risen from sleep. We are young, the sap runs strong in us, and we stretch ourselves and laugh. Then the sun rises higher, and it is high noon, and the light is clear, and colors are bright, and life shines out in a splendid fullness. Jack has his Jill, and Benedick his Beatrice, and Millamant her Mirabell. But then the sun sinks down, the day draws to its close, the shadows gather, and darkness comes, and voices fall lower, and we hear the whisper, and the stealthy footfall, and we see the light in the cranny of the door, and the low star reflected in the stagnant tarn. A nameless fear descends upon us. Ancient apparitions stir in the shadows. We listen spellbound to the messengers from another world, the unnatural horrors that visit us in the night.

I shall leave the doctors of psychology to explain the connection between this ancient terror and the dread of the unknown darkness in our minds which they have begun to call the subconscious. It is enough for us to know that the connection exists, and that it is the cause of the curious hold which light and shadow can exercise over the imagination of an

縮、闃暗、落入無止盡的黑夜。幽暗之谷⋯⋯在閱讀的你們還與那生者同在，而在書寫的我卻早已踏入了闃黑的境域⋯⋯完了，好娘娘；光明的長日已盡，我們要走向黑暗了⋯⋯[16]是個清晨，陽光普照，芳草含露。上帝在祂的天堂裡，剛從睡夢中甦醒的我們，在年輕的身體裡竄流著充滿活力的血液，我們舒展四肢盡現歡顏。日頭逐漸高昇，已是正午，在澄澈的光照下，色彩是如此地飽滿、生命又是那麼地豐沛燦爛，戀人們儷影雙雙。但是，接著金烏西沉，白日已盡，暗影匯集，黑夜降臨，四下悄然，林中落葉沙沙作響，傳來了竊竊足音，門隙間流洩出的微光，寥落的星辰倒映在湖水裏。莫名的恐懼包圍著我們，古老的幻影攪和在幽影之中，如同被下了魔咒一般，我們靜靜聆聽著來自另一個世界的使者，那在黑夜裡拜訪我們的恐懼。

　　我還是把這種對於未知黑暗的恐懼，和亙古的驚駭之間的關聯，留給心理醫生來解釋，這已經被他們命名為潛意識的詞彙。我們只要知道這兩者之間的確存在著實際的關係，也正是這種光與影之間奇妙的關聯，可以激發觀眾的想像。我

16 The valley of the Shadow出自聖經舊約《詩篇》（*Psalm* 23），"Yea, though I walk through the valley of the shadow of death, I will fear no evil" 即便走在死蔭幽谷也不怕遭害，因為上帝是我的牧者。"Ye who read are still among the living, but I who write shall have long since gone my way into the region of shadow" 出自愛・倫坡（Edgar Allan Poe）的作品《死蔭——寓言一則》（*Shadow—A Parable*, 1835），以寓言化的

audience. At heart we are all children afraid of the dark, and our fear goes back to remote beginnings of the human race. See the mood of an audience change, hear them chatter or fall silent, as the lights in the theatre are raised or lowered. See them rush to the nearest exit at the sudden rumor, "The lights have gone out!" See their instant reassurance as the broken circuit is repaired and the great chandelier blazes once more. It is such instinctive responses that give light its dynamic power in the theatre.

Our greatest dramatists have woven light and shadow into their creations. Dramatic literature is filled with examples. We see Lavinia Mannon as she closes the shutters of the Mannon house, banishing herself forever from the light of day. We see the moon shining fitfully through scudding storm-clouds over the ramparts of Elsinore, where the unquiet ghost of Hamlet's father wanders, wrapped in his black cloak, "for to go invisibell." We hear the tortured cry of Claudius, "Give me some light! Away!" The dim shadows of Pelléas and Mélisande embrace one another far away at the end of the garden;—*Comme nos ombres sont grandes ce soir!... Oh! quelles s'embrassent loin de nous!...*We

影子影射怪誕恐怖或死亡的陰影。"Finish, bright lady, the long day is done, and we are for the dark" 源自莎士比亞的Anthony & Cleopatra，原文詞句為 "Finish, good lady; the bright day is done, and we are for the dark…" 為待從 Iras 在 Cleopatra 皇后知覺大勢已去時對她說的話。上述三段皆以黑暗陰影喻死亡及恐懼的意象。

們的內心深處每一個人都像孩子一樣懼怕黑暗，而這種畏懼感是和人類的起始深深相繫。看看觀眾席中的觀眾在燈光裡交談私語，一旦場燈變暗他們立刻寂靜無聲，如果這時傳來了：「停電了！」的耳語時，看看他們是怎樣衝向最近的出口，直到電力系統復原，豪華水晶吊燈再度大放光明後，他們又是如何重拾安全感。這種直覺反應的激發，是讓燈光能夠變成劇場中強大力量的原因。

　　戲劇史上偉大的劇作家們已然把光影織進了他們的作品中，戲劇文學中的例證俯拾皆是。我們可以看到當拉維尼亞・曼儂（Lavinia Mannon）[17] 關上曼儂大宅的百葉窗，將自己永遠逐出陽光的照射。我們也看到斷斷續續的月光，透過疾馳而過的烏雲，隱約照在艾辛諾城堡周圍堤狀壁壘上，那是哈姆雷特亡父的不安鬼魂，穿著有如隱形的黑色斗篷所遊蕩的壁壘。我們也聽到飽受折磨的克勞地（Claudius）[18] 哭喊著：「去吧！給我一些光」。微光下佩里亞斯和梅莉桑德在遠遠的花園彼端緊緊相擁著——我們今晚的影子是如此的巨大⋯⋯噢！我們的擁抱又是如此遙遠⋯⋯我們也看到在露其

17 出自於尤金・歐尼爾作品 *Mourning Becomes Electra* 中的角色。
18 哈姆雷特之叔父，毒死自己的哥哥丹麥國王，篡奪王位，與哈姆雷特的母親結婚，後被哈姆雷特刺死。

watch the two women in the anteroom of Lucio Settala's studio as they gaze at one another across the shaft of light that falls along the floor between them. We wander with Lear through a storm that is like a convulsion of Nature, "a tyranny of the open night," an "extremity of the skies."

Here is the most wonderful example of all, the great classic example of dramatic insight:

> *Lo, you, here she comes! This is her very*
> *guise, and, upon my life, fast asleep.*
> *Observe her: stand close.*
> *How come she by that light?*
> *Why, it stood by her, She has light by her*
> *continually, 'Tis her command.*
> *You see, her eyes are open.*
> *Ay, but their sense is shut.*
> *What is it she does now?*

Shakespeare animates the scene with his own intense mood. The candle flame lives in the theatre. It becomes a symbol of

19 出自鄧南遮的悲劇作品 *La Gioconda* (1899)，劇中主角露其歐‧瑟泰拉為雕塑家，愛上模特兒 La Gioconda 而拋棄妻子 Silvia，劇中兩女對峙為高潮一幕。鄧南遮為義大利詩人、小說家及戲劇家（1862–1938）。

歐・瑟泰拉（Lucio Settala）[19]的工作室前廳裡，兩個女子隔著流洩在地板上的燈光互相瞪眼對望。我們和李爾王一同流浪於如同造物主暴怒的風雨中，那「廣袤夜空的暴虐」，是一種「崩殂之天」。

　　我再舉一個精采的例子，它可以說是闡釋戲劇洞察力的一個極為經典的例證：

　　侍女：你看，她來啦。她就是這個樣子。我以生命來
　　　　　打賭，她是熟睡著。
　　　　　仔細看她，站近一些。
　　醫士：她怎麼拿到那盞燈的？
　　侍女：怎沒有？就在她身邊啊，她身邊永遠點著燈，
　　　　　這是她的吩咐。
　　醫士：你看，她的眼睛睜著呢。
　　侍女：是的，但她的視覺是閉著的。
　　醫士：她現在做什麼呢？

　　莎士比亞以他獨有的濃烈基調將這一個場景賦予生命。劇場中的燭光，在此時轉換成馬克白夫人生命意像的寫照

Lady Macbeth's own life – flickering, burning low, vanishing down into darkness. *Out, Out, brief candle!* …Where the layman might see nothing more than an actual candle, made of wax, bought for so much, at such and such a place, the dramatist has seen a great revealing image. He has seen deep into the meaning of this terrible moment, and the taper is a part of it. *Animula, vagula, blandula,* little flame, little breath, little soul, moving before us for the last time…And the shadow on the wall behind "that broken lady" becomes an omen, a portent, a presage of her "sad and solemn slumbers," a dark companion following her, silent and implacable, as she passes from this to that other world. *She should have died hereafter. Life's but a walking shadow…*When we think of this scene we remember, not only the dreadful words and the distraught figure, all in white like a shroud; we see vast spaces and enveloping darkness and a tiny trembling light and a great malevolent shadow. The icy fear that grips us is built up out of all these elements. And when we put the scene on the stage we do not serve Shakespeare's drama as we should serve it until we have given each of these elements its full value and its proper emphasis.

As we dwell upon these great examples of the use of light in the theatre we cease to think of harmony and beauty and think instead of energy, contrast, violence, struggle, shock. We dream of a light that is tense and vivid and full of temperament,

——熒熒然蠟炬將成灰。**滅了吧！滅了吧！這淺淺的燭火！**
……對外行人來說，他們只看到這蠟燭的表象，店裡買的石
蠟現成品。但是戲劇藝術家卻看到了它所傳遞的訊息，他必
須深入地去理解這可怕的一刻，而燭光在此時就佔有著極其
重要的地位。微小的火焰、囁嚅的呼吸、卑微的靈魂，最後
一次走過我們眼前……在這位「身心俱疲的夫人」身後牆上
的影子，變成一種預示、跡象，預言了她「哀傷且沉鬱的麻
痺」，當她從此時此刻走向另一個世界時，黑色的身影伴隨
著她，安靜又無情。**從此她將死去，生命對她而言不過如同
移動的影子**……當我們想到這個場景時，我們想到的不止是
駭人的言詞、和穿著如同壽衣一般雪白的狂亂身影，我們看
到了巨大的空間中，鋪天蓋地的黑暗裡，渺小搖曳的燭火和
一個充滿敵意的巨大陰影，所有的這一切以一種令人不寒而
慄的恐懼將我們緊緊扣住。而除非我們能夠對這其中所有的
元素，給予其應有的價值和適度的強調，否則我們不應該將
莎士比亞的戲劇以我們自己都不理解方式再次放上舞台。

　　當我們沉浸在這些劇場中使用光的偉大例子的同時，我們
已經不再追求美觀與和諧，相反的是一種能量、對比、狂
暴、掙扎和震驚。我們夢想著一種濃烈且生動的光，充滿了

an impulsive, wayward, capricious light, a light "haunted with passion," a light of flame and tempest, a light which draws its inspiration from the moods of light in Nature, from the illimitable night sky, the blue dusk, the halcyon light that broods over the western prairies. We say with D'Annunzio, *I would that Nature could be round my creations as our oldest forefathers saw her: the passionate actress in an immortal drama...* Here before us as we dream is the frame of the proscenium, enclosing a darkness like the darkness that quivers behind our closed eyelids. And now the dark stage begins to burn and glow under our fingers, burning like the embers of the forge of Vulcan, and shafts of light stab through the darkness, and shadows leap and shudder, and we are in the regions where splendor and terror move. We are practicing an art of light and shadow that was old before the Pyramids, an art that can shake our dispositions with thoughts beyond the reaches of our souls.

The creative approach to the problem of stage lighting—the art, in other words, of knowing where to put light on the stage and where to take it away—is not a matter of textbooks or precepts. There are no arbitrary rules. There is only a goal and a promise.

敏銳，一種衝動的、反覆無常又難於捉摸的光，一種「被激情所縈繞」的光、騷動與激烈的光、一種被大自然的氛圍所激發的光，這光來自無垠的夜空，那陰鬱的藍，來自那孕育西方廣袤草原的幸福之光，我們和鄧南遮（D'Annunziou）一同追求──我企求在我的作品中，被那和我們祖祖輩輩所同享的大自然所充滿，她像一個充滿熱情的演員，在扮演著一齣永恆的戲……而現在在我們眼前的夢想是被舞台鏡框所封閉的黑暗，這黑暗帶給我們的悸動如同我們閉上的眼瞼。現在在這黑暗的舞台將在我們的手上燃燒發光，像伏爾甘（Vulcan）[20]的鍛鐵爐一般，發出燦爛的光芒，像利刃一般穿透黑暗而令它戰慄奔逃。我們登上了華采與驚懼共熔的境域，我們在執行一項比金字塔還要古老的藝術，光與影的藝術，這種藝術以一種超越我們靈魂深處的思想震動了我們的脾性。

對於舞台燈光這門課題（應該說藝術）的創意探索──了解在舞台上何處應該給光、何處應該把光拿掉──不在於教科書或是規條，這當中並沒有強制的規定。有的只是目標和

20 羅馬神話中火與鍛冶之神，相當於希臘神話之 Hephaestus。

We have the mechanism with which to create this ideal, exalted, dramatic light in the theatre. Whether we can do so or not is a matter of temperament as well as of technique. The secret lies in our perception of light in the theatre as something alive.

Does this mean that we are to carry images of poetry and vision and high passion in our minds while we are shouting out orders to electricians on ladders in light-rehearsals?

Yes. This is what it means.

許諾，在劇場中我們已經擁有充裕的條件，去創造這樣理想的、具昇華力的、富含戲劇張力的燈光。而我們是否能夠成功，技巧和敏銳度是同等的重要，端賴於我們是否將劇場燈光當成是一個有血有肉生命體。

這樣說來，是不是當我們在對著燈梯上的工作人員大喊大叫的同時，心中依然懷抱著詩意、願景和高度的熱情呢？

是的！就是這麼一回事！

現代人^的延伸^{思考}

　　燈光、燈光、大多數從事設計燈光設計的朋友們，在做設計時第一個想到的應該都是：光源從哪裡來（distrubution）？光的質感（texture）是什麼？光的強度（intensity）是多少？和光的色彩（color）是怎樣？這是教科書上鐵一般的科律,可是似乎很少人去注意到陰影中的大千世界。有多少人在停電的夜晚靜靜地看著闃黑中傢俱的輪廓？在燭光中欣賞自己搖曳的身影？在月光下發現粼粼波光的河海？層層的山巒在幽微中的壯闊？有多少人還記得光與影的一體兩面？我們在處理光的同時也在處理影子，更或者說適當的影讓光更為立體，適當的影讓光更有生命，適當的影讓演出更有層次。掌握光的力量只能從一個方面思考，可是再加上掌握影的力量，可以讓你的思考更增加一個向度。

　　作為一名燈光設計，有多少次在劇場裡聽著導演喊叫：「我看不到那個誰誰誰！」作設計的你我馬上拿出燈光圖和magic sheet找燈加光？ 在那麼死人的片刻下真的是需要加光嗎？還是需要拿掉一些不必要的光？導演所謂的看不見，到底是看不見什麼？是舞台上的人？還是那個誰誰誰所扮演的角色？角色是需要被如彩筆鑿刀的燈光所刻畫的。照明（to light）與照亮（to illuminate）的本質差距何止千里，set cue時所喊出的每一個channel number，到底跟你晚上回家時打開的一盞燈有何不同？它到底是為了你找拖鞋而開？還是打開它溫暖了你一整天的疲憊？

　　很難過地，在二十一世紀今天的台灣劇場中，依然充斥著燈

光設計者一股自慢自小的氣氛，永遠聽到「不急啦！舞台還沒出來！」、「沒關係啦！導演都還不知道要幹麻！」、「你們先開始沒關係，反正我們最後才工作！」。舞台還沒出來做為燈光設計的我們，對角色所處的空間光影就一點想像也沒有嗎？導演還不知道要幹麻時，我們對舞台的畫面就可以毫不關心嗎？因為我們工作的期程比別人晚，就有理由把整個製作拋諸腦後嗎？惡性循環的結果讓大多數的所謂燈光設計，依然從事著50年前「打燈」的工作，縱容導演在我們的左右指揮呼喝，最後歸結一句「那都是導演要的！」把責任完全拋給別人，那麼整個production中「你」又在哪裡？「你」又何關緊要？

我一直認為舞台和服裝的設計是容易取悅觀眾的，因為他們掌握的素材千變萬化、形式層出不窮，所有成品雖無法直接觸摸，但也以具體的形象佔有著觀眾的視覺；相對的，燈光所掌握的元素卻相當微薄，電源控制、燈具形式、色紙廠牌和無法觸摸的空氣微塵，在如此有限且侷促的條件下，卻能夠晨曦暮靄、皓月星空、叢林暗影、幽微低沉、冷冽肅穆、歡欣鼓舞由外至內的無所不包。它的奇妙與神通是無法言喻的，所以我更喜歡在舞台設計課上跟同學們說：「千萬要把你們燈光設計同學當神一般的敬拜，因為一個好的燈光設計可以拯救你的一堂爛景，而一個爛燈光設計可以毀掉你半年的心血。」而這神的地位應當如何自尊自重，在追求科學和技術與時並進的同時，也許如包比先生所說：「彷彿初雪乍落的清朗、有如深入生命的穿透、令人歡喜讚嘆的醒覺與探索。」應該是我們在思考角度、位置、亮度和色彩之前，所不可或缺的永世功課。

VII
Toward a New Stage
新的企望

What is called realism is usually a record of life
at a low pitch and ebb viewed in the sunless light of day.

— Walter De La Mare

In our fine arts not imitation but creation is the aim.

— Emerson

VII
新的企望
Toward a New Stage

所謂的寫實主義通常像是在陰霾的日子裡

所記錄低調且悲觀的生命。

——華特・德拉瑪[1]

在細緻的藝術中我們追尋的是創意而不是模擬。

——愛默生

Once again the air of broadway is filled with the gloomy forebodings of the self-styled prophets of the theatre who are busy assuring us for the thousandth time that the theatre is dying. In the past we have not taken these prophecies of doom too seriously, for we have observed that the theatre is always dying and always being reborn, Phoenix-like, at the very moment when we have finished conducting the funeral service over its ashes. But this time there is a greater content of truth in what the prophets are telling us. The theatre we knew, the theatre we grew up in, has recently begun to show unmistakable symptoms of decline. It is dwindling and shrinking away, and presently it will be forgotten.

Let us look at this dying theatre for a moment. It is essentially a prose theatre, and of late it has become increasingly a theatre of journalism. The quality of legend is almost completely absent from contemporary plays. They appear to be uneasily conscious of the camera and the phonograph. There are brilliant exceptions to this generalization—I need mention only *Green Pastures, Strange Interlude,* or Sophie Treadwell's exciting *Saxophone*—but in the main the dramas of our time are as literal

1 1873–1956，英國詩人與小說家，亦為童書作家，著名作品為 *Memoirs of a Midget* (1921)。
2 作者 Marc Connelly，本作品由一名黑人小孩眼光詮釋舊約聖經，並於 1930 年獲得普立茲戲劇獎。

百老匯的天空再一次充滿著幽暗的預兆，這些所謂預言家已經不止一千次的保證我們的劇場正在消逝中。過去我們對這些末日預言並不曾認真以對，因為我們知道劇場一直處於垂死狀態，但也一再重生。有如浴火鳳凰般，從自己的灰燼中再次獲得生命。但是眼前在這樣的預言中透露了更重要訊息，我們所認識的劇場、我們在其中成長的劇場，近年來正毫無疑問地有著墜落的趨勢，它正在衰退、消滅，不久的將來將被遺忘。

　　讓我們來看看這個將死的劇場。在本質上，它是個平庸的劇場，近來更有變成一種媚俗劇場的趨勢。劇場中原有傳奇一般的色彩，在當代劇作中似乎已消逝殆盡，這些人似乎對於攝影機和留聲機有著極度不自在的自覺。當然在這個通則中也有著極為動人的例外——我只舉幾個少數的例子，像是《青青草原》（*Green Pastures*）[2]、《奇異的插曲》（*Strange Interlude*）[3]，或是蘇菲·崔德威爾（Sophie Treadwell）[4]扣人心弦的《薩克斯風》（*Saxophone*）——但是我們大多數的戲

3　作者尤金·歐尼爾，劇作演出長達五小時，描述一名女子在未婚夫死於戰地後不斷追尋幸福。
4　1885–1970，二十世紀美國女性劇作家與記者。著名的作品包括 *Machinal* (1928)，以及 *Intimation For Saxophone* (1934)。

as if they had been dictated by the village iceman or by a parlor-maid peering through a keyhole.

It is this theatre that is dying. Motion pictures are draining the very life-blood from its veins.

Disquieting as this may be to the purveyors of show-business, there is a kind of cosmic logic in it. The theatre of our time grew up on a photographic basis and it would have continued to function contentedly on this basis for many years to come if motion pictures had not been invented. But nothing can be so photographic as a photograph, especially when that photograph moves and speaks. Motion pictures naturally attract to themselves everything that is factual, objective, explicit. Audiences are gradually coming to prefer realism on the screen to realism in the theatre. Almost insensibly Hollywood has brought an irresistible pressure to bear upon the realistic theatre and the picture-frame stage. Future generations may find it hard to believe that such things ever existed.

These statements are not to be construed as an adverse criticism of motion picture. On the contrary: motion pictures have begun to take on a new life of their own, a life of pure thought, and they are becoming more alive every day. The fact is that in our time the theatre has become mixed, confused, a

劇乏味到似乎像是鄉村小販所抄錄的對話，或是小旅店女服
務生從鎖鑰孔中偷窺的見聞。

　　是這樣的劇場在死亡，電影（motion picture）正在把劇場
血脈中的生命汁液消耗殆盡。

　　對表演藝術事業的提供者聽起來似乎足以令人擔憂，但這
當中有一個廣義的邏輯。我們所認識的劇場成長於一個照片
式（photographic）的根基，而如果電影不曾發明的話，劇場
未來還是會繼續自滿自足地運作。但是沒有任何東西比照片
更生動逼真了，尤其當影像裡面開始有動作和對話以後。因
此電影很自然地被所有真實、客觀、直接所吸引，而觀眾也
逐漸喜愛電影裡的真實感，超越過劇場中的真實。好萊塢在
一種完全不自覺的狀況下，讓寫實劇場和鏡框式舞台承受
著無可抗拒的壓力，未來世代將難以想像曾經發生過這樣
的事。

　　這樣的指陳不應該從表面上看作是對電影的負面評價，相
反地電影已經展開一種新的生命，一種純思想的生命，而且
日益壯大。實際上我們現在的劇場已經被攪亂混淆了，像個

hybrid. A play can be made from almost any novel and a motion picture can be made from almost any play. What this means is that the theatre has not yet been brought to its own perfection. Literature is literature and theatre is theatre and motion pictures are motion pictures, but the theatre we know is all these things mixed together and scrambled. But now—fortunately, some of us believe—we may note an increasing tendency toward the separation of these various arts, each into its own characteristic form. Motion pictures are about to become a great liberating agent of drama. By draining the theatre of its literalness they are giving it back to imagination again.

Think of it! No more copybook dialogue, no more drug-store clerks drafted to impersonate themselves in real drug-stores transferred bodily to the stage, no more unsuccessful attempts to prove to us that we are riding the waves of the Atlantic Ocean with Columbus instead of sitting in a theatre, no more tasteful, well-furnished rooms with one wall missing…A theatre set free for beauty and splendor and dreams—

Of late years realism in the theatre has become more and more closely bound up with the idea of the "stage picture." But now it would seem that this idea is about to be done away with once and for all. The current conception of stage scenery as a more or less accurate representation of an actual

混種產物，一齣戲可以改寫自任何一部小說，一部電影可以改拍自任何一齣戲，這其中所呈現的意義在於，劇場並沒有達到它應有的完美境界，文學就是文學，劇場就是劇場，而電影就只能是電影，但是我們所認識的劇場是所有這些的雜亂混和。不過現在──所幸依然有人相信──我們似乎看到一種區分這些個別藝術，讓他們回歸各自屬性的傾向。電影將成為一種更能解放戲劇的動能，只要它把戲劇中庸俗平凡的渣籽去除，電影將能夠重新把想像還給觀眾。

試想！不再有陳腐的對白、不再有雜貨店的店員被拉上台，在一個徒具表象的雜貨店裡扮演自己；沒有令人失望的嚐試，讓我們在劇場裡以為自己和哥倫布在同一艘船上，共同抵禦大西洋的風浪；不再有既雅緻又裝潢精美，但少了一面牆的房子……那是一個被美和光輝和夢想所解放的劇場。

近年來劇場中所謂的寫實主義，似乎已經變得和「舞台畫面」無法分割，但這樣的想法現在似乎就要永遠消逝了。對於舞台佈景的思考，通常是在某種程度上對一個真實場景的

scene—organized and simplified, to be sure, but still essentially a representation—is giving way to another conception of something far less actual and tangible. It is a truism of theatrical history that stage pictures become important only in periods of low dramatic vitality. Great dramas do not need to illustrated or explained or embroidered. They need only to be brought to life on the stage. The reason we have had realistic stage "sets" for so long is that few of the dramas of our time have been vital enough to be able to dispense with them. That is the plain truth. Actually the best thing that could happen to our theatre at this moment would be for playwrights and actors and directors to be handed a bare stage on which no scenery could be placed, and then told that they must write and act and direct for this stage. In no time we should have the most exciting theatre in the world.

The task of the stage designer is to search for all sorts of new and direct and unhackneyed ways whereby he may establish the *sense of place.* The purpose of a stage setting, whatever its form, whether it be for tragedy, comedy, history, pastoral, pastoral-comical, historical-pastoral, tragical-historical, tragical-comical, historical-pastoral, scene individable or poem unlimited, is simply this: *to remind the audience of where the actors are supposed to be.* A true stage-setting is an invocation to the *genius loci*—a gesture "enforcing us to this place"—and nothing more. The theatre we know occupies itself with creating stage "illusion."

重現——正確的來說，是重組和簡化，但是本質上依然是一種重現——但是這一現象即將被某種更不具象、更難觸知的理念所取代。在劇場的歷史中有個老生常談，只有在戲劇本身缺乏生命力的年代，舞台畫面才會變得重要，卓越的戲劇不需要被描繪、被解釋、被潤飾，它們只要在舞台上演出就能展現生命。我們之所以長久以來使用寫實「佈景」，是因為這麼多年來，我們的戲劇本身的生命力不足而不能免除使用寫實佈景。事實就是這麼簡單。但是，這種想法看起來似乎將要被棄之如同敝屣。如果今天我們能把一群導演、演員和編劇，放在一個空無一物的舞台上，然後告訴這群人，他們只能為這個空舞台編劇、導演和表演的時候，我們將立刻看到世界上最精采的劇場由是產生。

　　舞台設計師的工作是藉著尋找嶄新、直接又不陳腐的方式，建立一種**場域感**（sense of place），不論它的型式如何，不論它是針對悲劇、喜劇、歷史劇、田園劇、田園喜劇、歷史田園劇、歷史悲劇、歷史田園悲喜劇，還是難於分割、場景無盡詩意的戲劇，舞台設計的最基本目的，就是**點醒觀眾們演員所身處的場所**。真正的舞台佈景是在於對**場域特質**（genius loci）的召喚——一種「強化空間感」的企圖——就是這麼簡單，我們所認識的劇場它的魅力在於充滿了創造舞台「幻象」（illusion），然而我們現在所熱衷的不是幻象而

What we are now interested in, however, is not illusion, but allusion, and allusion to the most magical beauty. *I seek less*, said Walt Whitman, *to display any theme or thought and more to bring you into the atmosphere of the theme or thought—there to pursue your own flight.* This is precisely the aim of stage designing, to bring the audience into the atmosphere of the theme or thought. Any device will be acceptable so long as it succeeds in carrying the audience along with it.

The loveliest and most poignant of all stage pictures are those that are seen in the mind's eye. All the elaborate mechanism of our modern stage cannot match for real evocation the line, *Tom's a-cold*. A mere indication of place can send our imaginations leaping. *We'll e'en to't like French falconers, fly at anything we see...* It is this delighted exercise of imagination, this heady joy, that the theatre has lost and is about to find once more. Call upon this faculty—so strangely latent in all of us—and it responds at once, swift as Ariel to the summons of Prospero.

Shakespeare could set his stage with a phrase. Listen—

是隱喻（allusion），對極度迷人的美的隱喻，華德·惠特曼
曾說：「我不企圖展現任何主題或見解，我更期望引導你們
進入它們的渲染當中──自此展開你們自己的翱翔。」這正是
舞台設計的目的，帶領觀眾進入主題和意圖，只要能夠成功
地在這個主軸上引導觀眾，任何方式都應該被接受。

　　最美麗最動人的舞台畫面是透過心靈之眼所看到的。任何
現代劇場精巧的機械，都無法和一句簡單台詞所能勾起的思
緒匹敵，像那一句「湯姆正冷著呢！」[5]一個簡單的提示就
能帶領我們的想像起飛，我們將如鷹隼般飛翔，翱翔在目光
所企及的任何所在[6]……當今劇場失去的正是這樣想像力所
帶來的歡快和無上喜悅，而它即將被重新拾回。只要我們開
口呼喚這種能力──它是如此奇妙地潛藏在我們所有人心中
──它將立即回應，迅捷一如艾麗兒回應普洛士帕羅的召喚。

　　莎士比亞用簡單的幾句話，就能構築出他的舞台場景。
聽啊──

5 出自莎士比亞《李爾王》一個場景，對話中不斷出現這一句對白，象徵說者有所
　要求但不直接明白講出，因而牽動觀眾許多聯想。
6 出自莎士比亞《哈姆雷特》，哈姆雷特接見伶人時對他們說的話，希望演員們隨
　意發揮，讓想像力馳騁以自由展現技藝。

This castle hath a pleasant seat ; the air
Nimbly and sweetly recommends itself
Unto our gentle senses…

Listen again—

Now we bear the king
Toward Calais; grant him there; there seen,
Heave him away upon your winged thoughts
Athwart the sea…

And here is William Butler Yeats' introduction to *The only Jealousy of Emer—*

I call before the eyes a roof
With cross-beams darkened by smoke.
A fisher's net hangs from a beam,
A long oar lies against the wall.
I call up a poor fisher's house…

這座城堡的位置很好，清爽的空氣
吹拂著我們微妙的感覺……

再聽聽看——

這會兒我們送國王奔赴卡萊，
假定到達了那，讓人看到了他，
再憑你思想的雙翼，
護送他橫渡海洋

下面是威廉・巴特勒・葉慈在《愛默僅有的忌妒》（*The Only Jealousy of Emer*）的開場——

一片屋頂在我眼前展開
交錯的樑椽有著煙薰的痕跡
桁下垂著漁人的網
靠牆立著的是長長的槳
我看到貧窮漁夫的住所……

And here is the speech of Hakuryo the Fisherman in the Japanese No drama, *Hagoromo*, so beautifully translated by Fenollosa—

> *I am come to shore. I disembark at Matsubara. It is just as they told me. A cloudless sky, a rain of flowers, strange fragrance all about me. These are no common things. Nor is this cloak that hangs upon the pine tree.*

And finally—to take a more familiar example—here is a passage from Thornton Wilder's play, *Our Town*. The narrator is speaking—

> *This is our doctor's house—Doc Gibbs'. This is the back door.*
> *This arched trellises are pushed out, one by each proscenium pillar.*
> *There's some scenery for those who think they have to have scenery.*
> *There's a garden here. Corn…peas…beans…hollyhocks.*

These stage directions (for that is what they are; they direct us) evoke the *locale* and the mood of the particular drama in question with great ease and with great economy of means. How

還有費諾羅薩（Fenollosa）[7]以優美文字所翻譯成的日本能劇《羽衣》中的漁夫白龍（Hakuryo）所說的——

> 來到這片海灘，我登陸於松原。誠如人們所言，無雲的空中，灑滿花雨，馥郁芳香繚繞著我，眼前一切皆非尋常，更有那高掛松梢的袍服。

最後，舉一個大家熟悉的例子，摘取自桑頓‧懷爾德（Thornton Wilder）[8]的劇作《小鎮風光》（*Our Town*），敘事者說——

> 這是醫生家，吉勃醫生的家，這裡是後門。
> 兩道拱形的木格子牆從鏡框的左右兩邊被推出來
> 這些佈景，是為了那些認為必須有佈景的人準備的。
> 這裡是個花園，玉米……豌豆……蠶豆……蜀葵……

這些舞台指示（的確是這樣，它們導引著我們）用最輕鬆簡約的方式喚起了這齣戲的背景和基調，多麼簡單、多麼有

7　1853–1908，美國的東方文化學者、美術史學家，長期任教於日本，對十九世紀日本傳統美術的復興影響深遠。

8　1897–1975，美國小說家、劇作家，作品有：*The Bridge of San Louis Rey* (1927)、*Our Town* (1938)。

simple they are, and how telling, and how right! A few words, and the life-giving dramatic imagination answering the summons, fresh, innocent, immensely powerful, eagerly obedient.

In Shakespeare's day the written and the spoken word held a peculiar magic, as of something newborn. With this exiting new medium of dramatic expression at hand it was simple for a playwright to transport his audience from place to place by a spoken stage-direction,

In fair Verona, where we lay our scene…

or by a legend, THIS IS MASTER JONAH JACKDAWE'S HOUSE, OR, PLAIN NEAR SALISBURY, painted on a signboard. A printed legend seen on our stage today would arouse only a momentary curiosity, or at most a pleasure akin to that of examining some antique stage trapping in a museum, a sword once handled by Burbage, a letter penned by Bernhardt. There is little to be gained by attempting to re-establish such purely literary indications of place in the theatre. But the spoken word still retain its power to enchant and transport an audience,

9　約1567–1619，英國著名演員，善演悲劇，曾飾莎士比亞戲劇哈姆雷特、奧賽羅等主要角色 。
10　1844–1923，原名Rosine Bernard，法國女演員，音色優美，表演感情豐富。

力，卻又多麼正確。簡單的字句，讓那激發生命的想像力立即回應了呼召，是那麼地清新、單純，不可限量地強大，卻又不可思議地馴服。

在莎士比亞的時代，書寫字彙和口語似乎有著一種奇異的魅力，彷彿是一種嶄新的發現，有了這樣讓人興奮的新媒介在手，劇作家可以很容易地以口述的舞台指示，將觀眾引領到各個不同的所在：

　　我們的場景將在美麗的維洛那展開……

或者用一種圖說的方式在板子寫著：這是**約那‧捷克道威（Jonah Jackdawe）的房子，或是薩理斯貝瑞（Salisbury）附近的曠野**，今天如果在舞台上用一塊板子寫上地名只會引來一陣好奇；或者頂多像參觀古代劇場中的機關佈景一般引發觀眾的樂趣好感，其程度就如同看一把伯比奇（Burbage）[9]使用過的劍，或是一封柏恩哈特（Bernhardt）[10]所寫的信一般無二。在當今的劇場裡企圖重建這種純文字的指示沒有多大的實質意義，但是口語在傳導和吸引觀眾方面依然有著它無

and this power has recently been enhanced to an extraordinary and altogether unpredictable degree by the inventions of the sound amplifier and the radio transmitter. The technicians of the radio learned long ago to induce the necessary sense of place by means of spoken descriptions and so-call "sound-effects." These devices have caught the imagination of radio audiences. They are accepted without question and cause no surprise. We can hardly imagine a radio drama without them. It is odd that our playwrights and stage designers have not yet sensed the limitless potentialities of this new enhancement of the spoken word. A magical new medium of scenic evocation is waiting to be pressed into service. Imagine a Voice pervading a theatre from all directions at once, enveloping us, enfolding us, whispering to us of scenes "beautiful as pictures no man drew"…

Today we are more picture-minded than word minded. But what we hear in the theatre must again take its place beside what we see in the theatre. If we are to enhance the spoken word by any means what ever we must first be sure that it is worth enhancing. Here is a direct challenge to our dramatists and our actors to clothe ideas in expressive speech and to give words once again their high original magic.

Imaginative minds have been at work in our theatre for years and they stand ready to create new scenic conventions at a moment's notice. We may look with profit at a few of the

比的魔力。而這股力量又被近期所發明的擴音機和無線電廣
播發射機推向了無與倫比的全新境界，無線電工程師很早就
知道利用口述以及所謂的「音響效果」的方式建立臨場感，
這種方式深深地吸引著收音機的聽眾，從沒有人會質疑也不
會引起驚訝，如果廣播劇當中少了音響效果，實在很難想像
它會變成什麼樣子。但很可惜的是我們的戲劇工作者和舞台
設計師們，似乎還沒有嗅到這項強化口述語言工具的無限潛
力。一個新穎又具魅力的新媒介即將成為激發場景想像的新
動力，一霎時聲音瀰漫在劇場中，包圍我們、擁抱我們，在
我們耳邊輕輕低語著「如同從未被人所描繪過的美景」……

　　當今我們的心智思維更傾向圖片視覺而非文字言說，但我
們在劇場裡所聽到的還是要和所看到的並行，如果我們打算
無所不用其極來強化言說文字，我們得先確定這文字著實具
有吸引力。要以意味深長的台詞表達想法，且讓言詞重拾原
有的獨創性魅力，這的確是對劇作家和演員們直接的挑戰。

　　腦海中的想像已經在我們的劇場中運作多年，而它在不久
的將來將會創造新的，我們可以從觀察近年來幾個出色的

outstanding productions of these years. *The Cradle Will Rock*:
A neutral-tinted cyclorama. A double row of chairs in which
the members of the cast are seated in full view of the audience.
An upright piano set slantwise near the footlights. The author
enters, sits at the piano, plays a few bars of music, announces the
various members of the cast, who bow in turn as their names are
mentioned. Then he says simply, The first scene is laid in a night
court. Two actors rise and speak the first lines. The play has
begun…*Julius Caesar*: The bare brick walls of the stage of the
Mercury Theatre stained blood-red from floor to gridiron. The
lighting equipment fully visible. A wide low platform set squarely
in the center of the stage. A masterly handling of the crowds
and some superb acting…Stravinsky's *Oedipus* Rex presented by
the League of Composers: The great stage of the Metropolitan
Opera House a deep blue void out of which emerge the towering
marionettes who symbolize the protagonists of the drama. Their
speeches declaimed in song by blue-robed soloists and a blue-
robed chorus grouped in a pyramid on the stage below them…
The procession of wet black umbrellas in the funeral scene of
Our Town. The little toy Ark in *Green Pastures*. The Burning Bush
in the same play, a tiny faded Christmas tree with a few colored
electric light bulbs hanging on it. Best of all, and ever to be

演出中獲得益處：在《搖籃搖》（*The Cradle Will Rock*）[11] 一劇當中，淡淡大地色系的天幕，觀眾看到所有演員坐在兩排椅子上，一台直立式鋼琴斜放在接近腳燈的位置，作者進場在鋼琴邊坐下，彈了幾個小節的音樂，把每一個演員所扮演的角色向觀眾一一介紹，當演員被介紹時它們個別起立向觀眾行禮，然作者簡單的宣布第一景是發生在一個夜晚的庭院裡，兩個演員起立開始了第一句台詞……《凱撒大帝》，水星劇院（Mercury Theatre）中，舞台上裸露的磚牆從地板到舞台頂棚都沾染成血紅色，燈光設備清楚可見，舞台中央有一個低矮的平台，優秀的表演加上群眾場景被處理得極為出色……指揮家協會所推出的史特拉汶斯基《伊底帕斯王》，大都會歌劇院的舞台上在一片空虛的深藍色中，高聳著一具象徵主角的懸絲傀儡，穿著藍色袍服的獨唱家和合唱團，在舞台上以金字塔式的排列激昂地歌詠著台詞……在《小鎮風光》最後葬禮那一場中，濕淋淋的黑傘隊伍。在《青青草原》中的玩具方舟，而在同一齣戲裡叢林火災一場，只用了一棵掛著幾個彩色小燈泡，小小的又將枯萎的聖誕樹來表示，而其中最令人印象深刻的是朝聖群眾向著應許之地前進

11　美國作曲家 Marc Blitzstein 創作於 1937 年的音樂劇，諷喻資本社會的貪婪腐敗。

remembered, the March of the Pilgrims to the Promised Land on a treadmill retrieved from a musical comedy and put by the author to an exalted use of which its original inventor had never dreamed. And there are many others.

Audiences have found these productions thoroughly convincing. Their delighted acceptance of the imaginative conventions employed gives proof—if proof be needed—that the unrealistic idea has come into the theatre to stay. Whether the particular devices I have noted are to be adopted in future or not is a matter of no importance. We may take courage from them to move forward boldly and with confidence.

Newer and more imaginative scenic conventions will presently become firmly established in the theatre and representations of place will be superseded by evocations of the sense of place. Then the stage designer can turn his attention away from the problem of creating stage settings to the larger and far more engrossing problem of creating stages. For the primary concern of the stage designer is with stages, and not with stage settings. All our new devices for scenic evocation will be ineffective except in an exciting environment. The new drama and its new stage setting will require a new type of stage. What will this new stage be like?

的隊伍，竟然是運用原本是為了一齣歌舞喜劇所設計的輸送帶，把原創者的意圖提升到了一個他所不曾想像的境界。當然還有更多的例子。

觀眾都覺得這樣的製作相當有說服力，他們對於想像式創作手法的欣然接受證實了一件事——如果需要證據的話——不寫實的做法已經開始在劇場中體現，我前面所提到的各種奇特裝置在此完全不是重點，重要的是，我們從這些人當中學習到勇氣，同時大膽、自信地和他們一起前進。

更新更具想像力的劇場裝置，在不久的未來將更堅實地進駐劇場，而描述式的場景也將被召喚式的場景所取代。因此舞台設計者將可以更專注心力在舞台，而不再為佈景所困，因為作為一個舞台設計者，我們所應該關注的是表演空間的本體，而不是實際具像的佈景，如果沒有一個能夠激化想像的環境，那麼所有的新穎設備都將徒具其形而已。所有新思維的戲劇和舞台佈置需要一個新型式的舞台，這個舞台會是怎麼樣的風貌呢？

First of all it will be presented frankly for what it is, a stage. I have never been able to understand why the stages of our theatres should invariably be so ugly. Theatre owners take great pains to make the auditoriums of their theatres glowing and cheerful and comfortable, but what we call a stage today is nothing more than a bare brick box fretted with radiator pipes. Why should this be so? One would think that a stage was something to be ashamed of, to be hidden away like an idiot child. Surely the first step toward creating a new stage is to make it an exciting thing in itself.

This stage will be simple, with the simplicity of the stages of the great theatres of the past. We shall turn again to the traditional, ancient stage, the platform, the *tréteau*, the boards that actors have trod from time out of mind. What we need in the theatre is a space for actors to act in, a space reserved for them where they may practice their immemorial art of holding the mirror up to nature. They will be able to move with ease to and from this space, they will be able to make their appropriate exits and entrances. We shall find a way to bathe these actors in expressive and dramatic light. And that is all.

I am looking forward to a theatre, a stage, a production, that will be exciting to the point of astonishment. Behind the proscenium will stand a structure of great beauty, existing in

　　首先，它必須確實地彰顯它的原始功能，就是一個舞台。我一直沒搞懂為什麼我們劇場的舞台，竟是如此一成不變地醜陋，劇場老闆們花了很大的氣力，把觀眾席弄得美侖美奐、明媚怡人，但是今天被我們稱之為舞台的東西，只不過是交纏著暖氣管線的磚箱而已，為什麼會這樣呢？舞台是那麼令人感到羞恥的東西，好像它是一個見不得人的智障兒。當然要創造一個新的舞台，我們必須把屬於舞台所應有的激越找回來。

　　這樣一個舞台，必須和歷史上誕生偉大劇場的時代一樣簡約，我們將重新拾回傳統古老的舞台型制，演員們踏著記憶中高起的台板來回逡巡。在劇場中我們需要的就是讓演員表演的空間，一個專為他們預留的空間，以展現他們那向自然借鏡的亙古藝術。在這裡他們可以自在地穿梭，他們可以展現應有的上下場風範，我們將找到一種能夠讓他們沐浴在既具表現性，又富戲劇性的光感中。就是這樣。

　　我在期待一個劇場、一個舞台，甚或是一個製作，它能夠使人激動到訝異的程度，在鏡框後面的舞台是一個出眾的場域，具有極致美感以及令人激賞的尊貴。想像的奔馳中它將

dignity, a Precinct set apart. It will be distinguished, austere, sparing in detail, rich in suggestion. It will carry with it a high mood of awe and eagerness. Like the great stages of the past, it will be an integral part of the structure of the theatre itself, fully visible at all times. Will this stage be too static, too inflexible, too "harshly frugal" for audiences to accept? Not at all. If it is beautiful and exciting and expressive we shall not tire of it. Moreover, its mood will be continually varied by changes of light.

Our new-old stage—this architectural structure sent through moods by light – will serve as never before to rivet our attention upon the actors' performance. It will remind us all over again that great drama is always presented to us in terms of action. In the ever-shifting tableaus of Shakespeare's plays, in the flow of the various scenes, he gives us an incessant visual excitement. Once we have arrived at an understanding of the inner pattern of any one of his plays and can externalize it on Shakespeare's own stage we discover an unsuspected visual brilliance arising directly from the variety of the action. It is the performance, not the setting, which charms us. The fixed stage becomes animated through the movement of the actors. All good actors will respond like thoroughbred race-horses to the challenge.

會引人矚目，卻又儉樸，捨棄了細節，卻又充滿了聯想。伴隨著它的是高度敬畏與渴求的心境，正如過去偉大的劇場舞台一般，它將和劇場建築本身成為不可分割的一部分，在任何時間都一覽無遺。這樣的舞台對觀眾來說，不會太過於靜態、太過沒彈性、太過「寒傖」嗎？絕不會！一旦只要它夠美，具表現力，我們就絕不會對它厭倦，更何況它的調性又將隨著燈光的變化不斷改變。

在這個藉由燈光散發它結構魅力的古今交融的劇場，將以前所未有的凝聚力讓我們更加專注於演員的演出，它也將再一次點醒我們，所有偉大的戲劇所呈現的全是關乎於動作（action）。在莎士比亞場景變換多端的戲劇當中，隨著場景流動的節奏提供了我們無止境的視覺激盪，一旦我們能夠體悟任何莎劇中的內在模式，而且能夠將之體現於莎劇所應有的舞台上，我們會發現到從這些場景中所散發出來無庸置疑的視覺光彩。吸引我們的是演出，而不是佈景。這樣一個沒有變化的舞台，卻因為演員的動作而生機蓬勃，任何一個優秀的演員面對這樣的舞台，都將變成像是訓練精良的駿馬面對挑戰一般躍躍欲試。

The fixed, impersonal, dynamic environment will be related to the particular drama in question by slight and subtle indications of place and mood—by ingenious arrangements of the necessary properties, by the groupings of the actors, by an evocative use of sound and light. Then the actors will be left free to proceed with the business of performance. In this connection we may again note a striking characteristic of radio drama. A stage setting remains on the stage throughout the action of any particular scene. But the setting of a radio drama is indicated at the beginning of the performance and then quietly dismissed. Radio audiences do not find it necessary to remain conscious of the setting during the action of the drama. They become absorbed in the performance at once. Why should not this be true of theatre audiences as will? Here is an idea that is filled with far-reaching suggestion for our stage designers. Can it be that the stage settings of today are too much with us, late and soon? Would not a setting be more effective if it were merely an indication of the atmosphere of the play offered to the audience for a moment at the beginning of the performance and then taken away again?

If we discard for a moment the idea of a setting as something that must act all through a play along with the actors and think of it instead as a brief ceremony of welcome, so to speak, a toast to introduce the speakers of the evening, all sorts of

　　這樣一個型式固定，客觀卻又深具活力與機能性的空間，藉由一些對空間和氛圍細緻又微妙的提示，就能針對不同的戲劇發揮它的功能——例如經由運用必要道具的巧妙擺放，或者是演員隊形的組合，亦或是借助具感染力的燈光或音響的幫助，此後演員們將在這樣一個舞台上盡情地發揮他們的表演專業。在這裡我們再一次發現到廣播劇驚人的特質。在任何一場戲的演出時，舞台上的佈景從頭至尾提醒著觀眾它們的存在，但是在廣播劇當中，所有的場景只有在演出開始時提示聽眾，然後就安安靜靜的消失了。收音機的聽眾們從來不需要在收聽過程中被提醒場景的存在，因為他們被戲劇本身所吸引。同樣的事為什麼不能發生在我們劇場中的觀眾席裡呢？在這裡向我們的舞台設計師們提出一個遠大的構想——會不會我們的舞台佈景遲早對我們來說變成一種累贅？如果舞台佈景只是演出開始前對劇情氛圍的提示，而後漸漸從觀眾眼前消失的話，這樣的佈景是不是就更具效果了？

　　讓我們暫時拋開一堂佈景必須自始至終與演員共同演出的這樣一個觀念，相反地，如果我們把它看作是一種簡短的儀式，就像是在歡迎當晚演講者的一個簡短致敬，在我們眼

arresting and exciting visual compositions occur to us. Scenery takes wings, becomes once more a part of the eternal flight and fantasy of the theatre. Let us imagine a few of these "transitory shows of things." A curtain lifted at the back of the stage to reveal a momentary glimpse of a giant painting of the park on Sorin's estate—the First Act of *The Sea Gull*. A delicate arrangement of screens and ironwork laced with moonlight for the setting of a modern drawing-room comedy, visible at the rise of the curtain, then gliding imperceptibly out of sight. A motion-picture screen lowered at the beginning of the performance of *He Who Gets Slapped*, the life of the little circus given to the audience in a series of screen "wipe-outs." A group of actors arranged in a vividly expressive tableau at the rise of the curtain to evoke a battle-scene from *Richard III*, dissolving into the action of the play. And so on. Such ideas may seem far-fetched, but they are by no means so far-fetched as we might be inclined to believe.

No one seriously interested in the theatre can be anything but overjoyed at the encroachments of Hollywood upon Broadway. Hollywood is doing what the artists of our theatre have been

12 作者為契訶夫（Anton Chechov, 1860–1904），海鷗象徵生活中憂傷而說不出的痛苦，此劇作表現悲傷的寫實風格，但特別以喜劇方式呈現讓觀者更有深刻感受。
13 原著為俄國劇作家 Leonid Andreyev (1871–1919)，本作品是 MGM（Metro-Goldwyn-

前呈現出各種令人讚嘆激動的視覺構成，我們的佈景就能展開雙翼，再一次成為翱翔於劇場永恆奇幻的一部分。讓我們試著想像一下這些如曇花一現般的景象：舞台後方升起一道幕，我們驚鴻一瞥地看到一幅繪製的索林莊園（Sorin Estate）──《海鷗》（*The Sea Gull*）[12]的第一幕，細緻的帳幔與鍛鐵製品和月光交織出這一齣現代客廳喜劇（drawing-room comedy）的場景，幕升起的瞬間呈現在我們眼前，隨後在我們不知不覺中從視線裡消退。在《被掌摑的人》（*He Who Gets Slapped*）[13]演出開始時降下一張電影螢幕，畫面中次第交替著呈現出小型馬戲團的生活。大幕開啟時，一群演員以生動的畫面讓觀眾聯想到戰爭場景，然後將場面逐漸融為正式的劇情，用這樣的方法來呈現《理查三世》（*Richard III*）[14]。這些想法看起來似乎有點不切實際，但也正是這樣的好高騖遠是我們所必須堅持相信的。

　　除非樂於見到百老匯被好萊塢蠶食鯨吞，否則沒有人會真正關心劇場將走向何處。好萊塢所做的事，是我們劇場人已

Mayer 米高梅）公司所發行的第一部電影。一名科學家在飽受羞辱後決定成為一名受人辱罵的小丑。
14 莎士比亞作品，故事以英王理查三世史料為背景。

trying to do for years. It is drawing realism out of the theatre as the legendary madstone—the Bezoar of the ancients—drew the madness from a lunatic patient. The only theatre worth saving, the only theatre worth having, is a theatre motion pictures cannot touch. When we succeed in eliminating from it every trace of the photographic attitude of mind, when we succeed in making a production that is the exact antithesis of a motion picture, a production that is everything a motion picture is not and nothing a motion picture is, the old lost magic will return once more. The realistic theatre, we may remember, is less than a hundred years old. But the theatre—great theatre, world theatre—is far older than that, so many centuries older that by comparison it makes our little candid-camera theatre seem like something that was thought up only the day before yesterday. We need not be impatient. A brilliant fresh theatre will presently appear.

經努力過多年的工作，他們像傳說中能夠吸出瘋狂病症的解毒糞石（bezoar）一般汲取劇場中的寫實主義。唯一值得保留的劇場，唯一值得擁有的劇場，是電影視野所不能觸及的劇場，只要我們能夠將腦海中照片式的觀念消除，唯有我們製作一個完全與電影命題相對的演出，這個演出是電影所沒有的，也無關乎電影的，那麼那消失已久的魔力將再重返。我們要謹記，寫實戲劇未及百齡，而我們的劇場，偉大的劇場，世界的劇場，是遠遠地超過，和它的歲月相較之下，我們所熱衷這種偷窺鏡頭式的劇場，像是幾天前才冒出來一般。我們無須不耐。一個光彩奪目、生機蓬勃的劇場即將登場。

現代人^的延伸^{思考}

　　電影的興起在原作當時的確為劇場帶來不小的震撼與衝擊，然而在今天，劇場所受到的衝擊比起七十年前有過之而無不及。劇場的演出依然深受好萊塢的威脅，再加上成百的電視頻道、網路和線上遊戲。身為設計的我們，究竟要如何在這五光十色的大環境下來定位自己？

　　劇場的特質就在它起始的那一瞬間留存至今，它製造一種幻覺而不在於重現真實，它製造一種渴望而不在於具體滿足。同時劇場也是一種毒，一旦沾染上了這種毒，能夠戒掉的人相信不多。維持這種癮頭最大的動力就在一種夢想，而劇場就成了最大的夢工廠。為自己織夢、為觀眾造夢。既然夢中充滿了各種可能性，那我們的劇場又何須畫地自限？因此外在的形式真實與否，並不是作者所關心的重點，能否召喚出演出本身的靈魂才更是他所關心的。而戲劇演出的靈魂就在文本，我們如何從文字的表面進入它的深處 ？

　　多少年以來我們讀詩、讀小說的同時，在腦海中有著一幅又一幅的畫面閃過，清冷的街道、熱鬧的酒館、黏膩的午後……這些畫面在我們閱讀的同時出現，是再自然也不過的事，為什麼我們在面對劇本的同時就失去了飛躍思緒，而被文字所框限住呢？依稀記得聖經中有一句話是這樣說的：「文字叫人死，但經義卻讓人活。」正是如此，我們必須穿透文字的表象，進入它背後所撐起的整個宇宙。文字，是人類發明中極端奧妙的一項成就，光是文字本身就能夠同時具備了精確與曖昧的雙重性，一旦當文字透過語言、語音、語氣的傳達，就接連地產生

了許許多多的面貌。

　　「閱讀」一直以來被認為是一個單一動作的詞，鮮少人會把「閱」和「讀」兩個字拆開來看。而把整件事停留在單純的一個「閱」字上面，忘記了一個需要發出聲音的「讀」字。欣賞一般文學著作我們也許可以用一個純粹的「閱」來面對，可是當我們面對充滿對白的劇本時，如果少了一個「讀」字，那麼如何完整的進入這個如此仰賴文字和聲音的藝術中呢？有聲的閱讀是讓一個設計工作者進入文本世界的重要工具，在聲調和語氣的推波助瀾下，文字背後的意義才能逐漸在我們的眼前展開。

　　表面上看起來作者似乎對於「寫實」這件事充滿了不安的情緒，但追根究底的說，包比先生希望我們能夠探討的「寫實」是內在的、深處的。外在模擬的真實一如樣品屋一般，徒增熱鬧氣氛地不屬於任何人。而當這個真實是從內在發展出來，就猶如我們踏進古蹟一般，雖然無人但那千年的故事瞬間就湧向我們的心間腦海，彷若重生。這也就是作者一而再、再而三反覆說明的「召喚」，當文本召喚著你的設計時，也同時召喚了觀眾。一旦這樣的「寫實」建構完成，外在的形式就自然誕生，至於是否「肖真」其實已完全在他的關注之外。有這樣的關心，才能夠為自己也為觀眾構築一個如夢的夜晚。

　　我們的劇場走到了今天，我們仍有企望嗎？我們能給下一個世代新的企望嗎？我想這一切都還依賴著我們所想要面對的真實到底是什麼，以及想為我們的劇場建構怎樣的夢想。

VIII
Behind the Scenes
幕落之後

And now the play is played out, and of rhetoric enough.

— Socrates

And is life not like the play? The gods who watch the drama
know that somebody must play the villain's part,
and somebody the pauper's...
He, therefore, who is wise plays pauper, king, or villain
with the gods in mind.

— Talbot Mundy

VIII
幕落之後
Behind the Scenes

戲已終了,所有華麗詞藻也終將結束。

　　——蘇格拉底[1]

生命不就像戲劇嗎?看著戲劇進行的眾神,

清楚地知道誰應該扮演惡棍、

誰適合扮演受難者……

那扮演受難者的、王公貴冑的,或是惡棍的,

他們心中必須謹奉著自己的神祇。

　　——陶博·曼地[2]

The taxi drops me at the old Nixon Theatre in Pittsburgh. I have traveled all day to come here. It is late. I go up the dark dirty alley littered with newspapers and refuse, to the grimy old sign, STAGE DOOR. Inside, the doorman, the letter-rack, the dark stage with its one tiny pilot-lamp, a pin-point of light in a region of shadows. The stage is lonely, and forlorn, and as silent as midnight. Ropes descend from the darkness of the flies, dim curtains fade away into mystery. How well I know these stages, with their chill, brooding atmosphere, their echoes and their memories! Here, in this Cimmerian darkness, in this strange sunless Acheron, dwell the great spirits of the Theatre. I feel them in the air around me.

A partly assembled setting is standing on the stage. I see the walls of a room hung with pictures and elaborate window draperies. I walk around the setting and go behind it. There is no back. Only a wooden framework covered with canvas, stamped with the name of the scene-painter and blackened by the handling of numberless stage-hands. Behind this scene, which will presently seem so real when viewed from the front, there is nothing. Nothing at all. Only the empty echoing stage, desolate, ominous, prophetic.

夜已深，計程車停在匹茲堡的尼克森劇院，經過一整天的旅程，我終於到了。穿過四散著舊報紙和垃圾的晦暗小巷，看見陳舊微明的標誌寫著STAGE DOOR（演職員出入口）。門內、警衛、郵件櫃，闃黑的舞台上，點著一盞永不熄滅的工作燈（pilot-lamp），巨大的黑暗中散發著針尖一般的光亮。幽暗空中垂下的繩索，布幕消失在朦朧的神祕黑暗中，荒涼無依的舞台如夜一般地靜悄。這樣的舞台我是多麼地熟悉啊！它們的寒涼、它們的默想、它們的回音、它們的記憶。這裡，環抱我的空氣告訴我，在這黑暗的王國，陽光照射不到的冥河，居住著劇場中偉大的精靈。

搭了一半的佈景兀自矗立在舞台上，那是一個房間，有著華麗窗簾和畫像的幾面牆，繞到牆的背後，背後什麼都沒有，只有包覆著帆布的木框，木框上印著繪景人的名字，和無數工作人員的烏黑手印。這一場景從正面看起來是如此地真實，但在它的背後卻什麼都沒有，一無所有，有的只是空蕩回響的舞台。那令人畏懼卻又充滿預示的荒蕪。

1 約470–399 B.C.，古希臘哲學家。其思想和詰問論證法經由其弟子柏拉圖的《對話錄》流傳於世。
2 1879–1940，英國文學家，作品多描寫大英帝國殖民底下的印度居民與英國人之間的種種互動。

I stand for a while in the shadowy wings, in the half light that brings dreams. Here, I say to myself, is where actors spend their lives. It is their only home. A strange home for anyone to have, this comfortless chill void.

I go into the old green-room. I look at the faded photographs of bygone celebrities, the sons and daughters of Thespis, yellowed and blurred. The mask of Lear's fool seems laid over these faces, with their mobile features, their large eyes, their sensitive mouths, their sad wise air of the seasoned player— over-emphatic brave faces of those who have dared to pass out of life into the life of the theatre. There is a certain pathos about these figures. I think of the Saturday night parties, the jumps on trains, the bustling up alleys in the dark, the knowledge of a life back stage, behind the scenes…

Why did these actors go into the theatre? Why did they choose to paint their faces, learn endless lines, get up on the stage before audiences? Perhaps they themselves did not know. They were drawn to the theatre by some nameless ambition to dominate, it may be, some desire to "show off," or by some half-grasped intuition as to the nature of their chosen calling. But no matter

　　我在翼幕間佇立了片刻，在這製造夢幻的微明亮光中，我對自己說，這裡、就是這裡，就是演員們消磨他們生命的所在，這是他們唯一的家。這無人安慰的冰冷虛空，是常人所無法擁有的一個家。

　　走進了古老的演員休息室（green room），望著牆上舊照片裡模糊泛黃的過往名流，他們都是泰斯庇斯（Thespis）[3] 的後裔，有著表情豐富的面孔、誇張的眼眸、敏感的雙唇、散發著憂鬱智慧氣質的季節性演出者，李爾王弄臣的面具似乎都在他們臉上駐足過。是這些刻意浮誇的面容，曾大膽的將生命分贈給劇場，這些身影有著奇妙的感傷力，讓我想到了週末夜晚的聚會，一班換過一班的通勤列車、黑夜暗巷的奔行、後台人生的智慧、在景片之後……

　　這些演員為什麼走進劇場？為什麼選擇在自己的臉上塗抹濃豔的色彩？在舞台上、在觀眾面前、演繹無盡的台詞？或許他們並不自知，也或許是在他們內心深處有一股莫名的主宰慾、又或許是「炫耀」的慾望、更或者是對天性召喚一知

3 西元前六世紀希臘悲劇詩人，被譽為「悲劇的創始者」，為戲劇史上可考的第一個演員，因而後世稱演員為泰斯庇斯。

how they began, they presently became part of the Body of the Theatre, as people become part of the Body of the Church. They became the Ladies and Gentlemen of the Theatre.

Not all of them were born in the theatre, but all of them were born for the theatre, born to tread the boards, to wear the sock and buskin. They sensed the theatre with a kind of sixth sense. In due time they came to look at life in a way that was peculiarly theatrical. They came to see all life in terms of impersonation.

We speak of a scientific attitude toward life, or of a philosophical attitude, or of a religious attitude. But of all conceivable attitudes the theatrical attitude is the most truly creative. To see life as these actors saw it is to move in a realm of truth inhabited by few. Our poets and visionaries attain to this truth in rare and isolated moments of detachment. But audiences come face to face with it every night of their lives—yes, and twice a day on Wednesdays and Saturdays—in every theatre, at every performance. It lies at the root of all dramatic instinct, and it is the essence of the art of acting.

It happens to each one of us at times to feel separated from ourselves, going through the business of living as if we were at once a character in a play and the actor who impersonates that character. Two people dwell in us, an outer self, a being

半解的直覺。但不論他們如何開始，他們已經成為劇場的主幹，一如教堂的中殿，他們是劇場中的王公貴冑。

　　這群人不全都出生於劇場，可是他們全都是為劇場而生、為舞台而生、為喜劇與悲劇而生。他們依憑直覺體悟劇場，在適當的時候，以獨特的劇場觀面對生命，他們以一種扮演的角度來檢視生命。

　　有人用科學的角度觀察生命、有人用哲學的態度審視生命、更有人用宗教的眼光來探討生命。然而在所有可想見的觀點中，劇場觀的生命觀卻是最具創造力的。正如這少數游移在真理世界中的演員，他們眼中所看到的世界。詩人和預言家們，僅能在人跡罕至的孤絕片刻中獲得這真理，但是觀眾們每天、每晚、在每一個劇院中都能與它相遇——的確，週末假日還有兩次相遇機會。這一切都根源於戲劇本能，它也正是表演這一行當的精髓。

　　我們都經歷過一種抽離自我的狀態。在生命的歷程中，我們扮演的角色一如演員在舞台上所演繹的角色。兩個不同的人居住在我們的身體裡，一個外在的我，一個會應答別人呼

who answers to the name of John Doe or Richard Roe, a kind of character-part, so to speak, and an inner self, a mysterious essence, a hidden flame, a shy wild Harlequin who plays this part before the world. We feel the presence of this other self when some moment of stark reality strikes through the conventions of our everyday lives. There is no one who has not experienced at some time or other the sense of inward withdrawal. All life is indeed a play in which we act out our roles until the final curtain falls. This idea of the theatre goes deep. We recognize its truth in our inmost hearts. We know that it is true as we know that our souls are immortal. I am persuaded that the consciousness of a dual personality—the sense of otherness, of apartness, the sense that we are possessed, that another's voice ever and again speaks through us—is a thing that is very common in human experience and that it is the only thing that separates us from the brutes. Perhaps it was the sense of *theatre* that made us human, ages ago.

If it is true—as Shakespeare makes the melancholy Jaques say—that all the world's a stage, and all the men and women merely players, playing our many parts on "a vaster place than any stage," it follows that we must be playing these parts before an audience. Who and what is that audience? Shall we ever know? Perhaps it is an unseen audience, a hierarchy of invisible

喊的我，不論你叫張三或李四。另一個內在的我，是個神祕的本體，一股隱藏的火焰，面對這世界的時候，它像是隱藏在丑角面具後的演員。每當清晰的真實，意外地穿越我們日常生活的模式時，我們都能體會到另一個自我的存在。幾乎沒有人不曾體會過這種內在自我的外現，事實上，所有的存在都是一齣戲，我們在其中扮演應有的角色，直到落幕。這個概念更深層的意義在於，我們承認真實存在於我們內心深處。我們之所以這麼認為，一如我們相信靈魂的不朽。我相信雙重人格的感知——一種自外的、抽離的、讓人著魔的，像是另一個人透過我們的軀體在發言——是人類的共通經驗，也正是這樣的經驗能使我們的生命脫離苦澀平淡。或許正因為這樣**劇場感**的生命，才在幾萬年前成就我們獨特的人性。

　　如果這一切屬實——正如莎士比亞筆下的丑角所言——這世界是個舞臺，世上的男男女女都只是演員，每個人在「全世界最大的舞台」上扮演著各自的角色。那麼接下來的問題是，演員必須面對觀眾，那我們的觀眾是誰？我們是否察覺得到？會不會是一群我們所看不見的觀眾？一種無形力量的

powers, the Great Republic of "ethereal dominations" that Blake and Shelley saw. I think of the unseen audiences of Toscanini, made free of his art by the miracle of radio transmission…Or is the earth itself a living, sentient being, as the poets have told us, and is it her approval for which we strive, all unknowing, in our performances? And when the curtain has fallen on the last act of our lives, if we have played our parts to the best of our ability, may we hope to hear from beyond the curtain some vibration of divine reassurance, some echo as of ghostly applause?

And is there an Author of the piece, who assigns to each of us his part and makes us "masters of all this world?" And shall we one day be allotted other parts to be acted on other and yet vaster stages? Or shall we return again and again until all parts are played and drama itself is finished?

These players became aware of the profound duality of life at the moment when they spoke their first lines on a stage, and thereafter all their acting was animated by it. They called it giving a good performance. But what they meant was that a spirit was

4 1792–1822，英國浪漫派抒情詩人。作品有 *Queen Mab* (1813)、*The Revolt of Islam* (1817)、*Prometheus Unbound* (1820)。
5 1757–1827，英國詩人、畫家和神祕主義思想家。著有 *Songs of Innocence* (1789)、*Songs of Experience* (1794)、*Jerusalem* (1820)。

級制？是雪萊（Shelley）[4]和布雷克（Blake）[5]眼中看到的，由「靈氣所主宰」[6]的偉大共和體？這令我想到，透過奇妙的無線電傳播，托斯卡尼尼（Toscanini）[7]的無形聽眾群們因為他的藝術而體會自在奔放⋯⋯又或許像詩人所言，地球就是一個生命有機體，在她的默視下我們無知無覺地進行演出，如果我們盡心盡力完成我們的角色，當生命之幕最終落下時，我們能否聽見大幕外傳來微微的震動、那朦朧的掌聲迴響、那來自上蒼的肯定？

在這個作品是否有個作者？它指明了我們每一個人所扮演的角色，而使我們自以為是「世界的主宰」？會不會有一天我們被指派去另一個更大的舞臺，演出另一個角色？還是我們將一直不停反覆地出現在這裡，直到所有角色扮演完畢、直到戲劇不再有意義？

演員們在說出第一句台詞的同時，就已經體驗到了雙重性生命的奧義。自此爾後，他們所有的演出也都是由此而激發活化，這樣的經驗被演員們認為是好的演出。而真相是，在

6　可解釋為古人所想像的天空的上層空間，充滿精氣或靈氣。
7　1867–1957，義大利名指揮家。曾任米蘭斯卡拉歌劇院、紐約大都會歌劇院及紐約愛樂交響樂團指揮。

present in them for a time, making them say things that they themselves did not know they knew. This knowledge took its toll of them. They paid for it with a part of their souls. No wonder theirs was a Profession set apart.

The thing that is absent from these records is the thing that never can be recorded, the emotion that these artists aroused in our hearts, the sense of triumph they gave us. Their peculiar power lay in this, that in their impersonations they could show us man's creating spirit, in action, before our eyes. They did not teach or preach about life or explain it or expound it or illustrate it. They created it—life itself, at its fullest and truest and highest.

And in the end they put aside the make-up and the vesture and went away into the darkness, leaving us only a few fading photographs and old playbills, and their imperishable memories.

Alone with their secret, in the old green-room, I think of the words of Plotinus: *For the soul, a divine thing, a fragment as it were of the primal Being, makes beautiful according to their capacity all things whatsoever that it grasps and moulds.*

那一個當下似乎有某個精靈進駐在他們身上，令他們說出了自身所不自知的已知。無怪乎表演成為一項獨特的專業，因為這項智識是透過演員作為傳達工具，而演員也以他們部分的靈魂交換了這份智識。

在這些紀錄裡面所看不到的東西，也正是那無法紀錄部分。那是這些藝術家們在我們心中所激發的情感，他們所造就我們的滿足感。他們奇妙的能力就在於透過他們的扮演，我們能活生生地親眼目睹人類創造的精神。這群人並沒有對我們指點、說教生命；也沒有解釋、闡述或描繪生命，而是以最飽滿、最真實、最尊貴的面貌創造生命──生命它自己。

而最終，他們卸下了妝扮及包裹，消失在黑暗中。留給我們的只有幾張褪色的照片，老舊的節目單和給予我們無法磨滅記憶。

在這古老的休息室裡，懷著他們的祕密。我想起了柏羅丁（Plotinus）[8]的字句：**這非凡的心靈，也許只是生命的一個斷章，但它（the Soul）之所以能造就完美，是因為我們心靈深處能掌握著且影響著一切。**

8　約205–270，出生於埃及的羅馬新柏拉圖主義哲學家。

The Dramatic Imagination　戲劇性的想像力

作者　　羅勃・愛德蒙・瓊斯（Robert Edmond Jones）
譯者　　王世信
審稿　　聶光炎
執行編輯　台灣技術劇場協會
美術設計　王志弘
內頁構成　吳莉君
企劃編輯　葛雅茜
文字編輯　馬繡茵
校對　　馬繡茵、林佳慧、汪晴

行銷企劃　蔡佳妘
業務發行　王綬晨、邱紹溢、劉文雅
主編　　柯欣妤
副總編輯　詹雅蘭
總編輯　　葛雅茜
發行人　　蘇拾平
出版　　原點出版 Uni-Books
　　　　新北市231030新店區北新路三段207-3號5樓
　　　　電話：（02）8913-1005　傳真：（02）8913-1056
　　　　台灣技術劇場協會（TATT）
　　　　11255台北市北投區開明街71號 B101室
　　　　電話：（02）2892-1709　傳真：（02）2892-8631
發行　　大雁出版基地
　　　　新北市231030新店區北新路三段207-3號5樓
　　　　24小時傳真服務（02）8913-1056
　　　　讀者服務信箱Email: andbooks@andbooks.com.tw
　　　　劃撥帳號：19983379
　　　　戶名：大雁文化事業股份有限公司

初版一刷　2009年10月
二版一刷　2024年1月
定價　　440元
ISBN　978-626-7338-51-3
版權所有・翻印必究（Printed in Taiwan）
ALL RIGHTS RESERVED

The Dramatic Imagination: reflections and speculations on the art of theatre
©1941, 1969 by Robert Edmond Jones (1887–1954)

國家圖書館出版品預行編目資料
戲劇性的想像力/羅勃・愛德蒙・瓊斯（Robert Edmond Jones）著；王世信 譯.
二版. 一新北市：原點出版：大雁文化發行，2024 .01
304面；16×22.5公分
譯自：The Dramatic Imagination: reflections and speculations on the art of theatre
ISBN 978-626-7338-51-3（平裝）　　1. 劇場藝術　　981　　112020273

本書獲財團法人國家文化藝術基金會贊助出版